Mom and Dad,
THANK YOU FOR YOUR LOVING AND UNENDING ENCOURAGEMENT.

Super Dave,
I WILL FOREVER BE HAPPY THAT YOU SWIPED RIGHT.

Table of Contents

3	Contents
6–7	Acknowledgments
9–13	Introduction by Jill Silva
15–17	The Business of Food Trucks
21–25	Anousone's Mobile Cuisine
27–41	Ash & Bleu Cheese Co.
43–53	Bay Boy Specialty Sandwiches
55–63	Beauty of the Bistro
65–75	Betty Rae's
77–83	Bochi
85–93	The Casual Foodie
95–105	Cirque du Sucre
107–117	CoffeeCake KC
119–131	Indios Carbonsitos
133–137	Jazzy B's
139–149	KC Pinoy
151–159	Melt Box
161–173	Mudbug Mobile Madness
175–185	Plantain District
187–197	Pita for Good
199–209	Seven Swans Crêperie
211–217	El Tenedor
219–222	About the Author
225	About the Photography

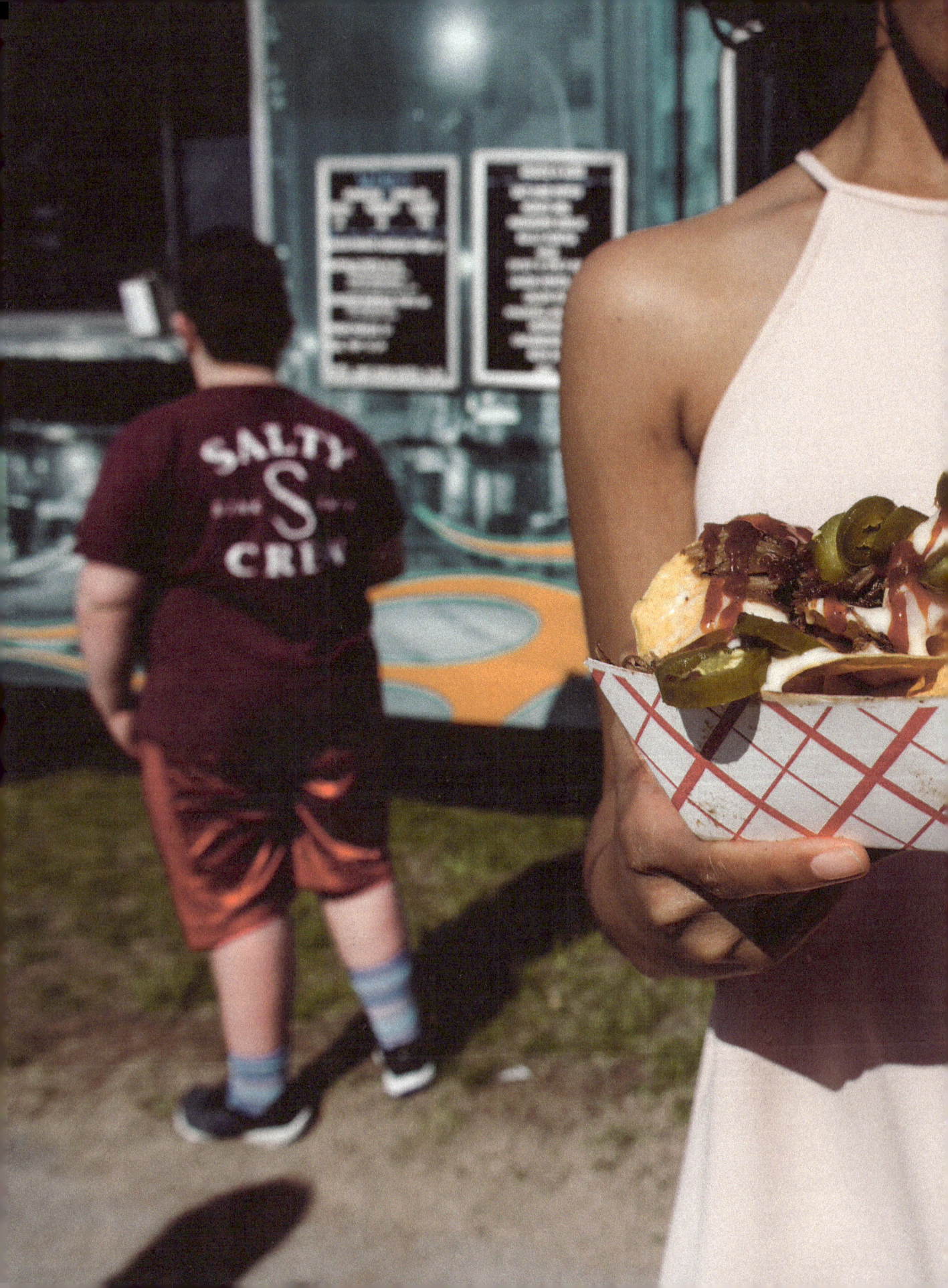

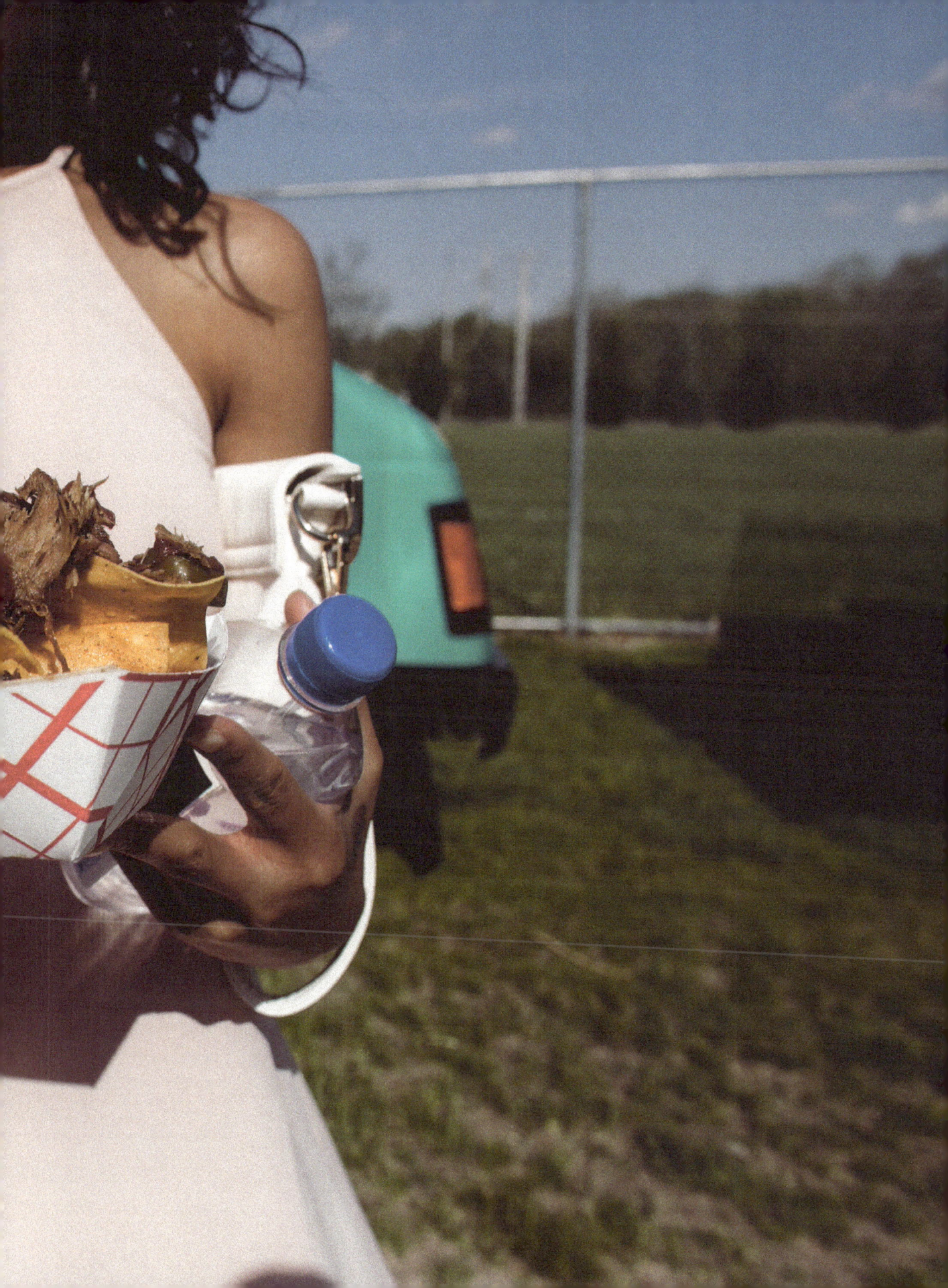

Acknowledgments

I rewrote this first sentence so many times; each version more cliché than the last. I'm not about to start my first book with a cliché. Yet, neither my imagination nor my vocabulary can find the words to express my gratitude to the countless people who contributed their stories and who taught me the importance of telling those stories.

When I say "this book would not be possible without the food truck owners who contributed to it," that is no hyperbole. It's fact. A heartfelt thank you (and a round of drinks) is owed to the food truck owners who so generously offered time from their hectic schedules (or peaceful hibernation periods) to tell me about what they do and why they do it. You are emblematic of the American dream. The value of hard work, grit, and creative tenacity is evident in all that you do. It was my profound pleasure to hear your stories and my honor to share them in this book.

TO JASON AND ALLISON DOMINGUES: Your photography is unparalleled. I am so thankful for the generosity of time and talent you lent to this project.

TO KAREN TOPHAM AND PETER LUBLINER OF LAKE FOREST HIGH SCHOOL IN ILLINOIS: Thank you for helping me discover and foster my love for writing. Your editing guidance is still the little voice in the back of my head as I write. When I would show up before school every day eagerly waiting to show you my revised story too many days in a row, you were wise to tell me to take a step back for a while and come back to it with fresh eyes. I do not know how you summoned the patience, but I'm grateful you did.

TO DR. DAVID KAMERER OF LOYOLA UNIVERSITY CHICAGO: Thank you for encouraging me to blog, and for guiding me in my career path even after graduation. I left your classroom and shortly thereafter started my first blog. It was about the emerging food truck scene in Chicago. This hobby led me to finding real community, and with it came friendships and a newly discovered passion for advocating for the constitutional freedoms being denied some of our talented and ambitious friends and neighbors as entrepreneurs, even in 2018.

TO JILL SILVA, for supporting Kansas City trucks from day one, introducing this fleet of foodies to the public, and highlighting their contributions to the Kansas City food community. You are an ally and advocate for budding food truck owners who are often encouraged by your stamp of approval. You may not fully know the impact you've had, but you've certainly contributed to the growth of this group of entrepreneurs.

TO MORGAN PERRY, for taking me under your wing and your role in making Kansas City feel home away from home. There are boatloads of local business owners who are wiser and (more) successful because of your counsel. Were it not for your encouragement I am certain this book would not exist.

TO JOHN PAJOR FROM THE CITY OF KANSAS CITY, MO. BUSINESS CUSTOMER SERVICE CENTER (KANSAS CITY BIZCARE). When I was first dipping my toe into the water to learn about food trucks in Kansas City, I reached out to the city and they connected me to you. You were the first person with whom I was able to really geek out about food trucks here.

Introduction
by Jill Silva

Food trucks offering everything from Spanish tapas to flaky Australian meat pies to lavender-infused crème brulee have become a fixture at music festivals, farmers markets, wineries, corporate picnics, weddings, and charity events.

Most trend watchers credit Kogi BBQ for revving up the nation's food truck engine starting back in 2008. The fusion taco concept was the creation of street-smart Korean chef Roy Choi, who had grown up in Los Angeles, where taco trucks had long been a time-honored culinary tradition.

As food editor for The Kansas City Star, the viral dispatches about Kogi immediately caught my eye. But my stomach rumbled impatiently as I waited for a sign it would happen here. In March 2011, a Yelp post hinted at the location of Indios Carbonsitos, a "Mexi-Q" truck based on mash-ups of the owner's favorite foods: Mexican and Kansas City barbecue.

I dashed to the corner of 10th and Orville streets in Kansas City, Kansas, to find the owner Adrian Bermudez had parked in front of his parents' home. His menu included a variety of street tacos, barbecue tamales and ahogadas, a carnitas sandwich drowning in a spiced tomato sauce.

By the next weekend, the owner of a small grocery nearby had called the police, and Bermudez was out roaming for another parking spot. He had better luck at South Sixth Street and Kansas Avenue across from a body shop and a supermarket, where his customers included a police officer and a chef.

Bermudez's transient business model led him to post his changing locations on Facebook: "I was a Facebook and Twitter snob," he said. "I did not want to have anything to do with it, but a friend of mine told me I was missing out on a lot of publicity. When I started using Facebook, my business really started to take off."

On the other side of the state line, Simonie Wilson, owner of 3 Girls Cupcakes, was mapping out a reliable delivery route. The mobile bakery offered eight flavors, including the best-selling red velvet and the designated "flavor of the day," which included Hippie Chow, a spiced cupcake swirled with brown sugar cream cheese frosting and dotted with a sprinkling of locally made organic granola.

As Wilson flipped up the order window and tapped a message into her iPhone, instantly sharing her whereabouts with 1,000 Twitter followers and 1,500 Facebook friends, she also tapped the name of other mobile eateries she encountered on the street into her phone. "Every week that I'm out," she said, "there's another truck."

Gaining critical mass raised visibility, but parking remained a road block: There were surprisingly few places for food trucks to stop within the city limits, and the suburbs were even more restrictive. As Wilson dropped me back off at the newspaper, she asked if I knew of a parking lot where she and other new trucks could gather for a "rally." It was one of those a-ha moments: I pitched the idea of using The Kansas City Star's company parking lot at 17th & McGee streets and somehow convinced my editor and the newspaper's skeptical publisher to try the idea out.

Food Truck Friday kicked off with Indios Carbonsitos, 3 Girls Cupcakes, and five other food truck businesses highlighted in my 8-page feature story. Half-page print ads and public Facebook invitations helped get the word out to a still wider audience.

After checking in with the city government about permits, inspections, and liability, I crossed my fingers and hoped for good weather and a hungry crowd. Food Truck Friday coincided with First Fridays, an art and culture event that would guarantee foot traffic.

My shock at a robust turnout soon gave way to concern as lines snaked across the asphalt and the wait times climbed to 45 minutes and an hour. But rather than creating frustration, there was a sense of com-

munity over an al fresco dining experience that was on its surface novel, but at its core working to strip away the intimidation factor foodie culture often fosters.

Food Truck Friday routinely attracted 3,000 to 5,000 people. Buskers, roller derby queens, and movie-goers dressed as zombies mingled as the lines ebbed and flowed. Older patrons tended to come early, sometimes toting lawn chairs. Family, kids, babies, and dogs dotted the picnic tables and lawn.

The number of events steadily increased over the next seven years, from two, to four, to six per year, and the lot became prime real estate for a budding community of mobile entrepreneurs. The Star lot offered enough space to park 10 to 12 invited trucks, with additional ones jockeying for perimeter street spaces up to 24 hours in advance. The events were scheduled to run 5 to 8 p.m., but generally continued until the trucks ran out of food at 10 or 11 p.m.

My goal was to carefully curate a list of reliable chef-driven concepts. Regular attendees included: El Tenedor, Crave KC, Beauty of the Bistro, Little Italy, Cajun Cabin, Monk's Roast Beef, Bochi, Pie Hole, Wilma's Real Good Food, Jazzy B's, Poppy's Ice Cream, and Torched Goodness. At the final event in May 2017 before The Star's parking lot was sold to developers, the roster had grown to include notable newcomers Cirque du Sucre, Magnolia's on the Move, Taste of Brazil, and KC Pinoy.

Port Fonda, a renovated Airstream trailer that got its start at Food Truck Friday, stands out as Kansas City's Kogi equivalent. "It's really a new genre for our city," chef Patrick Ryan said. "It's something I do not think anyone can duplicate."

The mobile Mexican menu was a hot draw — as Ryan simultaneously churned out traditional street food then he turned around and used the dinette to host a $200 prix-fixe meal for six starring a succulent bone-in Berkshire pork shoulder from Arrowhead Farms, served carnitas-style

with Rancho Gordo beans, fresh corn tortillas, guacamole, and fresh salsa.

For a year and a half, Ryan anchored a few blocks away from The Star at The Rieger. Our paths crossed again when I gave Port Fonda a four-star dining review, considered a shocking move that set the food community and fellow critics buzzing.

By putting food trucks on an equal footing, I was championing unconventional food experiences that could reach a broader, more diverse audience. Soon after the review, Ryan announced he'd be taking his concept to Westport, turning it into a brick-and-mortar cantina. (Luckily, chilaquiles are still available on the regular menu, and the pork shoulder dinner is available off the to-go.)

Port Fonda's meteoric rise – which included a highly coveted James Beard nod for Ryan – further mowed down the perceived barriers between what constitutes high and low cuisine. KC Hopps restaurant group soon added The Moose Truck, and Bread & Butter Concepts rolled out Taco Republic, followed by McGonigle's Meat Wagon, Betty Rae's Ice Cream, and The Doughnut Lounge.

Meanwhile, the definition of a food truck expanded to include Pigwich, a non-moving offshoot of the Local Pig butcher shop in the industrial East Bottoms, and Anousone's Mobile Cuisine, a Laotian-themed truck moored at Little Piggy, a seasonal food truck "hub" on Southwest Boulevard.

Savvy truck owners have organized into a variety of food truck associations. Facebook groups have cropped up to fill up catering dockets. Once skittish about regulating roach coaches, city governments are now bullish on the business of food trucks. Infrastructure is taking root: Mid Continent Public Library hosts business boot camps and Food Truck Central, a much-needed commissary kitchen, welcomes mobile vendors of all stripes.

I have been honored to roll with members of the Kansas City's tight-knit food truck community and tell their stories. As Food Truck Friday wound down, I met Alex, who brought fresh eyes to the local scene with her "Kansas City Food Truck Blog."

Together, we hope this passionate guide continues to get the word out, because whether you crave fusion tacos or a bowl of steaming ramen, Canadian-style poutine or a farmstead cheese plate with your choice of sheep's or cow's milk, the quality and variety of eats offered on Kansas City's streets are hard to beat.

JILL WENDHOLT SILVA CREATED THE POPULAR FOOD TRUCK FRIDAY FRANCHISE WHILE SHE WAS FOOD EDITOR AT THE KANSAS CITY STAR. NOW WORKING AS FREELANCE FOOD WRITER AND BLOGGER, SHE CONTINUES TO RALLY AROUND INNOVATIVE STREET EATS.

The Business of Food Trucks
by Morgan Perry

Kansas City is a city of business education. Home to the Ewing Marion Kauffman Foundation, we have numerous business resource organizations whose mission is to support small businesses and entrepreneurs. Unfortunately, no one was paying specific attention to food businesses. I mean, these are small businesses that build products that you put inside of you and no one was helping them!

To help fill this void the library system I work for teamed up with veteran food trucker Brandon Simpson of Jazzy B's and created a semi-annual food truck workshop that we've now been running for four years. With the approachability and low entry barrier that food trucks provide, we have been able to help a wide range of entrepreneurs recognize that not only is a successful business within their reach, but there are also countless resources available to help them learn and improve their business skills. So what makes the food truck scene in Kansas City so different?

Kansas City has always had a style all its own. Long renowned for its fountains, jazz, and of course, barbeque, the city has a vibrant food culture that is far more diverse than just brisket and burnt ends. One particular segment of our food culture has forged a unique place in the often perilous restaurant industry. Food trucks have emerged as a legitimate choice for entertainment dining within the local food economy and are causing others to reimagine what food truck culture can be.

When you really think about it, we all know that food is actually quite far from simple. First of all, food is intimate. It's a product prepared by another person that you actually put inside you. Apps are fun, but they do not go inside your body. Second, food isn't just calories, it's culture. Certain smells or styles of food connect us to our memories or elicit emotions. There's a reason they call it "comfort food." Finally, yes food is energy and there will always be certain markets for trucks that "lunch it out" and pursue the work crowds. In fact, such "freezer-to-fryer" type

food trucks often have the highest profit margins. But Kansas Citians embrace a completely different category of food truck. Artisanal food trucks that specialize in 'homemade gourmet' meals are by far the most popular, and many have even developed their own cult following.

So we've established that to be a successful food trucker in Kansas City, it takes more than just a membership to a warehouse store. Food truck patrons expect something unique - and they're willing to pay for it. Most successful artisanal trucks charge around $15 for an entree. Catering opportunities abound as well as countless events like First Fridays and other local community festivals. Employee appreciation and other corporate events also quite frequently choose to bring in food trucks over other options as the popularity of food trucks soars. Many trucks are so popular that they are even guaranteed a certain level of sales by event organizers. Obviously, market oversaturation isn't a problem when trucks can command a $900 guarantee!

Even with the popularity of food trucks, it takes a bit more than just quality cuisine to truly separate yourself from the other food trucks in Kansas City. While there are around 25 trucks that command sales guarantees, there are also around 100 or so that do not. So how have these particular trucks established this new model of success? The answer is powerful and consistent branding.

In Kansas City, your brand is the complete experience you provide your customers. Brightly colored vinyl wraps or paint schemes, big personalities, and unique fusions of various cuisines draw the largest lines and spark the most comments and loyalty. A sometimes obsessive attention to detail reveals both a passion for their craft and a business savvy sense of brand identity. I'll give you a great example: We have several food trucks offering Filipino food. While the food from almost every truck is unique and high quality, one truck in particular stands out in the crowd. KC Pinoy could also be known as the NO LUMPIA truck and Chrissy, the owner, makes no apologies for it. Rather than serving what people expect from Filipino food, Chrissy serves only her

grandmother's recipes - and Grandma did not do lumpia. But that isn't the only memorable thing about the meal: the cutlery is hand-wrapped, the straws are always paper with a red stripe, and the garnish is a carrot beautifully cut to resemble a flower. These small details are the kind of thing that keep customers coming back again and again.

While Kansas City doesn't currently embrace the pop-up or hub model of food truck commerce the same way it does events, it's important to remember that the scene is constantly changing. As some trucks decide to sell, evolve, retire or even transition to a brick and mortar restaurant, an influx of new food truckers could potentially influence what the future may look like. But for the time being, event-based artisanal trucks that offer an eclectic combination of quality cuisine, memorable people, and unique branding are setting the standard for what it means to be a Kansas City food trucker.

MORGAN PERRY IS THE BUSINESS OUTREACH SPECIALIST FOR THE MID-CONTINENT PUBLIC LIBRARY AND A FOUNDING MEMBER OF THE SQUARE ONE SMALL BUSINESS SERVICES TEAM.

PHOTO CREDIT: ALISTAIR TUTTON PHOTOGRAPHY

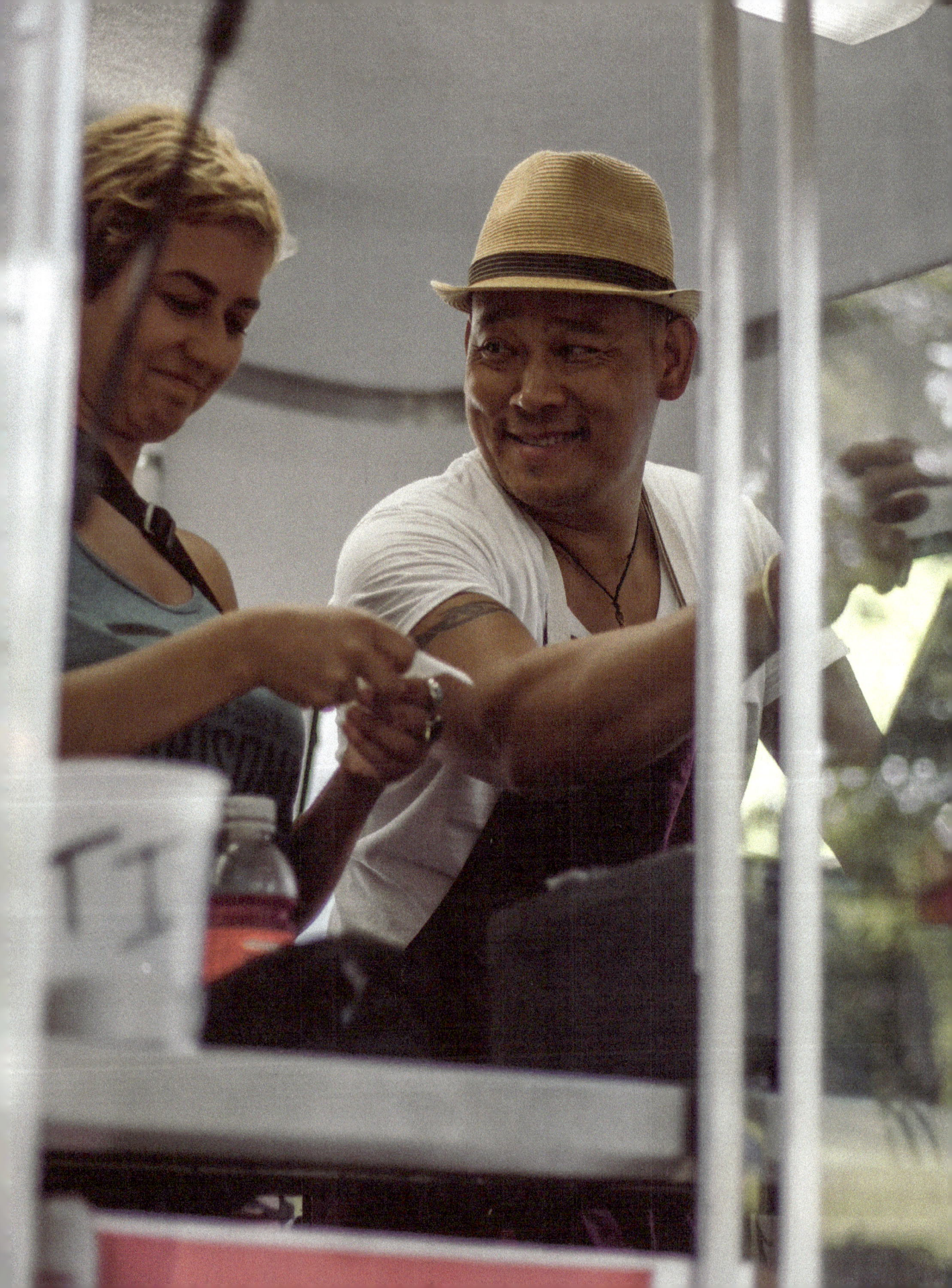

Anousone's Mobile Cuisine

SOCIAL
f @kcmobilecuisine

SUMMARY
Anousone's Mobile Cuisine is chef Anourum Thomson's food truck, with a menu inspired from his native Laos.

STORY
Anourom (pronounced Honor-ohm) Thomson is a charismatic, ebullient guy who exudes as much happiness as he does passion for what he does. You would never know by talking to him that his path to get to here, to life in Kansas City as a business owner, was a turbulent one.

Thomson came to the Unites States as a refugee from Laos in 1980 after his mother, three siblings, and grandmother escaped on a longboat in the dark of night, crossing the Mekong River to safety in Thailand. After spending over a year in a refugee camp his family came to the United States, while his father stayed behind. It was here that his mother met an American man who she married. Her new husband adopted her four children, making them Thomson's too.

After Thomson graduated high school he went on to play soccer on a scholarship from Johnson County Community College, but a knee injury forced him to rethink his plans. Thomson was immediately drawn to the culinary arts. His love of food stemmed from his mother's cooking; it brought him closer to his Laotian culture and a bit of comfort while being far away from his home country. "I use my heritage, past and present life experiences, and positive intention to inspire my love of all things food," he says.

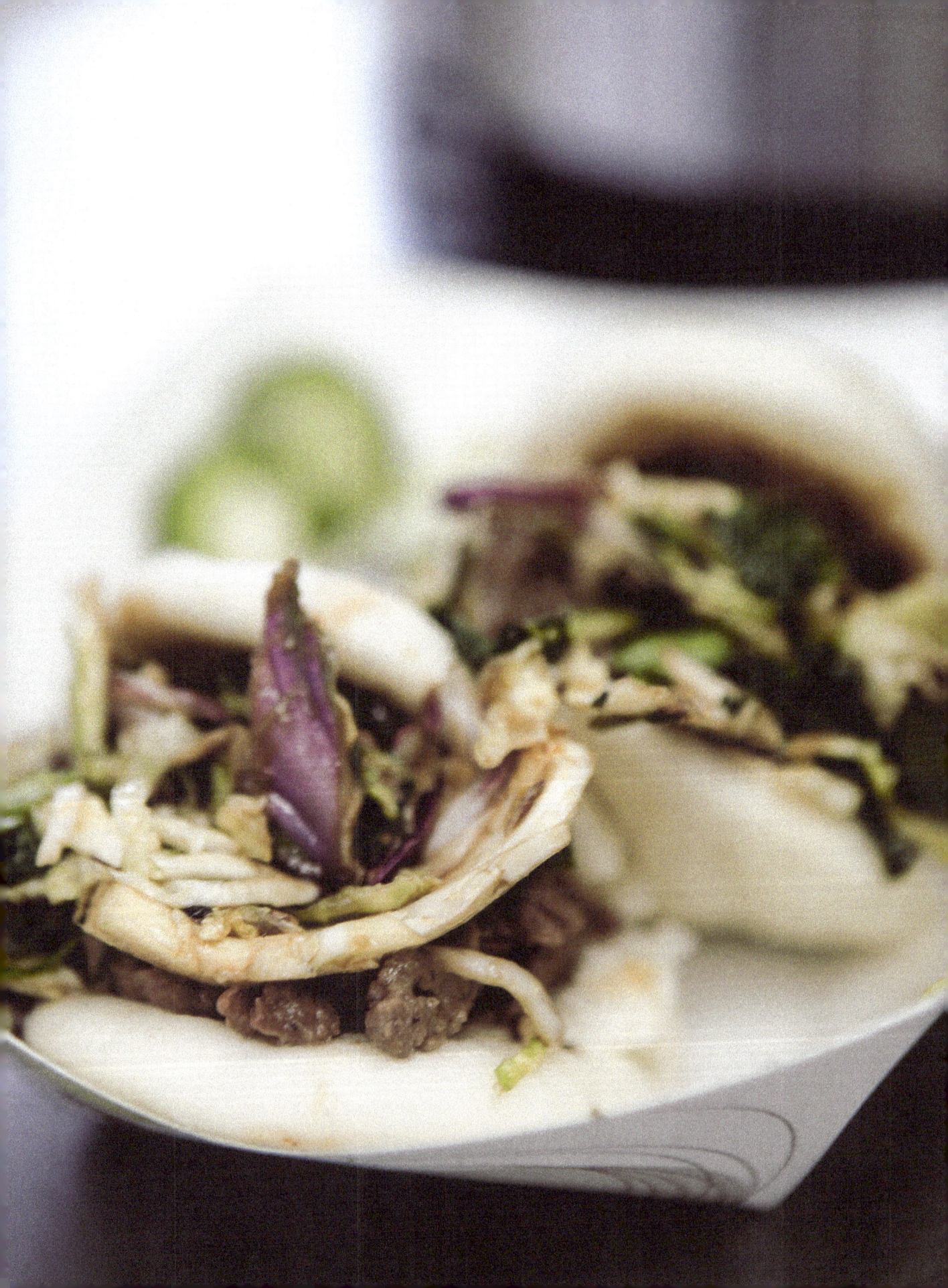

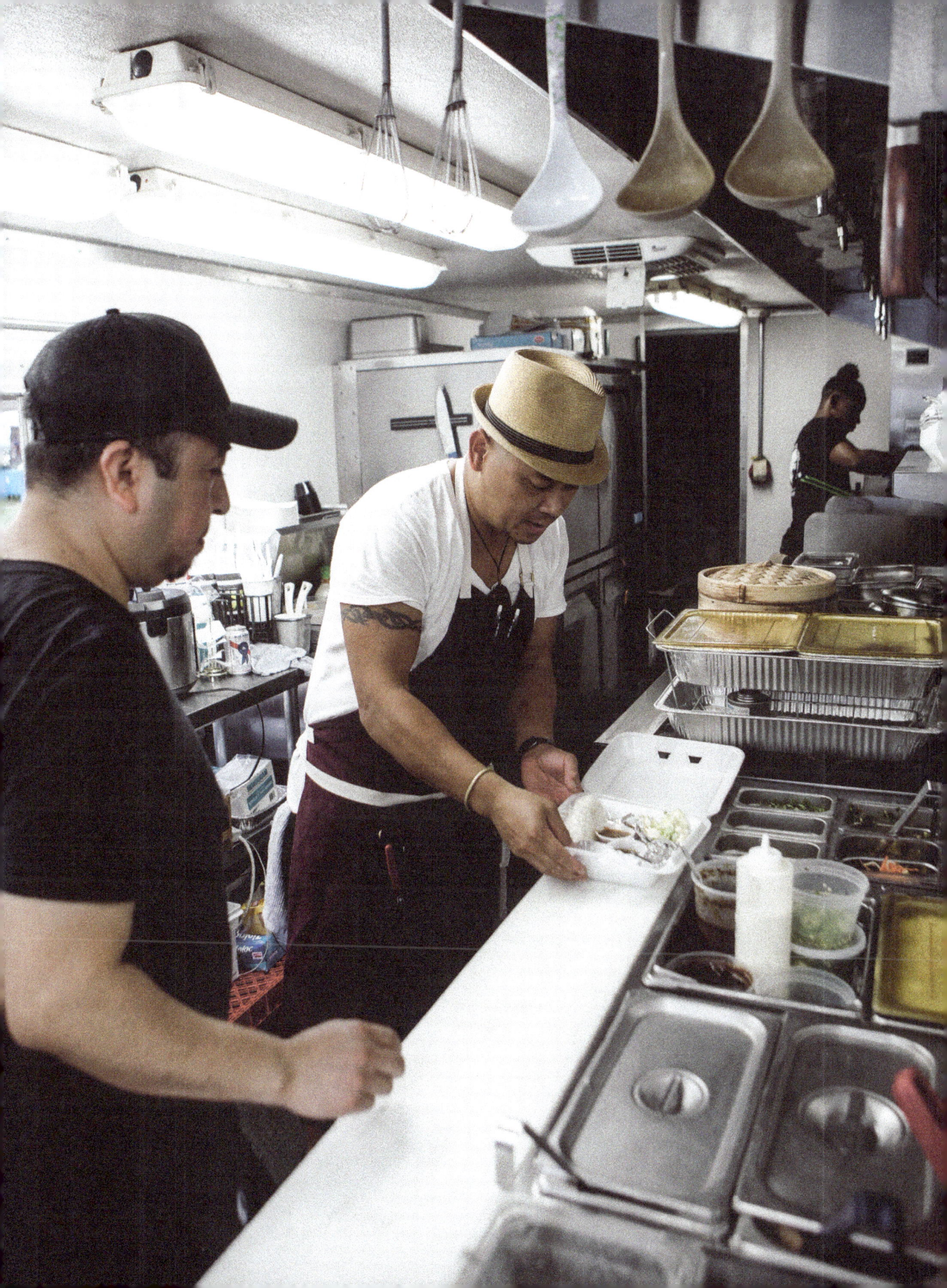

His love for his family inspired the name for his business. "My business is named after my older brother Anousone (pronounced ah-NEW-sone) who became ill and died after eating a poisonous bug when we lived in Laos. I had three siblings that perished in Laos. I thought it was a great way to honor him and convey our story with food."

When I first met Thomson, it was his first month in business. His food trailer is permanently parked at the Little Piggy lot, where it is today. At the time, he was experimenting with his menu and testing dishes with his new customers. He has evolved his menu as a result, adjusting his recipes based on customer feedback. "My menu has become somewhat more traditional with respect to the Laotian dishes I now offer," Thomson says. "As my business evolves I am learning that I can be more adventurous and true to both my heritage and nationality. I really enjoy challenging my customers' ideas of how they believe Asian food should taste."

The top-selling menu item is Thomson's steamed buns, which are little pockets filled with tasty dollops of meat. "I appreciate the contrast of the light and airy buns and savory side of the protein infused with the crunchiness and acidic aspect of the fast-pickled cucumber," Thomson says.

As business continues to grow, Thomson is looking to the future. "If all goes as planned, I will be the first 'mobile mortar' of its kind in the region. In other words, I can tow my vintage Spartan trailer to a place like the Heart of America Shakespeare in the Park festival for a large event, or park it at the food lot and connect it directly to the sewer system to become a brick-and-mortar.

While there is not a singular event that stands out to Anourom about his first year in business; he does fondly recall severable memorable moments. "I get great satisfaction from conversing with my customers and creating an overall positive experience," he smiles.

"This trailer means everything to me. I ended an 18-year career as an executive chef at a well-known high-end steak house [to start this business]. It has been a lifelong dream to open my own business and I found a novel way to introduce contemporary Laotian American cuisine to the Kansas City area."

Q&A

DO YOU HAVE ANY PETS?
Marcus, a 12-year-old Australian Cattle Dog we adopted a couple of years ago. My wife has a soft spot for old dogs, and he is blind as a bat! We also have a spicy 10-year-old Tortoiseshell cat name Hazel.

WHAT MAKES YOU FEEL PROUD?
Our son seeing me work hard to provide for our family. He is adventurous with food; the last time we went to Laos he ate crickets, beetles, mealworms, and grasshoppers. That makes a papa proud for sure!

IF I COULD EAT JUST ONE DISH FOR THE REST OF MY LIFE IT WOULD BE:
Pho

WHAT'S ON YOUR PLAYLIST?
Love and Rockets, Bauhaus, Led Zeppelin, Pink Floyd, Leonard Cohen, Gipsy Kings, 80s hip-hop.

WHAT'S THE LAST BOOK YOU READ?
"Undisputed Truth," Mike Tyson's autobiography

WHAT'S YOUR GO-TO GUILTY PLEASURE TV SHOW?
The Walking Dead

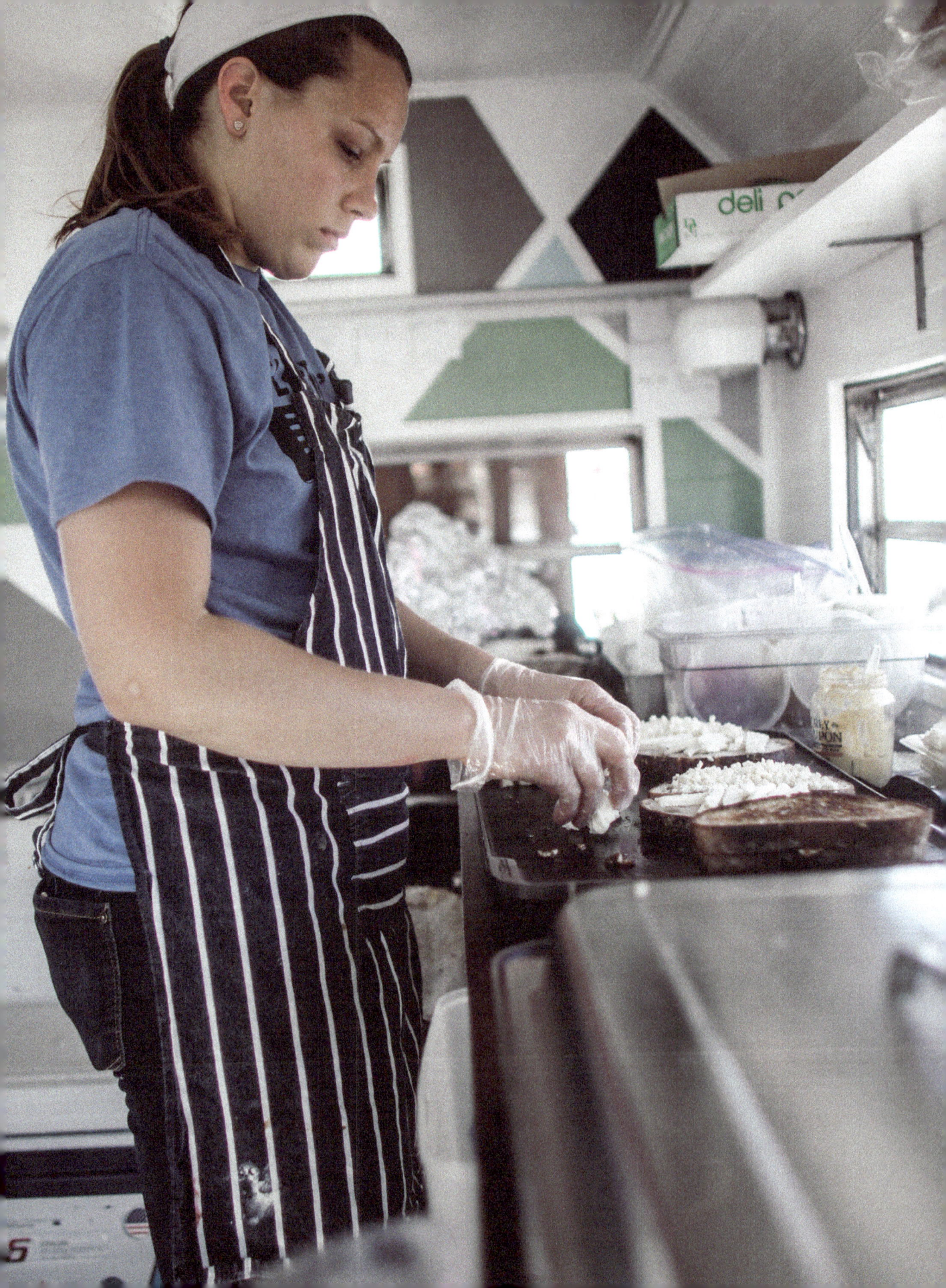

Ash & Bleu Cheese Co.

SOCIAL
f @AshAndBleu @ash.bleu.cheese.co

SUMMARY
Ash & Bleu is a specialty cheese-centric truck. Grilled cheese sandies are a staple and fan favorite. You can also buy locally-sourced cheeses from the truck.

STORY
When Bethany Harris launched her cheese-centric food truck in 2017, even she did not anticipate the level of success and interest that would come her way, right away. "My first season blew my expectations out of the water, Harris says.

Growing up in the small town of Blande, Missouri gave Harris an appreciation for local farming and food production. Her father, a cattle farmer, often scouts out family-owned cheese producers in the region and sends the tip to his daughter.

Harris grew up close to food, getting jobs at a waitress. While in college pursuing a degree in intercultural studies, she met her husband. Together they would move to Prague for his job, where Harris began to cook more than ever before. She became part of a community of expats who would get together and make food that they craved from home. Regularly hosting her friends and experiencing the generous hospitality of others in Prague, Harris realized not only did she enjoy hospitality, but she also had a knack for it.

After Prague, Harris lived in Ft. Collins, Colorado for 10 years. She knew she wanted to explore hospitality, and worked for a catering company for a year before enrolling at Johnson & Wales culinary school in Denver.

This was a good hour's drive from Ft. Collins. She would get in her car at 4:45 a.m. to make the journey, well before the sun would peek up over the horizon.

"Culinary school was like boot camp," Harris said of the grueling schedule. Clean, ironed chef whites were expected and inspected for proper creases in the pants. While finishing culinary school, Harris worked for Chef Bradford Heap at Colterra Food & Wine. While working as a prep cook and at the salad station for $5 per hour, Chef Heap taught her about technique and running the back of the house; she considers him a great mentor.

After working her way up to pastry chef and opening a second restaurant with Chef Heap, Harris took a job closer to home in Ft Collins. Nine months pregnant and working the line at all hours of the day, she knew it was time for another change, and thus began her work at Whole Foods, which eventually brought her to Kansas City.

Harris has worked at many of Kansas City's best locally-owned baking-famous restaurants. In order to introduce herself to the fine folks at Ibis, for example, she baked some bread and brought it into them along with her resume. Naturally, she got the job. She took a significant pay cut leaving Whole Foods, but, she says, "Compensation is about more than money. It's about coworkers, gaining experience, work culture, hours, the whole package."

Harris enjoyed working at Ibis until she made the decision to dedicate herself to her own business where she would still be selling Ibis bread, only now it would be from a food truck with delicious cheeses sandwiched between the slices. She had once dreamt of opening up a brick-and-mortar cheese shop like her favorite specialty shop in Prague, but startup costs for this business model were prohibitive. She and her husband bought and remodeled her sexy food camper all on their own, without having to mortgage away their homes and futures, and they wasted no time. She bought the trailer in March of 2017 and was hitting

the pavement by the first week of May.

Harris knew that the Overland Park farmers market would be right up Ash & Bleu's alley. Her clientele has a lot of overlap with the farmer's markets, plus it gave her the advantage of a regular weekly stop. However, she was hesitate to sign up for a slot at the market. "I think you grossly underestimate your own ideas," she said, "I convinced myself this was a really good idea but worried about how it would go. I blew my own expectations out of the water. I was shocked how it worked out."

Harris considers herself very pragmatic. She had considered every scenario, from wild success to slow and painful failure. "If it fails monetarily, it doesn't fail in the sense that I tried something I've always wanted to do and did not go into a mountain of debt," she stated. Had she gone the brick-and-mortar route, the potential of failure had much more dire down sides.

As much success as she experienced in her first year, it did not come without some bumps and bruises. "I was naïve about how seasonal the food truck business really is," she said. Business in Kansas City often comes to a screeching halt for many of the trucks come October or November, and they remain in hibernation until spring.

A couple months after launch, any residual uncertainty washed away when Jill Silva wrote a glowing article about Ash & Bleu in the Kansas City Star. "It kept me encouraged and energetic about the business. The article affirmed I had a good idea. Having Jill's stamp of approval was really important, and it happened at a great time when tensions were high and I was really trying to figure things out."

Since moving to Kansas City and becoming part of the food scene, Harris has also been a student of the local food community. "There are some really amazing classically trained chefs here, but also just as many passionate cooks. Passion comes from experience, background, and gut. [This combination] gives the food scene a lot of depth, making food with substance. I try to do the same thing on a small, dinky level."

Q&A

WHERE IS YOUR FAVORITE PLACE TO VACATION?
New Zealand

WHERE IS YOUR DREAM VACATION SPOT?
Brazil

WHAT IS YOUR FAVORITE CHEESE RIGHT NOW?
Petit Basque. It comes in a wheel at Whole Foods, and my kids buy me a wheel of it for special occasions.

WHAT IS THE MOST UNDERRATED CHEESE OR MOST MISUNDERSTOOD CHEESE?
Anything soft ripened with rind. When you cut it, it's gooey. Many people do not want to eat rind but it's the best part, and it's underrated because people do not know how to eat it, so they stay away.

VEGAN CHEESE: YAY OR NAY?
Nay for me. I understand people who can't or do not want to eat dairy, but its not my bag. For customers who have problems with lactose, I try to point them to goat cheese.

WHAT IS A FAMILY TRADITION YOU KEEP ALIVE?
I am very stuck in my way about Christmas. Working in food service most of adult life, you do not get Christmas, especially when we were in Colorado far from our families. By necessity we stayed put and made our own Christmas. I have never woken up on Christmas morning anywhere but our own house, and that still holds true. I do not want to go anywhere else for Christmas. It's a law.

WHAT ARE YOUR FAVORITE LOCAL RESTAURANTS?
El Pollo Rey and tamales from Carnicería San Antonio (both in Kansas City, Kansas).

DO YOU HAVE ANY BUCKET LIST AREA RESTAURANTS?
There's many popping up, I have an ongoing list. Justice Drugstore, Black Dirt, and Manifesto, to name a few.

WHAT IS YOUR GO-TO GUILTY PLEASURE TV SHOW?
Anything on PBS and NPR, Masterpiece Theater, This Is Us, Royal Tenenbaums, Wes Anderson anything, and I am huge into Saturday Night Live.

WHO DO YOU ADMIRE?
My mom, and the female cast members of Saturday Night Live: Tina, Amy, Maya; they're not afraid to make fun of themselves, and in the end they come out looking stronger. I take myself kind of seriously. It's like a spiritual awakening reading their books. You are who you are; own your strengths and weaknesses and you will come out on the other side stronger if you take it all in stride and put it out there. There's a lot of strength in that.

FANTASY DINNER PARTY, YOU'RE HOSTING. WHO ARE THE GUESTS?
Those 3 SNL ladies, Bill Murray, Barack Obama, Michelle Obama, Jimmy Fallon, all the people who make me laugh. And Bernie Sanders.

DO YOU PREFER TO READ A BOOK OR LISTEN ON AUDIOBOOK?
Read a book.

ARE YOU AN EARLY RISER OR A NIGHT OWL?
Both! I like staying up late to watch movies/read without kids, but I have to get up early because of the kids

BURNT ENDS OR BRISKET?
Burnt ends

Ash &

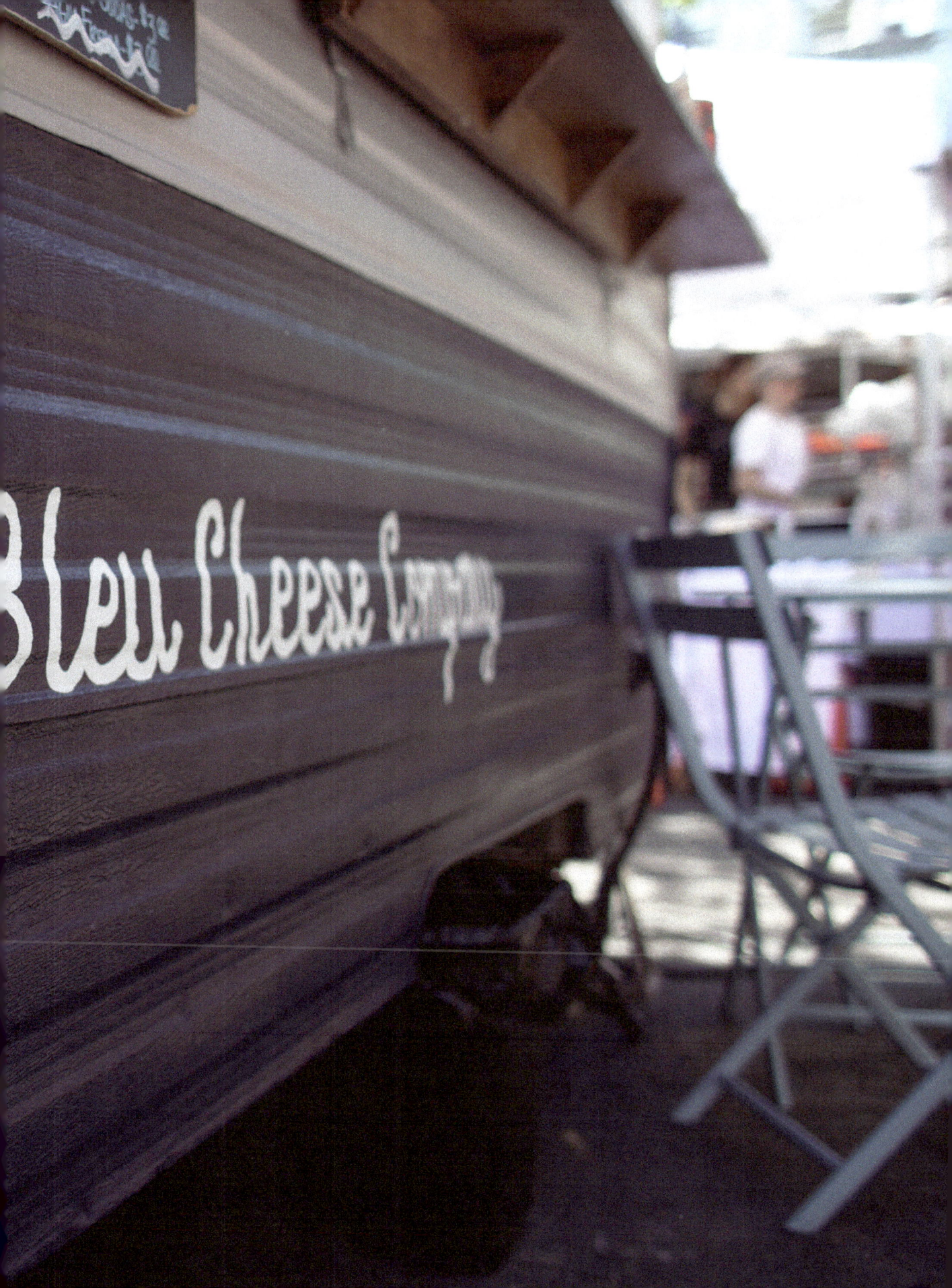

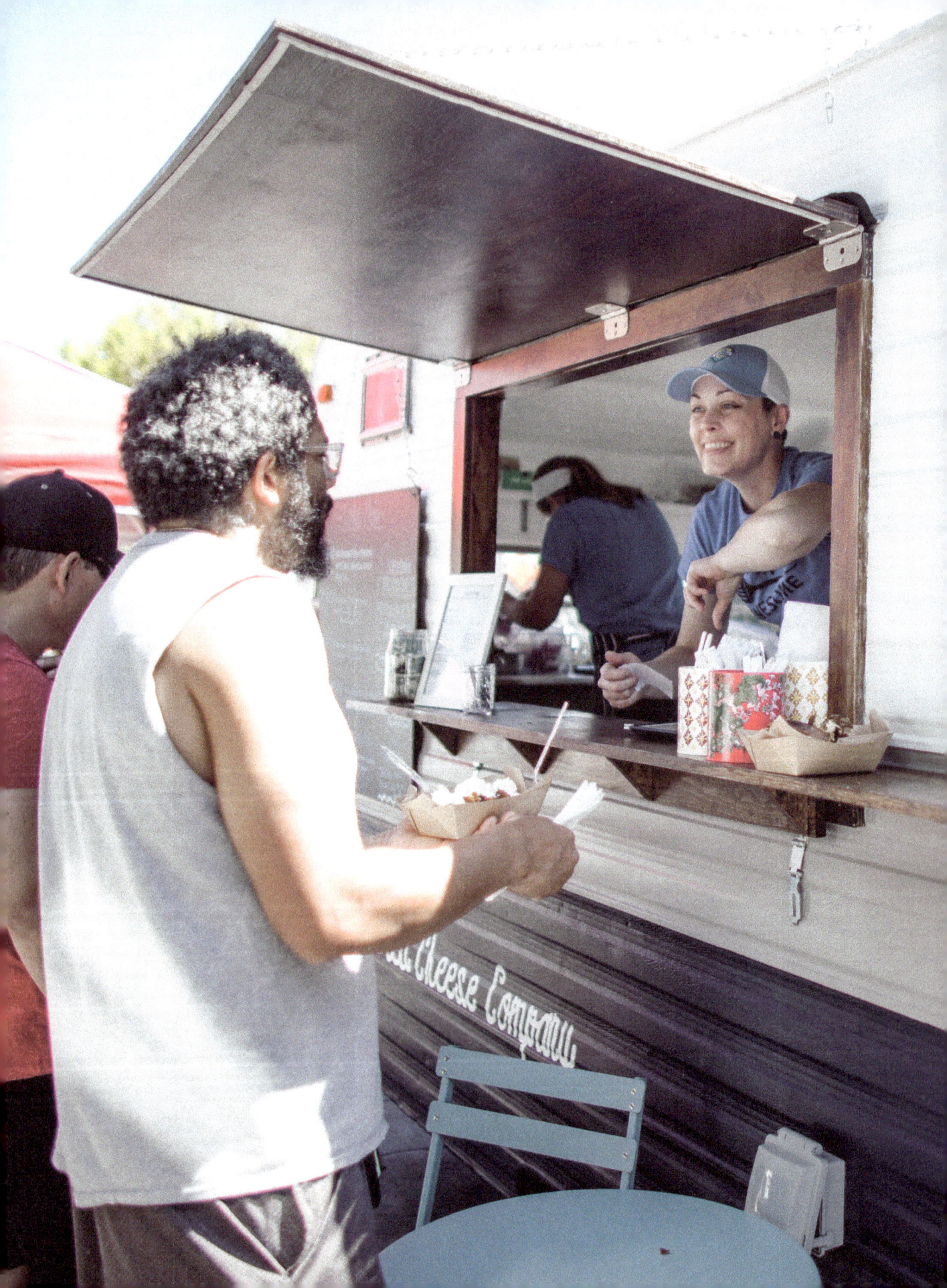

SAMPLE MENU

GRILLED CHEESE SANDWICHES

Plain Jane
Ham & cheese, spinach artichoke, plum & chevre. A blend of two regionally produced cheeses topped with seared cheese curds between two toasty slices of Ibis Bakery bread.

Local Brother's Keeper
Cheddar, smoked ham, Dijon mustard on Ibis Bakery bread. Sometimes we go crazy and put an egg on it! Spinach cream cheese spread, chopped artichokes, garlic and Parmesan on Ibis Bakery bread. Locally made fresh goat cheese, house plum jam, bacon, rosemary-thyme butter on Ibis Bakery bread.

Red Pepper Gouda
Frisian Farm's smoked gouda, roasted red peppers, bacon, and sautéed spinach on Ibis Bakery bread.

OTHER CHEESY GOODNESS

Cheese Plate
Regional farmstead cheese, fresh fruit, jam, Marcona almonds, Ibis Bakery toast and Potter's crackers.

Mac and Cheese
A rotating menu of seasonal flavors, all made from scratch and cooked to order.

Drinks
Fresh squeezed lemonade
Italian soda
Rotating, freshly made fruit-infused syrups mixed with bubbly water.

Strawberry Rhubarb Grilled Cheese

4 slices crusty sourdough bread

1 tablespoon salted butter

3 ounces fresh goat cheese, sometimes labeled chevre

4 strawberries, washed and sliced

1 teaspoon raw honey

3 tablespoons rhubarb butter

Preheat a flat stovetop griddle or pan for 1-2 minutes.

While your griddle is preheating, spread half the rhubarb butter on one side of the bread and crumble or spread half the goat cheese on the other.

Top the goat cheese with the 2 sliced strawberries and drizzle with raw honey. Do the same for the second sandwich.

Once your pan is hot, but not smoking, add the butter to the pan and let it melt.

As soon as its melted, put your four pieces of bread down in the pan, open faced style. If they won't all fit, just cook them one at a time.

Cook until the underside of the bread is golden brown, then put the two sides together.

Cook for 2-3 more minutes, flipping once or twice to avoid the bread getting too dark.

Repeat for sandwich number two.

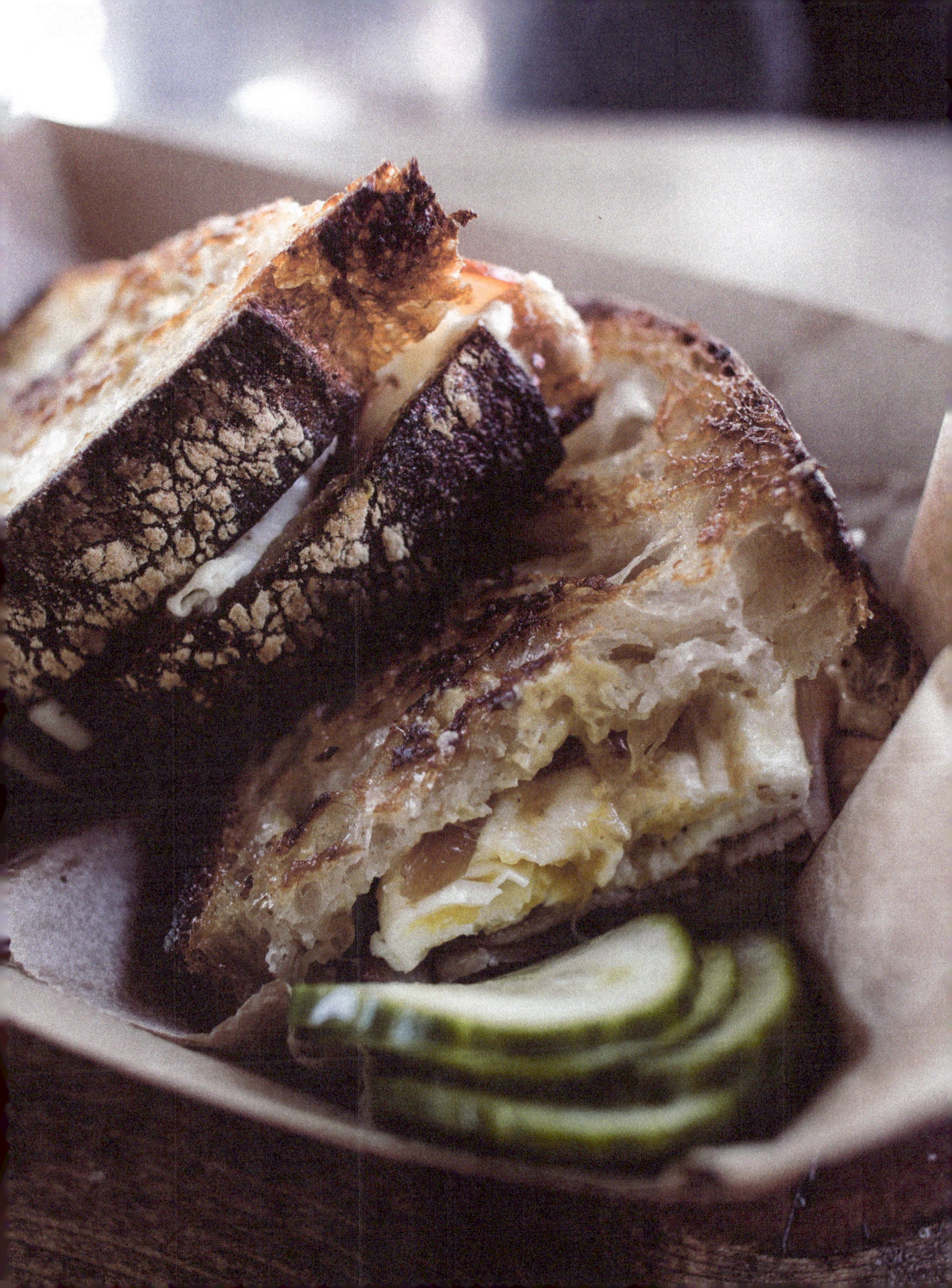

Rhubarb Butter

2 pounds fresh rhubarb, cleaned and chopped into 1" pieces

2 cups granulated sugar

2 oranges, zested and juice

Put all of the ingredients into a heavy-bottomed sauce pan and put on medium-high heat.

Bring mixture to a boil until the sugar is dissolved, then reduce heat and cook until the rhubarb has broken down and mixture is thick like apple butter. Stir frequently.

Transfer the mixture to a blender and blend until smooth. If you need to reduce the butter further, just return it to the saucepan and cook over low heat until the mixture is thick, stirring frequently.

Store in an airtight container in the refrigerator for 1-2 weeks.

Smoky Mac + Cheese

Makes 6-8 servings

1 pound dry rotini pasta

4 tablespoons butter

4 tablespoons all-purpose flour

1 cup chicken stock

3 cups whole milk

4 ounces medium or sharp cheddar cheese, shredded

8 ounces smoked gouda or cheddar

2 tablespoons neutral-flavored cooking oil (coconut, vegetable, etc.)

Kosher salt and pepper to taste

Topping:

1 1/2 cups panko breadcrumbs

2 teaspoons butter, melted

Preheat your oven to 350 F.

Fill a large stock pot 3/4 of the way full with water. Season the water generously with salt.

Over medium-high heat, bring the water to a boil. Once boiling, add the pasta and cook

3 minutes less than the instructions indicate. You want the pasta to be slightly firm. Once the pasta is done, drain all of the water and return the pasta to the pot.

Add the oil to the pasta and stir so the noodles are coated. Set aside, off the heat.

In a heavy-bottomed saucepan, melt the butter over medium heat. Once the butter has melted, add the flour and stir using a wooden spoon. Cook this mixture for 3 or 4 minutes.

Switching to a whisk, slowly add the chicken stock, whisking the whole time. Whisk until smooth.

Still whisking, slowly add milk to the saucepan. Keep whisking until the sauce is smooth.

Reduce your heat and stir continuously until the sauce is thick enough to coat the back of a spoon.

Once the sauce is thick, remove from heat and add the cheddar cheese first, then the smoked cheese, whisking until both are melted and fully incorporated. The sauce will get even thicker once the cheeses are melted.

Season the sauce according to your preference with additional salt and pepper.

Pour the sauce over the pasta and stir until the noodles are coated. Transfer to a 9x13 baking dish.

In a small bowl, mix the panko crumbs and melted butter until the mixture resembles wet sand.

Sprinkle over the top of the macaroni and cheese.

Bake for 20-25 minutes or until bubbly and golden brown.

Bay Boy Specialty Sandwiches

SOCIAL
- bayboykc.com
- @BayBoyKC
- @bayboykc

SUMMARY
Bay Boy Specialty Sandwiches is a concept started by childhood friends Julian Garcia and Jake Wilson, and centers around the San Francisco Bay-area specialty bread called Dutch crunch, famous for its crackled and crunchy top.

STORY
The story of Bay Boy Sandwiches is one of the most clever, resourceful journeys I have come across. Childhood buds Julian Garcia and Jake Wilson became inseparable when they met on the playground in first grade. With just their foodie palates and a few bucks in the bank, the two embarked on their mission to start a restaurant after college.

Garcia attended Shawnee Mission Northwest High School, then went on to study film at University of Missouri - Kansas City. Wilson, meanwhile, went to Mill Valley High School in Shawnee. The two made films together in high school, and Garcia took up a job at Johnny Jo's Pizzeria during college. During this time Garcia would experiment making different doughs and breads in his free time at Johnny Jo's. He spent a summer in the San Francisco area where he discovered the marvel that is Dutch crunch bread, also known as tiger bread.

Dutch crunch bread is truly delicious. The color of the bread looks like a sourdough bun or a mini French baguette. It is white bread that is dense and has a hint of sweetness, but by no means is a sweet roll. Before the oblong-shaped dough is baked, it is brushed with a rice paste. Once baked, the purpose of the rice paste becomes evident: it creates a very crackled top. The peaks of the crackled surface become toasted and oh-so crunchy.

With Garcia's Dutch crunch bread recipe perfected, Wilson worked on developing meat recipes and made-from-scratch sauces that would be just as thoughtful as the buns around it. We all have probably had many sandwiches with good bread and lack-luster fillings. It's a huge bummer. Similarly, we've all probably tried sandwiches with good meat and dry, tasteless, weird-texture bread. Garcia and Wilson wanted their specialty sandwiches to be composed entirely of outstanding ingredients, from top to bottom. And they are!

Once they had a few stellar sandwiches worked out, the two friends approached Johnny Jo about allowing them to do a pop-up concept out of his restaurant. He was generous enough to let them test their recipes and concept out of his shop (with the contingency that they keep on selling the pizza at the same time). Deal!

Jake and Julian started out by advertising the pop-ups to friends and family. Before they knew it, they amassed a following. This process took about a year and a half, from concept to launch and having a menu and rhythm worked out. Their next step was to figure out how to launch a food truck, a space all their own.

Except, they did not go the standard food truck route. They realized that they had been saving in start-up costs by doing a pop-up out of a restaurant. Could they apply that same approach to a food truck? Indeed, they found an existing food trailer to rent for a few days a week. Their first stop was none other than Johnny Jo's. Their fans followed them, and they amassed a very supportive network of sandwich-lovers. When the Mid-Continent Public Library asked them to serve lunch during one of their all-day food truck start-up classes, they couldn't get their generator to work. Luckily, veteran food truck owner Brandon Simpson of Jazzy B's leapt to their rescue. "We were able to get our hands on a food trailer last year, and tested the idea of getting a truck that we could cater events out of," Jake told Feast magazine. "The truck broke down one night when we were out with

it, and we decided then just to start with a smaller commissary kitchen catering business and sandwich shop, and grow from there."

That's where the restaurant comes in. Ever the resourceful entrepreneurs, Jake and Julian decided to launch a crowdsourced Kiva Loan to open their own brick-and-mortar. KIVA is an interest-free crowdsourced loan. They received $10,000 in funding from 114 supporters, which funded their restaurant launch. The loan covered equipment, building out their space in the West Plaza area, interior design and signage.

As a person who rarely orders a sandwich when eating out (because it's so hard to find a sandy with delicious breads and fillings), I thought they really might be on to something. This bread is not only very tasty, the crunchy top balances out the soft meats and cheeses between the buns. The flavor of the bread allows you to savor the abundance of flavors packed into the interior of the sandwich. It's too early to call, but the odds look favorable for these entrepreneurs.

Q&A

WHERE IS YOUR FAVORITE PLACE TO VACATION?
Julian: Colorado, NorCal but it has changed so much!
Jake: Camping. Going to Missouri around Lake of the Ozarks because there's good trout fishing.

WHERE IS YOUR DREAM VACATION SPOT?
Julian: New Zealand, Lord of the Rings-style.
Jake: Year-long beach tour round the world - swim, fight a sting ray, that kind of thing.

WHAT IS SOMETHING THAT YOU APPRECIATE ABOUT THE OTHER PERSON?

Julian: Jake's ability to be creative with flavors, and he loves solving problems.

Jake: I appreciate that he doesn't get down on himself or the business.

WHO IS SOMEONE THAT INSPIRES YOU?

Julian: It isn't just one person, it's a bunch of people I've worked with in the past in factory-type jobs. I always asked everyone what they want to be and why are they here. My boss wanted to be a chef, another colleague a writer, etc. They were there, 20+ years at an unrelated job. I do not want to be stuck like that, I want to absorb their lesson: do not be afraid to pursue your dream. That's why I went back to film school. I wanted to be creative and stay creative. And add something positive and flavorful to the world.

Jake: Working at a bunch of really crappy jobs with good people - I just want to be treated with respect. We are equals and because we are equals we can respect each other. I do not like the whole "I'm better than you" thing. I have worked for good bosses, like Joey and Ethan at Up-Down. They have created a great culture I want to rip off. They've been really helpful from a business and leadership perspective. I try to learn a lesson from everyone; everyone has something to teach you.

WHAT ARE YOUR FAVORITE RESTAURANTS IN THE KANSAS CITY AREA?

Julian: Salvadoreños, a pupusa joint. Also, KC Bier Company and any local microbreweries.

Jake: Thai Palace - it's a hole-in-the-wall and the food is great. Up-Down - I really like video games and they have a massive library of whisky.

WHAT IS YOUR GO-TO GUILTY PLEASURE TV SHOW?

Julian: Brooklyn 99, West World.

Jake: Gundam (anime about robots); The Magicians, which is science fiction about magic; Firefly, forever and always.

WHAT IS THE LAST COSTUME YOU WORE ON HALLOWEEN?

Julian: Shark.
Jake: [Julian and I] were going to do Mario and Luigi and two princesses (our wives). I was Luigi at Up-Down. Another year I was Towelie from South Park.

DO YOU HAVE A FAVORITE INSTAGRAMMER YOU FOLLOW?

Julian: I follow Kansas City area food bloggers, Men's Humor, and The Trollercoaster.
Jake: I'm more of a Reddit guy. I like the technology subreddit, coding subreddit, and trolling X-chromosomes (like rage comics about women's stuff but it's pretty universally applicable).

LAST PODCAST YOU LISTENED TO

Julian: The Sword of Ker, food truck podcasts, Tribe of Mentors. I'm trying to be a better me for us!
Jake: You're enough you for me right now. *laughs* I listen to The Dollop.

WHAT IS YOUR SUPERPOWER?

Julian: I'm tireless.
Jake said Julian instantly makes everyone smile.
Jake: Visualization. When there's a complex set of issues, I can narrow in to resolve it. Also, I have a lot of energy.

FANTASY DINNER PARTY, YOU'RE HOSTING. WHO ARE THE GUESTS?

Julian: Donald J. Trump.
Jake: Teddy Roosevelt, [Nikola] Tesla, [Thomas] Edison, Kim Jong Un, Michelle Rodriguez, Ryan Gosselin, Obama, Don Cheadle, and several filmmakers.

WHAT DO YOU CONSIDER YOUR GREATEST ACCOMPLISHMENT?

Julian: We created something out of nothing.
Jake: We haven't gotten anyone sick.

Note: Jake was not joking, and in fact, almost every food truck I've asked this question to points to this as their greatest fear and tell me of all the things they do to ensure the safety and quality of their food.

WHAT CHANGES HAVE YOU SEEN IN KC?

Julian: I like that there's more individual mom-and-pop shops and restaurants popping up. I want more of that to dilute the chains. Once time we got excited about a Ruby Tuesday because it was new. When we got older and moved to Midtown we saw more unique places and diversity; that is important. I think people are hungry for stuff like that. There's so many flavors to taste,

Jake: I love this sense of community. Maybe I wasn't tuned into it before, but I think it seems to be growing. People helping people a little more than themselves. Connecting people you normally may not have connected with.

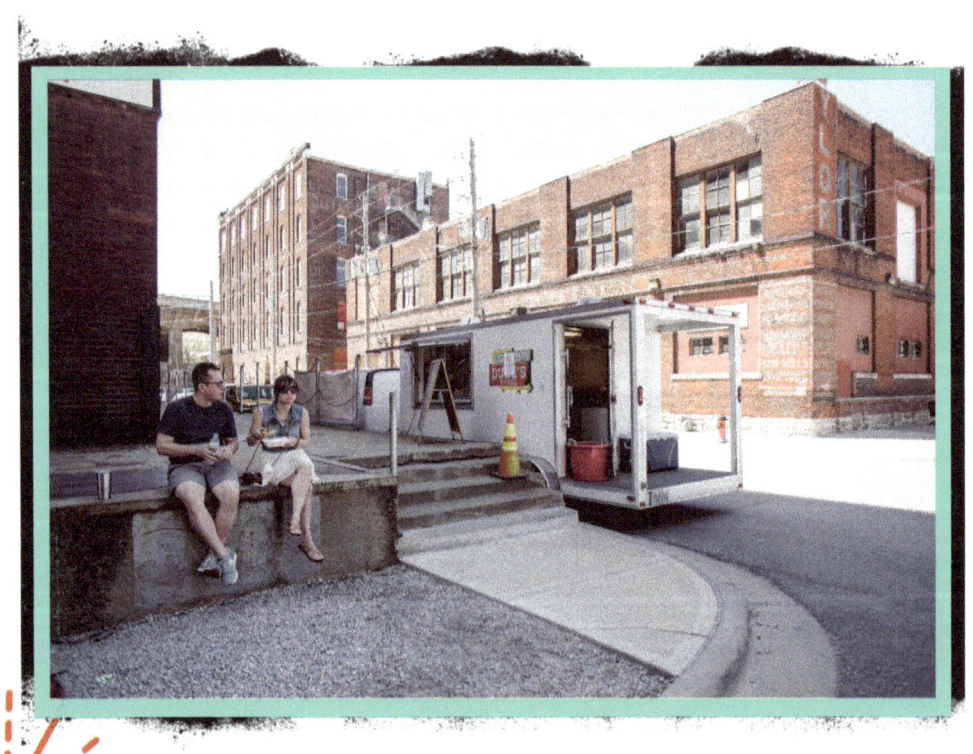

SAMPLE MENU

El Jefe
Smoked mojo pulled pork, sliced honey ham, pickles, swiss cheese, mustard, hot pepper sauce on a buttered & toasted Dutch crunch bun

Pastrami
Hot pastrami, spicy brown mustard, pickles, Swiss cheese, horseradish

Kimchi Grilled Cheese
Sautéed mushrooms, housemade kimchi, provolone, house sauce

Crown Town Club
Smoked turkey, honey ham, bacon, lettuce, tomato, red onion & chipotle mayo

Bay Boy
Genoa salami, garlic sauce, hot pepper sauce, mayo, mustard, lettuce, tomato, pickles, red onion, your choice of cheese

Veggie
Mushrooms, cucumber, garlic sauce, hot pepper sauce, mayo, mustard, lettuce, tomato, pickles, red onion, your choice of cheese

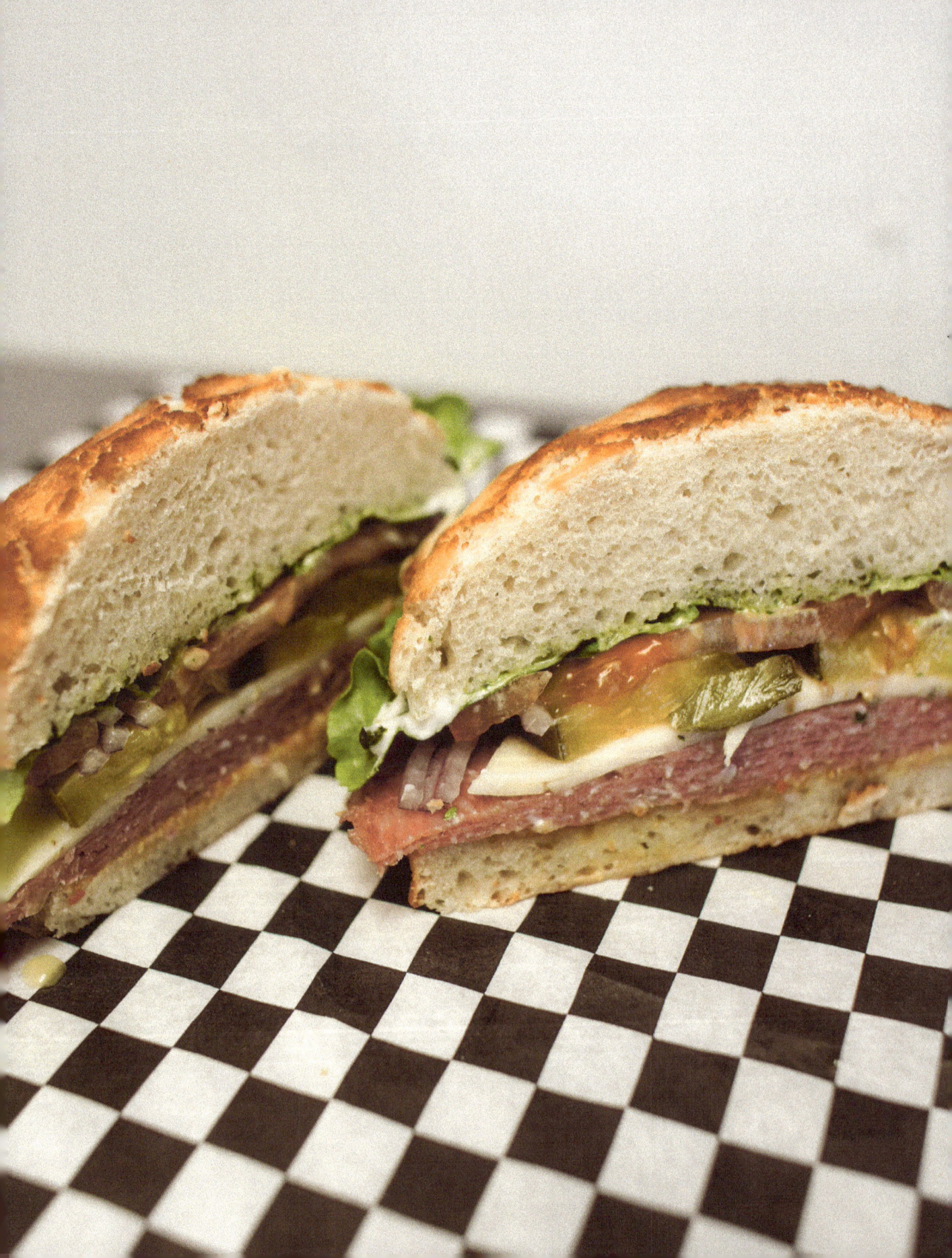

Dutch Crunch Topping

The Bay Boy duo is understandably tight-lipped on their secret Dutch crunch recipe, but below is a standard recipe for achieving that crunchy, crackled exterior.

1/2 cup warm water

1 tablespoon yeast

3/4 cup rice flour

2 tablespoon granulated white sugar

1/4 teaspoon salt

1 tablespoon vegetable oil

Dough for rolls

Combine ingredients and set aside for approximately 10-15 minutes or until mixture has doubled and is frothy.

Spread the mixture generously on unbaked rolls, applying to the tops and sides of the rolls, then bake according to the instructions of the rolls you're making.

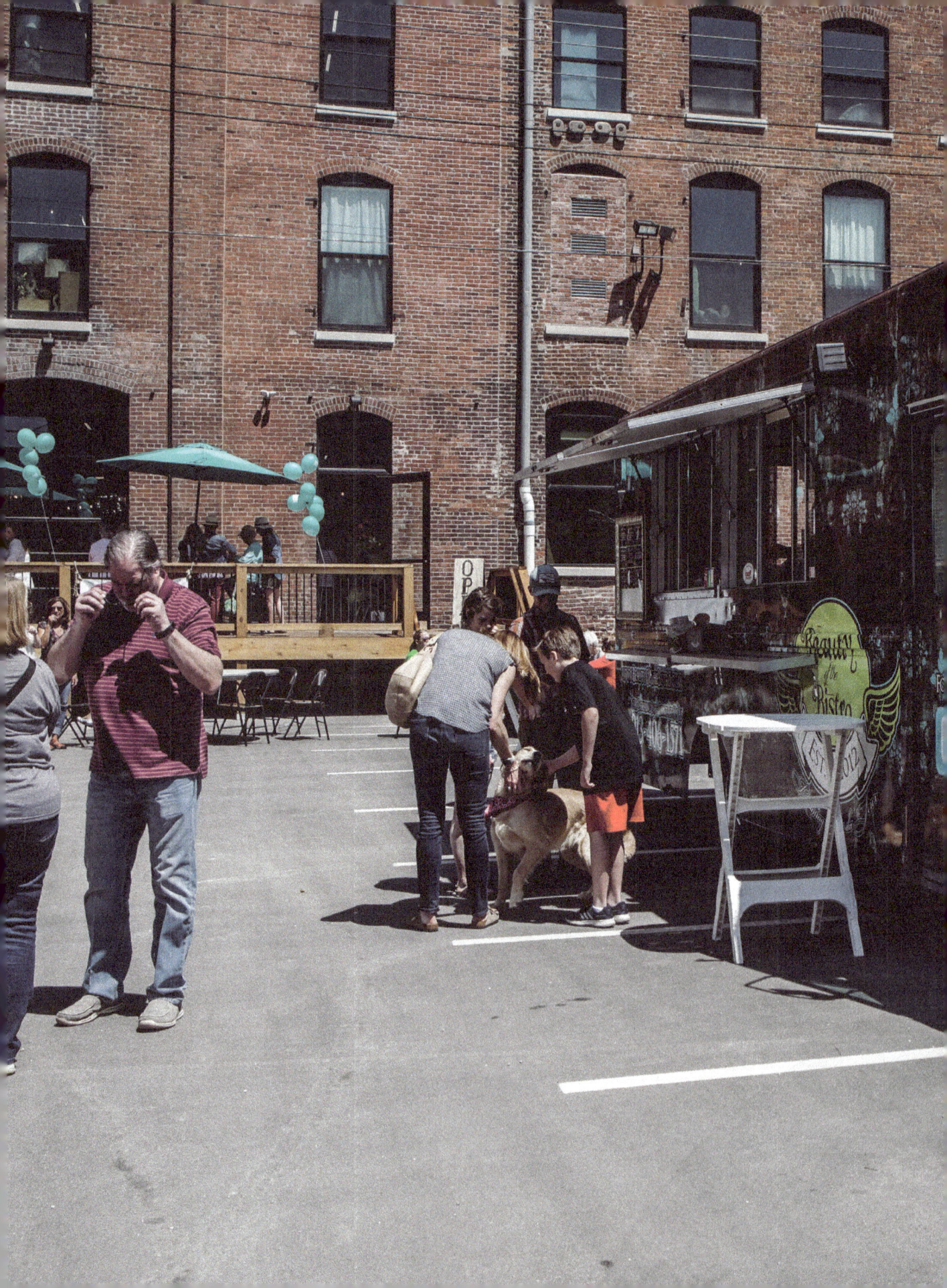

Beauty of the Bistro

SOCIAL

🐦 @beautyofbistro f @beautyofthebistro 🧭 beautyofthebistro.com

SUMMARY

Beauty of the Bistro is owned by Sidney Fish and launched in 2012, making it one of Kansas City's first food trucks. Fish is famous for her creative burgers, with next-level ingredients like homemade bacon jam and farm-to-market breads.

STORY

Before Fish was ever planning to own a food truck, she was studying interior design at the International Academy of Merchandising and Design. She was managing a showroom at Kansas City's Gift Mart after graduating, but when it closed she took a step back to evaluate what she wanted to do next. Was it design, or something different?

Fish had often done catering jobs for events hosted by friends and family, and the menus were always tasty, but safe. Being the creative spirit that she is, catering did not quite fit the bill for her next move.

"With the truck it's interesting, because we do very fun, outside-of-the-box menu. It's fun to watch people step outside of their safety net," Fish says. A food truck marries all the elements Fish loves about catering with the opportunity to express her creativity. By November 2011, Fish was developing potential menus for the truck, and by June 2012 she was serving burgers to trend-forward Kansas Citians.

Fish's customers seem to go bananas for her burgers. They are most def not your run-of-the mill burger. When asked if she thought Kansas City was ready for a fancy-pants burger, Fish said, "If I was 20 years younger, I would have worried more about pleasing everyone. In six years of serving, I have only had a couple people look at the menu and walk away."

Fish has two sons in their early twenties. The older of the two has worked the window a lot, and her younger son does a lot of the shopping for the truck. For many food truck owners, working events (which are primarily on weekends) often means missing family events. Her sons see the vision, though. While Fish admits it's a bummer to miss catching up with friends and family and learning about what's new in their lives, weekend business can be the lifeblood of a successful food truck.

So, what's the key to sticking it out long-term? "Shut down in the winter! That helps refresh you. I shut down and park the truck in storage. I travel a lot in winter, then come out in early March, at which point I am physically and mentally ready to get back into it. I couldn't do a year-round schedule like in Florida."

Fish says "it's the little things" that keep her smiling throughout the food truck season. "If we are serving somewhere at a public event and a customer comes back to tell me how much they love it, or if they leave a positive review on Facebook - those things keep you motivated. I feel like I have to keep upping my game to make the menu better and different, but then when someone tells you they are a burger fanatic and it's the best burger they've ever eaten, that's the best."

Q&A

WHERE IS YOUR FAVORITE PLACE TO VACATION?
Australia. My sister lives there.

WHERE IS YOUR DREAM VACATION SPOT?
I'm going to Belize! Other dream spots would be Italy and Spain.

WHAT ARE YOUR FAVORITE (AND LEAST FAVORITE) VEGETABLES TO GROW?
Corn and tomatoes are my favorites, potatoes and carrots are a nightmare.

WHEN YOU THINK OF GATHERING AROUND THE DINNER TABLE GROWING UP, WHAT WAS ON THE TABLE?
Vegetable and canned beets, pickled cucumbers. We raised our own cows, so beef steak or hamburgers from our own cows would be dinner. It was weird but that's just how it is.

WHAT IS A FAMILY TRADITION YOU KEEP ALIVE:
Things have evolved a lot. I lost my parents within a year of each other. All the traditions went away. My family and I travel a lot together. We once rented an Airbnb in Lake Chapala in Mexico for 17 days for the holidays. We did not miss the commercialism!

WHAT ARE SOME AREA RESTAURANTS YOU'VE NEVER VISITED BUT WANT TO TRY?
Howard's Grocery (burgers!). It's at E. 17th Street and Oak Street. [This location] used to be home to The Cashew. I have a paper in my wallet with places to go.

WHAT ARE YOUR FAVORITE RESTAURANTS?
Stock Hill, The Farmhouse, and I check out the Kansas City Restaurant Week list.

WHAT ARE YOUR GO-TO LOCAL RESTAURANTS:
Dos de Oros in Martin City, Nick and Jake's

WHO DO YOU ADMIRE?
Caroline Myss; I listen to her books on tape while driving. [Horse trainer] Monty Roberts; I like his book about how he grew up. He was in Kansas City a few years ago, and we watched him handle untrained horses.

FANTASY DINNER PARTY, YOU'RE HOSTING. WHO ARE THE GUESTS?
Chelsea Handler's dinner parties are epic, so definitely her; [chef-turned-rapper] Aston Bronson.

SAMPLE MENU

Trustee's Gouda Burger
Smoked gouda, apple chutney, arugula, garlic mayo on farm-to-market brioche bun

Boom Boom Burger
Pepper jack cheese, broccoli slaw, housemade salsa, jalapeño aioli on a farm-to-market brioche bun

Blue Moon Burger
Blue marble jack cheese, sun dried tomato relish, arugula, and garlic mayo on a farm-to-market brioche bun

Aubry Roadhouse Burger
Muenster cheese, housemade bacon jam, arugula, and garlic mayo a farm-to-market brioche bun

Chimichurri Chicken
Roasted chicken with provolone, topped with French-fried onions and housemade chimichurri on a toasted roll

Boom Boom Tacos
Applewood smoked pork, broccoli slaw, housemade salsa, jalapeño aioli in flour or corn tortillas

Market Salad
Fresh greens, seasonal fruit, feta cheese, red onion, honey roasted sunflower seeds, and housemade poppy seed vinaigrette

Chicken Salad on a Croissant
Chicken breast, cucumbers, celery, green union, Craisins, sliced almonds with mayo

Roast Beef on Rye
Thin-sliced roast beef and provolone with artichoke, asiago aioli, spinach on marble rye

Cowboy Skillet
Andouille sausage, chicken, red potatoes, zucchini, corn, red pepper, onion, mushrooms, with a drizzle of jalapeño aioli

Crawfish Mac n' Cheese
Sautéed crawfish, corn and green onions over housemade mac n' cheese

Cup of Mac n' Cheese
"Dirty" chips (seasoned potato chips), cracked pepper and sea salt, jalapeño, buffalo bleu, sea salt

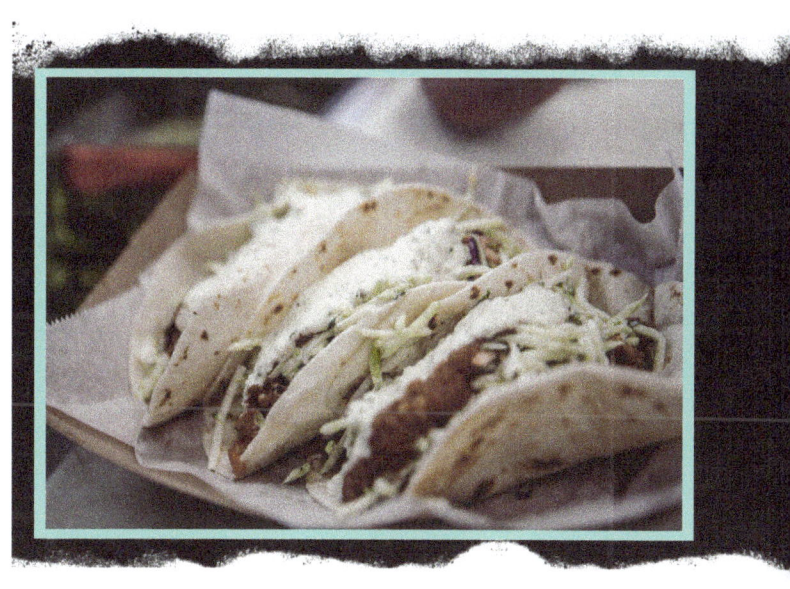

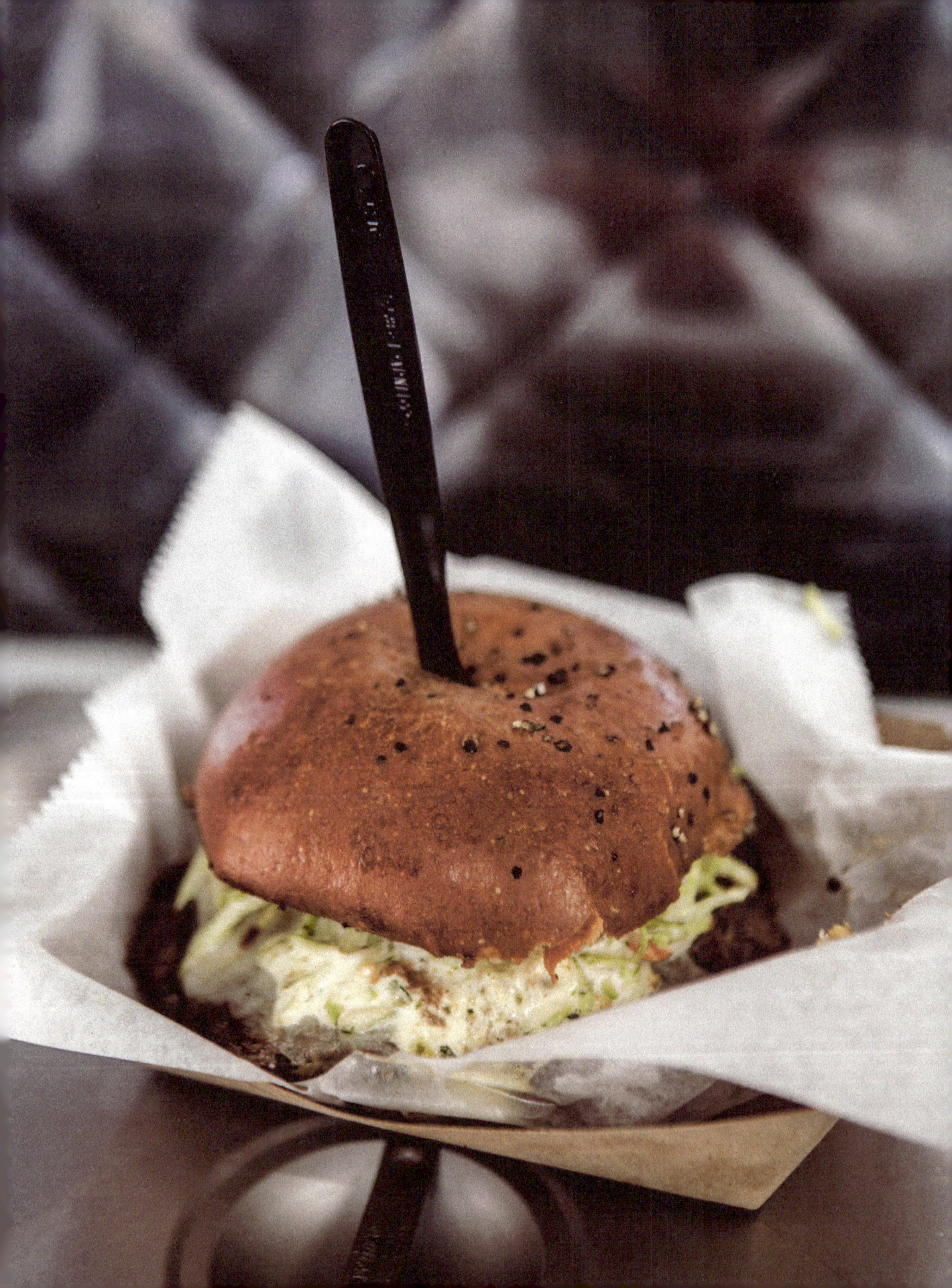

English Cowboy Sandwich

Created by Sidney Fish, owner of Beauty of the Bistro

Beauty of the Bistro's signature dish, Cowboy Skillet, is served on an English muffin with smoked gouda cheese and a fried egg.

4 Thomas' Original English Muffins, sliced in half

8 slices of smoked gouda

4 eggs

3 links of andouille sausage, sliced

1 red bell pepper, finely diced

1 cup mushrooms, sliced

1 medium zucchini, halved and sliced thin

¾ cup of fresh or frozen corn

Salt, pepper and oregano to taste

Sauté the red pepper, zucchini, mushrooms, corn and sausage in a skillet with olive oil, until vegetables are tender. Add sausage and cook until browned, breaking apart with spatula as it cooks.

While the above mixture is sautéing, fry 4 individual eggs, over easy, one for each muffin.

Toast the English muffins, and butter each side.

Place a slice of smoked gouda on muffin bottom, then spoon a generous amount of sautéed vegetable and sausage mixture onto English muffin.

Top with the egg, a second slice of Smoked Gouda, then the muffin top.

Place the completed dish on a panini grill or in the oven to heat throughout, until the smoked gouda begins to melt.

Serve with jalapeño aioli.

Jalapeno Aioli

1 cup buttermilk

½ cup mayonnaise

1 small can of green chilies

1 tablespoon Hidden Valley ranch salad dressing mix

½ cup sliced jalapeños

½ cup fresh cilantro

Place the ingredients in a blender, until smooth. Keeps fresh in a refrigerator for approximately 5 days.

Betty Rae's
ICE CREAM
MADE FRESH AT OUR SHOP IN WALDO, KCMO

SCOOPS
○ ○○ ⊙⊙
ONE BIG DOUBLE

CUP OR CONE
WATER BOTTLE

ROOT BEER FLOATS
▸ ANY FLAVOR ICE CREAM

SUNDAES
① ANY FLAVOR ICE CREAM
② CARAMEL OR FUDGE
③ ANY TOPPINGS:
M·Ms // GUMMY BEARS //
SPRINKLES // PECANS //
CHOC. CHIPS // PRETZELS //
OREOS // WHIPPED CREAM

FLAVORS

VANILLA BEAN
CEREAL MILK
COOKIES & CREAM
PEANUT BUTTER

BROWN BUTTER +
TOASTED PECANS

BLUE BERRY
SORBET

LAVENDER
HONEY

COFFEE
S'MORES
STRAWBERRY
CHOCOLATE
MINT·
CHOCOLATE COOKIES

GOAT CHEESE,
APRICOTS + CANDIED WALNUTS

NON-
DAIRY
CHOCOLATE

VEGAN
VANILLA

Betty Rae's

SOCIAL
bettyraes.com @bettyraesicecream @bettyraes

SUMMARY
Betty Rae's is known for their scratch-made ice cream, ranging from the classic flavors to trend-inspired, uncommon yet delicious flavor profiles. David Friesen and Mary Nguyen first launched Betty Rae's as a Waldo brick-and-mortar ice cream shop, and now serve their scoops on wheels.

STORY
If you love ice cream and live in the Kansas City area, chances are good that you've not only heard of Betty Rae's but also have made it a destination. Their Waldo shop popped up on the scene on March 25, 2016, and they launched their truck just one year later.

Friesen and Nguyen's romance budded while the two worked at Sparky's Homemade Ice Cream shop in Columbia, Missouri. Mary is a Kansas City native, while Friesen was born in Bucharest and also lived in California, Boston, and Honolulu.

Surprisingly, neither Friesen nor Nguyen went to culinary school, but their menu has all the airs of a trendy NYC shop started by an experimental chef. Friesen has worked in many kitchens, but says he is not classically trained. His menu is driven by adaptations of coastal trends, global cuisine, and combinations rarely seen on desert menus. "Innovative but not pretentious" is how he describes his menu. For example, Lavender Honey is one of his first flavors that was so popular it became a staple.

Betty Rae's premier Kansas City Barbeque ice cream has turned a lot of heads. The recipe includes Joe's KC burnt ends and sauce, two of Kansas City's most famous food items. In an interview with Jill Silva of The Kansas City Star in July of 2017, Friesen said "Barbecue is just so perfect. There's no reason the flavor wouldn't work."

The inspiration for another Betty Rae's creation, Chicken and Waffles ice cream, came from a book Friesen was reading about Charlie Parker. There was mention of chicken and waffles first popping up in the 1940s nightclubs. Why? Musicians would play late into the night, well past dinner time. The kitchen would have chicken left over from dinner service while they were getting waffles ready for breakfast service. In Friesen's recipe, the ice cream is seasoned with thyme and rosemary then served in a waffle cone. "If anything is good, you can make it into ice cream," Friesen proclaims.

While developing the menu, Friesen says range in flavors is key because you never know who is going to walk through the doors. It could be "someone in their 90s who wants to taste ice cream like they had as child, or a parent bringing their kids, or a foodie 40-year-old who only eats in nice restaurants and wants to experiment. You want to make everyone happy, so you make a place that makes everyone happy."

When it came to designing a food truck, Friesen and Nguyen hired a Kansas City-based food truck builder called Apex. One unique touch Friesen requested for the Betty Rae truck is a window for customers to see the ice cream selection just as they would if they were at a brick-and-mortar. It's a thoughtful touch that makes the customer's experience all the more enjoyable (and all the more difficult to choose a flavor).

Growing his own business did not come without its stresses. You wouldn't know it by talking to Friesen, who sounds so serene and zen about even the most excruciating of experiences. On their inaugural truck run of their brand new shiny truck, for example, it ended by having to tow the vehicle back to the shop for a repairs.

(Trucks can be quite temperamental, apparently.) Friesen and Nguyen welcomed their first child the week they signed the lease to Betty Rae's. "Business is way harder than kids. Kids aren't easy, but for any stress our kids cause, you love them no matter what. Sometimes you need to remind yourself why you love the business."

When asked about plans for expansion of the truck, Friesen says "there's two places I never want to be: outside Kansas City and in a grocery store aisle." I scratched my head and asked him to explain, "It's too far removed from our customers." What makes him excited to get up every morning is seeing smiling faces come through the door.

"We work in the happiest business," he gushes. He loves to see his first-ever customer and her daughter walk through the front door (the daughter is now 16 and he hopes she will want to work at Betty Rae's one day). Friesen enjoys being able to employ local high school students, then welcoming them back when they come for a visit during college. If that doesn't make your heart flutter and your eyes get dewy, I do not know what will. "Seeing happy people eating ice cream is kind of the best," he adds. We agree.

Q&A *with Friesen*

DO YOU PREFER TO READ A BOOK OR LISTEN TO AN AUDIOBOOK?

Read, but since we've had kids and opened a business I have finished a grand total of three books. I have an English literature degree and used to go through tons of books. Now, I listen to podcasts and audiobooks.

WHAT IS THE LAST PODCAST OR AUDIOBOOK YOU LISTENED TO?

A book about the history of Venice. I want to read Sapiens: A Brief History of Humankind but trying not to listen to the audiobook because I'd rather read it.

DO YOU HAVE ANY FAVORITE PODCASTS?
I listen to podcasts primarily about history or science.

ARE YOU AN EARLY RISER OR A NIGHT OWL?
Both, by necessity. Naturally I stay up until 2-3 a.m. but I need to wake up early for work and kids. I am trying to transform into early bird.

DO YOU HAVE A SWEET OR SAVORY PALATE?
I love salty snacks. I slowly overcook things because I love the char. At the same time, I'll put fudge on everything and eat a canister of whipped cream at the shop. I love our Cereal Milk ice cream: we make it with a house-made granola [composed of] seven very unhealthy cereals, plus Lucky Charms marshmallows, and mix into ice cream.

BURNT ENDS OR BRISKET?
Oh man. Those are my actual two favorites. KC does burnt ends so well, we use it in ice cream. In Austin [where his parents live] brisket is amazing, my dad even has smoker in his backyard. So, both!

WHAT WOULD YOU WANT FOR YOUR LAST SUPPER?
My mother-in-law is Vietnamese and is the most amazing cook. She makes the best pho, and makes it constantly. It's a steeping hot brothy bowl with lime, cilantro, and super thinly sliced beef. I can fill up without feeling heavy. It's a neat mix between French and Asian because of colonial influence; you see them both in pho. It's so well-balanced. Oh, and I would need some of her egg rolls on the side.

WHAT IS YOUR FAVORITE PLACE TO VACATION?
Europe's pretty neat. I lived in Hawaii, and for our honeymoon we went to an island called Molokai (off Maui). Only 7,000 people live there, and there's not a lot of tourism. It was like going to a tiny town in Missouri except on an island in the middle of the Pacific.

WHAT IS YOUR DREAM VACATION SPOT?
I've never been anywhere in Asia, and it would be nice to take our kids to Vietnam. Anywhere with the kids would be fun.

WHAT ARE YOUR FAVORITE AND LEAST FAVORITE ICE CREAM FLAVORS?
I hate [our] goat cheese [ice cream], but other people love it. We mix in walnuts and apricots. I really like our coffee ice cream, which is made with Thou Mayest coffee.

WHAT ARE YOUR FAVORITE LOCAL RESTAURANTS?
Aladdin Cafe on 39th St. has a dish called Koshary; it has Egyptian rice, lentils, tomatoes, and onions. It sounds so simple, but it's seasoned nicely and pretty filling. Papu's Cafe in a gas station in the Waldo neighborhood is really good Mediterranean and Greek food. Port Fonda, of course. When visitors are in from out of town, we them out for barbeque. Slap's Barbeque in Strawberry Hill is our go-to.

WHAT IS YOUR LEAST FAVORITE FOOD TREND?
I'm always interested to see what comes along. I like to see what people are into; I do not judge. We've never bothered with MEGA desserts like you see in Vegas that are primarily made for photo purposes.

WHAT'S THE WACKIEST THING YOU'VE EATEN AND LIKED?
Spam musubi - if you grow up in Hawaii you probably eat it monthly. It's like a giant piece of sushi but the meat is Spam and it's the size of your fist. It is sticky rice with teriyaki or seasoned/seared Spam, wrapped in seaweed, dipped in sauce.

WHAT IS YOUR GO-TO GUILTY PLEASURE TV SHOW?
Top Chef, and British baking shows for trend spotting (and I studied abroad in the UK so it's fun for that reason too). I do not believe in guilty pleasures; if I like it I enjoy it!

FANTASY DINNER PARTY, YOU'RE HOSTING. WHO ARE THE GUESTS?
Patrick Leigh Fermor, an Irish mid-century pre-WWII writer who dropped out of high school and backpacked, then wrote a series of memoirs about it later in life. Groucho Marx, P.G. Wodehouse, Jeeves & Wooster, stand-up comedians from today, and of course I would want my wife to be there; she's the better conversationalist anyway.

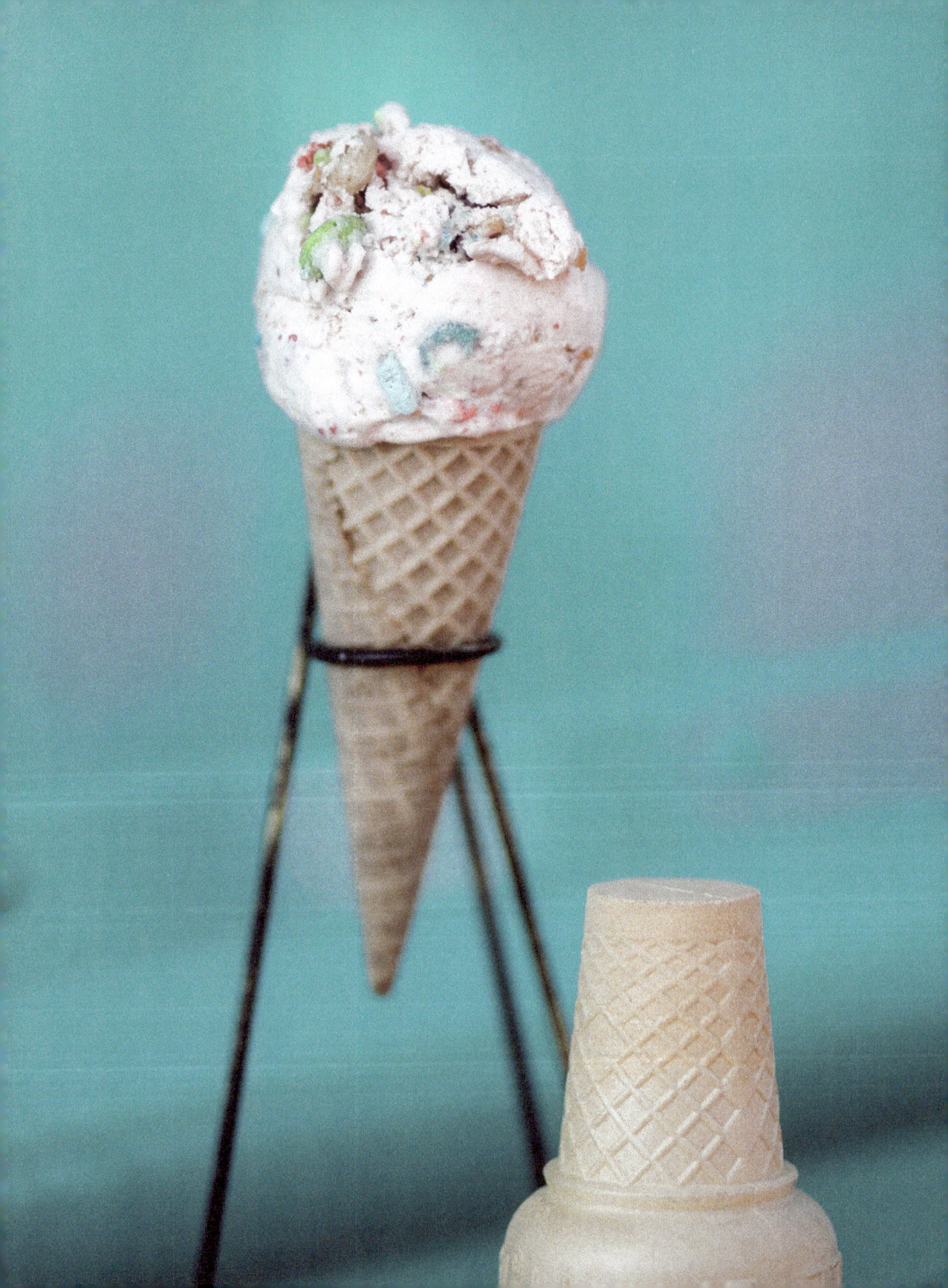

SAMPLE ICE CREAM FLAVORS

S'mores

Brown Butter with Toasted Pecans

Cereal Milk

Lavender Honey

Chocolate Brownie
Jasmine Green Tea

RazzBlue

Crème Brûlée Caramel

Watermelon Sorbet

Cinnamon

Coffee

Mixed Berry Sorbet

Hatch Chili Chocolate

Mango Frozen Yogurt

Goat cheese, Apricot & Candied Walnuts

Lemon Poppyseed Cake

Strawberry

Cookies and Cream

Brown Butter Base

- 2 1/2 cups heavy cream
- 1 cup whole milk
- 1/2 cup brown sugar
- 1/2 cup white sugar
- 1/2 teaspoon salt
- 4 tablespoons butter

In a small pot or pan, melt the butter over a medium heat, and continue to cook. The butter will begin to brown. If you see any smoke or smell bitterness, reduce heat. Once butter changes in color, stir with a metal or wooden spoon, scraping solids from the bottom of the pan. Before butter begins to burn, remove from heat.

In another pot, heat 1 cup heavy cream, 1 cup whole milk, 1/2 cup white sugar, and salt. Stir to dissolve the dry ingredients. When everything is incorporated, remove from heat.

Pour the 1/2 cup brown sugar into a metal or glass bowl, and then pour the brown butter over it (strain if necessary). Whisk to combine, then pour the heated cream and milk mixture over that. With a whisk (or immersion blender if you have one), stir well to combine everything into a smooth mixture, while still hot. When the mixture is smooth and shiny, with no chunks, pour in the remaining heavy cream while stirring. Chill in your fridge overnight.*

*ONE GOOD RULE OF TEXTURE FOR ICE CREAM IS TO HAVE YOUR INGREDIENTS AS COLD AS POSSIBLE BEFORE FREEZING. IT'S HARD ON THE PATIENCE, BUT YOU CAN'T ARGUE WITH THE RESULTS!

For our Brown Butter & Toasted Pecan ice cream, we wanted to treat a beloved classic with care and respect, to make the best version we knew how. Of the hundreds of flavors we've made in the last few years (with 25 flavors in our display case at any time), this one has been the most popular by far.

Home ice cream recipes vary widely based on taste preference, whether or not you want to use eggs (custard vs. Philadelphia style), the machine you're using at home, and so on. It's very easy to tweak this to your favorite recipe, so I've used an easy and simple base, but feel free to experiment! Brown butter can be added to any base easily, just be sure to temper the heated butter with a cooler mixture, so it doesn't seize up.

Browning butter is a nice way to add nuttiness and depth of flavor to any recipe that already uses butter, and you can use it in anything from stovetop cooking to baking, and especially desserts--brown butter cookies are amazing, with nuts, chocolate, whatever you feel like!

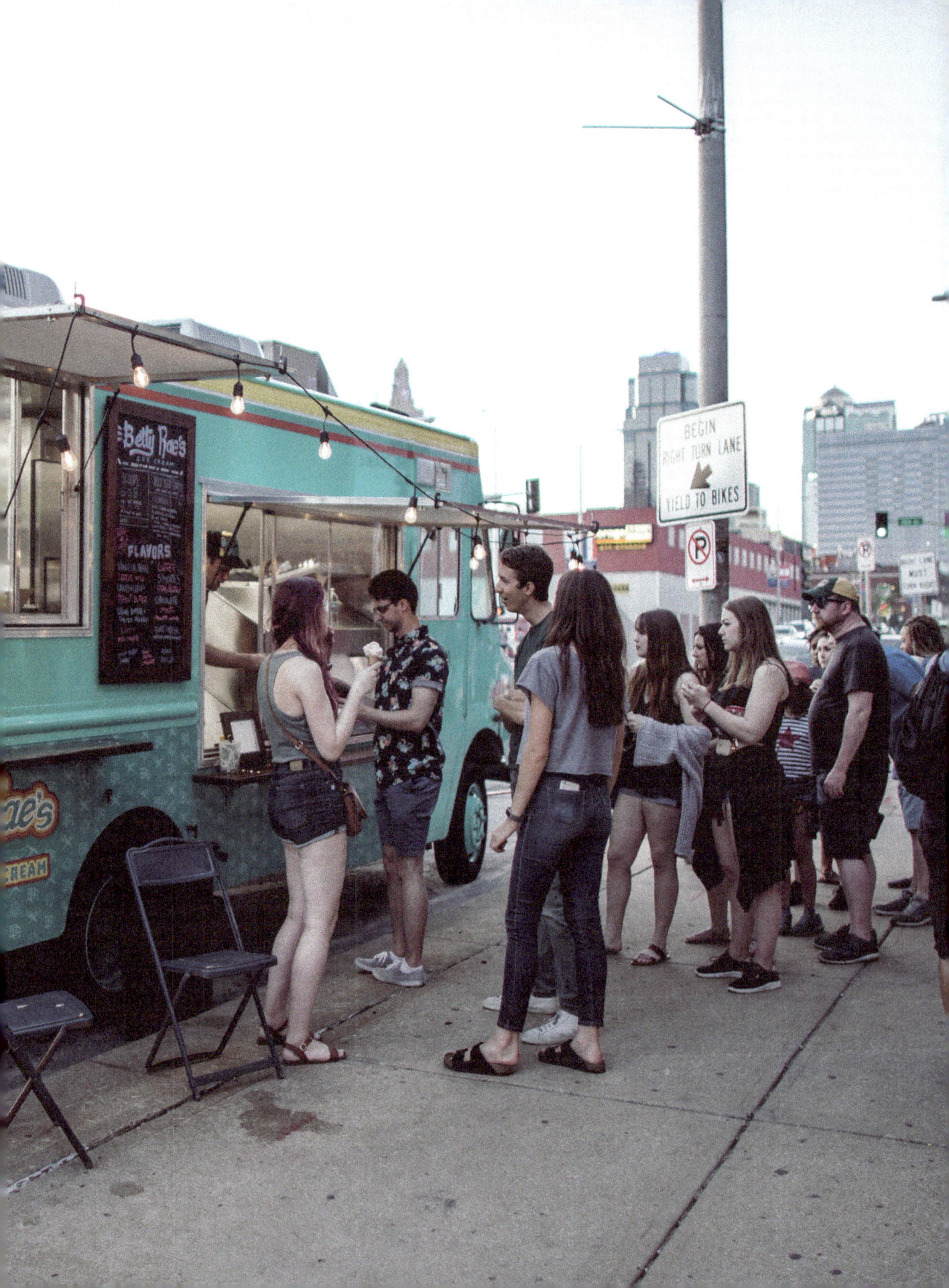

Toasted Pecans

4 tablespoons butter

1 cup brown sugar

1/2 teaspoon salt (or more to taste)

1 pound whole pecans

Preheat your oven to 350F.

In a pan, melt the butter with the brown sugar and salt on top. Stir while melting: a smooth, shiny, and fully incorporated texture is desired.

Place pecans in a metal bowl. When the mixture is fully melted and incorporated, pour over the pecans, and stir until every pecan is well coated.

Pour coated pecans onto a metal baking tray. Put into oven for 5 minutes, then remove and stir the pecans on the tray. This moves the outside pecans to the center, and vice versa, to ensure even baking. Bake for five more minutes, stir again. Add a few extra minutes if necessary.

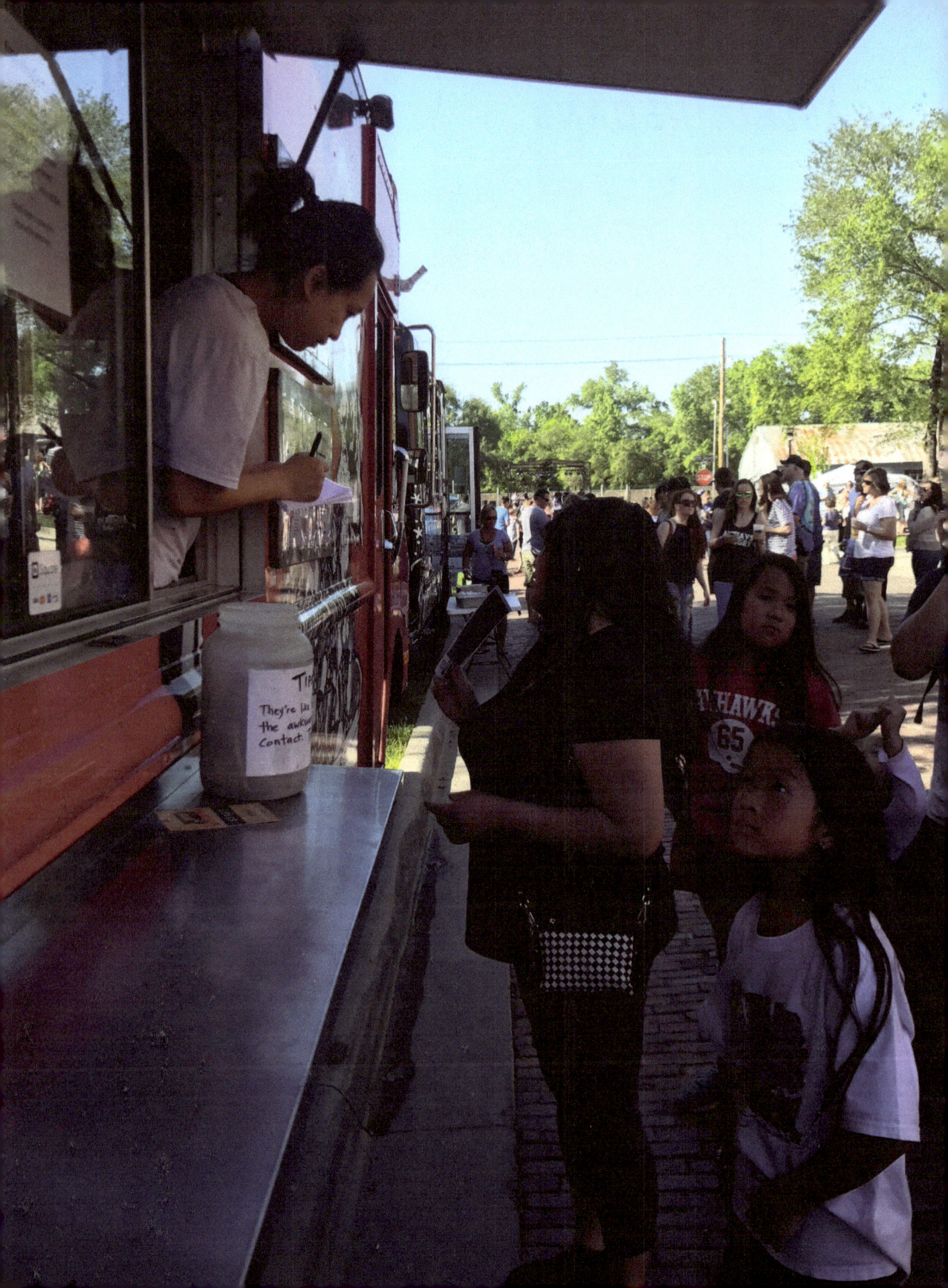

Bochi

SUMMARY

Bochi food truck was one of Kansas City's most loved food trucks owned by chef Xiong Chang. Their signature dish was fried rice-stuffed chicken wings.

STORY

Have you ever seen the movie Serendipity? Two strangers meet and share a memorable date, then part ways due to circumstances. Their paths almost cross by chance throughout the movie. That's how I feel about Bochi. It was recommended to me as the best food truck in Kansas City by countless people. At the 2017 Kansas Food Truck Festival, I finally got my chance to eat at this truck. One look at the menu and I knew it was love. One bite of Bochi's fried rice and I knew this was my food truck soulmate.

After that, I kept trying to attend events where Bochi was serving but life always got in the way. Before I knew it, I received word that Chang had relocated and the truck was no more. I was crushed, as are their droves of fans to be sure.

Though Bochi no longer roams the streets of Kansas City, I thought it important to include them. They were part a formative part of our food truck culture. Plus, I did not want their passionate fans picketing in my front lawn for failing to pay homage to Bochi.

To say Chang's food was delicious is an understatement. There was something so incredible about each element of his dishes: fried rice, fried rice-stuffed chicken wings, and the complex sauces that coat the wings. At first glance I thought the fried rice-stuffed wings may just be a clever gimmick to differentiate the truck and stir up some buzz. Oh, was I wrong.

The wings absolutely delivered in deliciousness, and were rightfully praised by the media and fans across Kansas City. The skin on the wing was beautifully roasted, browned and crispy. Plump, moist grains of rice

peak out from inside the wing, sprinkled with green peas and tiny carrot cubes. The blend of aromas from the piping hot, juicy chicken mix with the bouquet of seasonings in the rice. It's hard not to devour these wings as voraciously as a caveman.

For those who haven't had the chance to try this epic fried rice, Chang was generous enough to share his secret recipe with us in this book. Bochi closed shop in Kansas City in 2017 as Chang needed to relocate. He is now serving up the noms in the food truck hotspot of Portland, Oregon.

Chang, I think I speak for many foodies when I say thank you for serving the Kansas City community. We wish you success in all that you do.

Q&A

WHERE IS YOUR FAVORITE PLACE TO VACATION?
El Nido, Philippines

WHERE IS YOUR DREAM VACATION SPOT?
I love the occasional backcountry camping, but my wife also likes basic amenities of life. So a dream vacation would be a modern treehouse atop the tree lines of a forest.

WHO IS SOMEONE WHO INSPIRES YOU?
My wife, her sheer persistence and determination to kickstart her androgynous fashion line, VEEA. Her "never quit" attitude has been our mantra to keep going when times get rough.

WHAT ARE YOUR FAVORITE KANSAS CITY RESTAURANTS?
So many to choose from; if I had to choose one favorite, it would be: Pa-Ord Noodle, an unassuming Thai restaurant on Sunset Boulevard in Los Angeles. My wife and I always order and share the Thai boat noodle, the crispy pork with Chinese broccoli, and papaya salad. In Kansas City, Gangnam Korean Restaurant in Overland Park (favorite dishes: kalbitang soup and grilled samkyupsal), and K-Macho's in Overland Park

(FAVORITE DISH: Molcajete).

WHAT IS YOUR FAVORITE THING TO DO WHEN YOU'RE NOT COOKING?
I love to be in the great outdoors, play soccer, and enjoy board games with family and friends.

WHAT IS THE LAST PODCAST YOU LISTENED TO OR BOOK YOU READ?
I like listening to audiobooks during long drives, so on our move from Kansas City to Portland, we listened to a fantasy audio book The Chronicles of Lumineia by Ben Hale. I love fantasy and sci-fi; the imagination of worlds and times beyond our own is just so wild.

FANTASY DINNER PARTY, YOU'RE HOSTING. WHO ARE THE GUESTS?
I would love to someday host random dinner parties at my home to a group of different traveling couples, where I can share recipes I have absorbed from the many places I have visited in the U.S. and around the world, as well as share in stories and cultures that each of them have experienced in their travels.

IF YOU COULD JUST EAT ONE DISH FOR THE REST OF YOUR LIFE, WHAT WOULD IT BE?
Pho, Vietnamese beef noodle soup. Plain and simple, I love noodle soup.

WHAT IS YOUR FAVORITE MEMORY OF SERVING THE KANSAS CITY COMMUNITY?
I love the food truck community, the friendships and comradery among food truck owners all working together to fulfill the food trucking needs and demands of the ever-craving Kansas City community. I will miss the frustrated and happy faces of those who have waited an hour in line to get my food and then finally be able to shovel some fried rice into their hungry stomachs. Thank you, Kansas City!

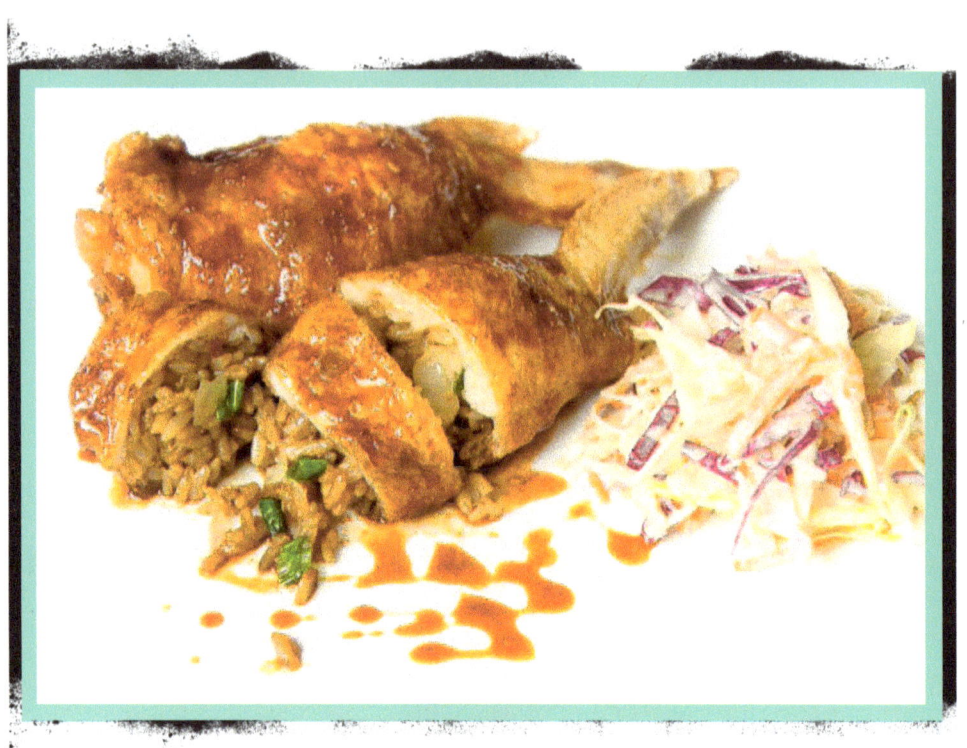

WHAT IS YOUR FAVORITE CONDIMENT?
Sriracha, of course. This was my go-to condiment all through college. My family usually makes a fresh chili paste from Thai chilies, garlic, cilantro, fish sauce and lime in a mortar to be served with our dinners. However, when you get lazy to make a chili paste, you squeeze some sriracha on your plate for that needed kick.

SAMPLE MENU

BUKU Fried Rice:
Jasmine parboiled rice stir-fried in garlic, onions, scallions, green & purple cabbage. Overflowing with your choice of meats.
Choose your meat
 All meat: Shrimp, chicken, and bacon
 Shrimp: Shrimp, seasoned with fried garlic flakes
 Bacon: Fried hickory-smoked bacon
 Chicken: Chunky chicken seasoned with chef special sweet soy sauce
 Veggies: Green and purple cabbage, onions, scallions, and garlic

WINGS

Stuffed wings:
Jumbo chicken wings unboned and stuffed with fried rice, onions, garlic, and shiitake mushrooms. Served with wing sauce and a side.

Unboned wings:
Unboned jumbo chicken wings, not the breaded white meat imposter. Served with wing sauce and a side.

SAUCE

GangNam: Korean flavor sweet apple-pear soy sauce
MeKong: Thai flavor, peanuty sweet chili
ShaoLong: Mandarin flavor, Sriracha buffalo

WING SIDES

Fried rice with veggies
Asian slaw coleslaw salad with special Asian dressing, Japanese mayo, soy milk, soy sauce, garlic, and sesame oil.

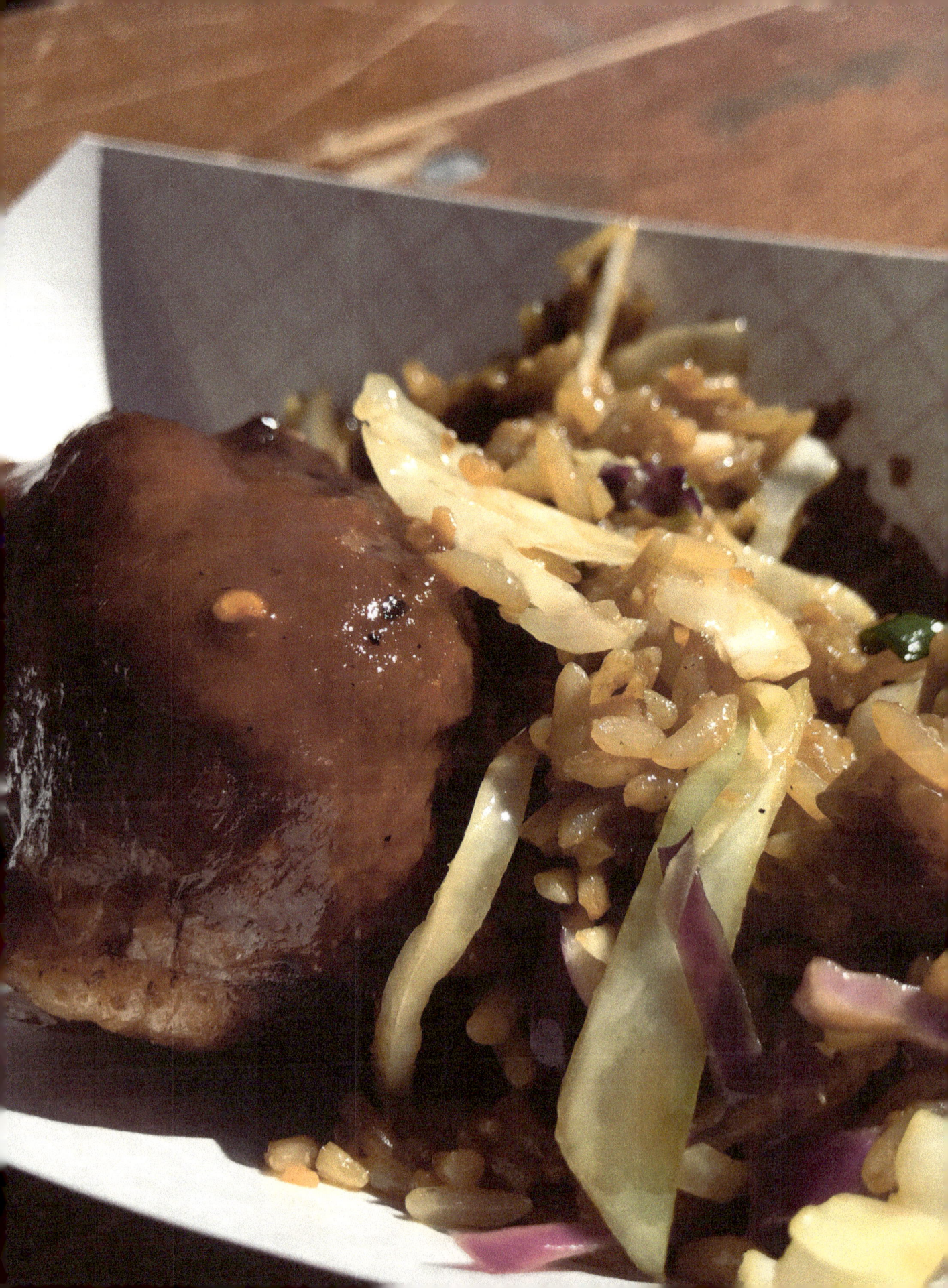

Bochi's Famous Fried Rice

3-5 servings

3 cups cooked rice (cooled down)

2 tablespoon minced garlic

¼ cup diced red onions

¼ cup sliced green onions

1 cup sliced cabbage (mixed green and red)

1 teaspoon vegetable seasoning

1 teaspoon chicken seasoning powder

1 teaspoon. garlic seasoning powder

2 tablespoon soybean salad oil (found at an Asian grocery store)

2 tablespoon bulgogi marinade (found at an Asian grocery store)

1 tablespoon soy sauce

3-5 pounds chicken thigh meat (or substitute any protein of choice)

Cook your rice and let it cool down. Pro tip: cook your rice in chicken stock and water mixture, with a few minced cloves of garlic

Prepare all your vegetables and proteins.

Cook your protein. I like to dice my chicken thigh meat, lightly season them with a bit of soy sauce, and pan fry them beforehand. You can broil, grill, or fry your meats and set them aside to put your fried rice separately.

Using a wok or frying pan heat up your pan on high heat. Add your oil.

Add your onions first then your garlic, and sauté until you can smell the aromatic fragrance from the garlic and onions. Careful not to burn your garlic.

Add your chilled rice. Stir and break up any clumps in your rice.

Add your dry seasonings: vegetable, chicken, and garlic seasonings. Mix well into rice.

Add your wet seasonings: bulgogi marinade and soy sauce. Stir well until rice has darkened.

Add your green onions and cabbage last to keep the crunchy texture from your vegetables.

Turn off your heat, and mix well.

Plate your rice, top it with your proteins, and enjoy the deliciousness.

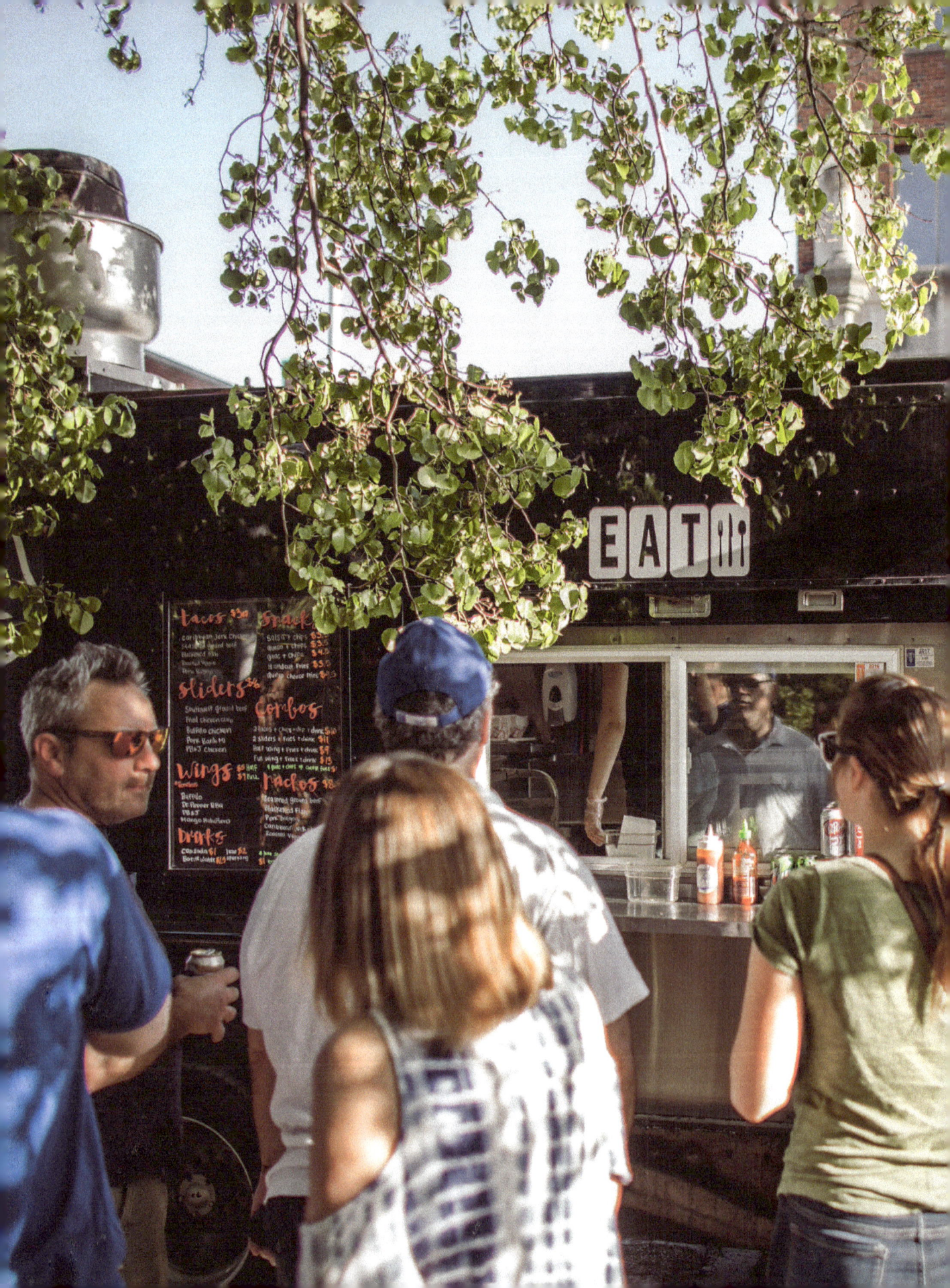

The Casual Foodie

SOCIAL
f @casualfoodietruck casualfoodietruck.com

SUMMARY
The Casual Foodie is a husband-and-wife-run truck with fresh ingredients and scratch-made food, giving old favorites a vibrant new twist. They like to call it fully loaded American fusion. Corey Schlep is the chef and Maddy Bliss Schlep assists with menu development and truck operations (all while holding down the fort at home).

STORY
The Casual Foodie is one of Kansas City's trucks with an ever-changing, fresh menu. They are not beholden to a single cuisine or food concept. Every time you walk up to the menu board, you will see menu items inspired by anything from a recent craving to a trendy flavor combination. That's what makes this truck particularly exciting every time you visit.

Corey studied hospitality and entrepreneurship at Johnson County Community College. Maddy got her degree in early childhood education at Old Dominion University in Virginia. The pair have a son named Elijah and daughter named Emmerson.

For years Corey worked as the executive chef at Yard House in the Legends mall. This is where he met and fell in love with now-wife Maddy. (Side note: if you hear these two interact it may make your heart grow three sizes. The level of mutual respect and adoration between the two is swoon-worthy yet not saccharine. But I digress.)

Corey was approached to start a restaurant with an investor, and when that fell through they were forced to go into "how do we recover" mode.

The idea of starting their own business was still appealing, but starting a restaurant is so costly. Initially Maddy wasn't keen on the idea of a food truck, but as the two continued to consider their options, she ended up seeing it as an opportunity as well.

The original idea for their restaurant was doing small plates (tapas), with influences from European, Italian, and Asian cuisines, but with their own added twist. For the truck menu, they went with a much, much smaller menu. They took their favorite items from the restaurant menu they planned, then tailored them to fit the capabilities and storage of food truck.

The two divide and conquer when it comes to their business responsibilities. Corey does the cooking and Maddy likes to participate in the creative side of the menu development. He handles a lot of the bookkeeping and day-to-day business while she is in charge of anything she can help accomplish from home, like creating recipes and managing the business communications. They've found this system works really well for them and allows Corey to engage more when he gets home at the end of the day. "We see a lot more of him than when he was working in the restaurant business," she notices.

Inspiration for their menu comes from a variety of sources. It may be a protein that piques their interest, or something they tried on their most recent date night. Or, inspiration may come from pregnancy cravings. "One of our sliders came from a major craving I had while pregnant. Our Southwest sliders are a cheeseburger with Doritos, guacamole, and nacho cheese."

While many food entrepreneurs start a food truck in order to grow seed money for their brick-and-mortar dream, these two aren't quite sure if they want to go that route (in large part because they have more family time running the truck than they did when in the restaurant business). The overhead of running a truck is way less than a restaurant, and

doesn't come with the same headache of staffing. "We are going on year three and are still loving the truck," Corey said.

Instead of opening a restaurant, the two are talking about launching another food truck with a concept unique and different from The Casual Foodie. In the more near future, they're planning on setting up a trailer at the Little Piggy lot that will be stationary and have a similar menu as their current truck.

One of the proudest moments of their truck career thus far actually came when they were relaxing at home. They got a knock on their door; it was someone from Nebraska Furniture Mart there to make a delivery. The delivery guy exclaimed how much he loved their food, and he had been a patron of theirs. They say it's fun to have fans drive by them on the road and honk and wave, and others come up to the window exclaiming how delicious the food is.

I was one of those people the first time I visited The Casual Foodie when they were parked outside my then-employer's office at lunchtime. I was looking for a low-carb option and Corey quickly offered to make me the bahn mi I wanted, but as lettuce boats instead of on bread. Yes, please! I strolled back to my desk and within minutes several co-workers came flocking around my desk because the food smelled so good. My health-minded coworkers saw that there was nary a carb in sight and were even more interested. I inhaled the delicious bahn mi boats quickly because they were so good. I returned for a second helping for dinner, and ordered for the same for two other coworkers.

These do-gooder truck owners are cognizant of special food diets and really make an effort to accommodate their customers. When they are asked to serve at schools, they even donate a portion of their proceeds to the Parent-Teacher Association.

Maddy noticed that the community was excited about supporting them as a small, local business from the get-go. They were asked to cater weddings, and book more and more weddings every year thanks to word-of-mouth and their customers' desire to engage with their local businesses. "Growing up, the only affordable options for dining out were chain restaurants. The privately-owned restaurants were usually more upscale. There is a market for local businesses that offer good, affordable food and it's growing in a huge way," Corey said. "We love to see better ingredients become more affordable for families."

Q&A with Friesen

WHAT ARE YOUR FAVORITE CONDIMENTS?
Both: Garlic aioli

ARE YOU NIGHT OWLS OR EARLY BIRDS?
Both: Night owls!

WHERE IS YOUR DREAM VACATION SPOT?
Corey: South of the Border, Mexico
Maddy: Dominican Republic, Greece

WHO INSPIRES YOU?
Corey: Bobby Flay was my first chef inspiration
Maddy: Bobby Huber, the first chef I worked under in Virginia Beach. He taught me a lot of flavor profiles and creativity in menu development. I was too young to serve, so I worked in his kitchen. Also, my mom! She went to culinary school and adopted me and my sister. I LOVE to bake and I got that from my mom.

WHERE YOU'LL SPOT US AROUND KANSAS CITY:
Maddy: You'll find us at Olathe events that are family-friendly. Little Monkey Bizness is fun. We go to the pool, and Worlds of Fun. For date night, we try to pick a new restaurant each time. We tried to have one date night per week, and that lasted about two weeks!

WHAT ARE YOUR FAVORITE TV SHOWS:

Corey: We are big Game of Thrones fans. We play a lot of family video games like Mario Kart and Mario Party.

WHO ARE YOUR FAVORITE INSTAGRAMMERS?

Corey: I just got Insta two weeks ago. Ask me again in a year!
Maddy: I follow Pauly Shore, all of the Game of Thrones cast (I wish Kit Harrington had an Insta!), Taylor Swift, Ed Sheeran, [Justin] Bieber

WHAT LOCAL RADIO STATION IS YOUR RADIO USUALLY SET TO?

Maddy: We listen to a lot of radio. Elijah loves to sing Maroon 5 so we listen to 93.3 and 99.7.

FANTASY DINNER PARTY, YOU'RE HOSTING. WHO ARE THE GUESTS?

Maddy: Ed Sheeran, Leonardo DiCaprio, and Harry Potter

YOU CAN ONLY EAT ONE DISH FOR THE REST OF YOUR LIFE. WHAT IS IT?

Corey: Tacos
Maddy: Mac and cheese

IMAGINE YOUR TV IS STUCK ON THE CHANNEL YOU WATCH THE MOST. WHICH ONE IS IT?

Corey: Food Network
Maddy: Nickelodeon for the kids (sometimes you need that for your own sanity). If I had to choose for myself, something with a lot of movies like ABC Family or AMC.

SAMPLE MENU

SNACKS
Chips & Dip: queso or salsa
Chips & Guacamole: pineapple pico de gallo, cotija cheese
House-Cut Fries: roasted garlic aioli
Cheese Fries: queso

BONELESS WINGS
Hot, Dr. Pepper, barbeque peanut butter & jelly

NACHOS
Jerk Chicken: cabbage, cumin-lime crema, pineapple pico de gallo, cotija cheese
Ground Beef: lettuce, tomato, cheddar
Roasted Veggie: cabbage, cumin-lime crema, pineapple pico de gallo, cotija cheese
Blackened Fish: cabbage, cumin-lime crema, pineapple pico de gallo, cotija cheese
Pork Bulgogi: cabbage, sambal aioli, fried egg

TACOS
Pork Bulgogi: cabbage, sambal aioli, fried egg
Caribbean Jerk Chicken: cabbage, cumin-lime crema, cotija, pineapple pico de gallo
Blackened Fish: cabbage, cumin-lime crema, pineapple pico de gallo, guacamole
Roasted Veggie: cabbage, cumin-lime crema, pineapple pico de gallo, cotija cheese
Seasoned Ground Beef: lettuce, tomato, cheddar

SLIDERS

Fried Chicken Club: Garlic aioli, lettuce, tomato, cheddar, candied bacon
Buffalo Chicken: ranch, lettuce, tomato, cheddar
Southwest Ground Beef: guacamole, pineapple pico de gallo, queso, Doritos, cabbage, chipotle aioli
Pork Banh Mi: sambal aioli, cabbage, cucumber-jalapeño relish
PB&J chicken: Just like the wings, but on a bun

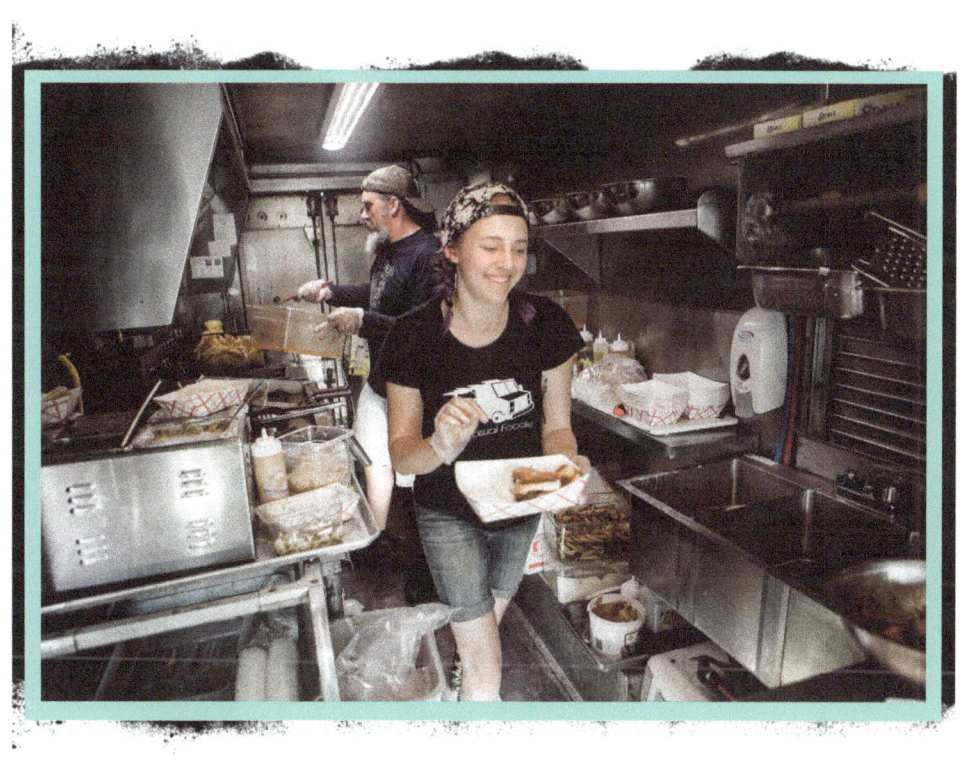

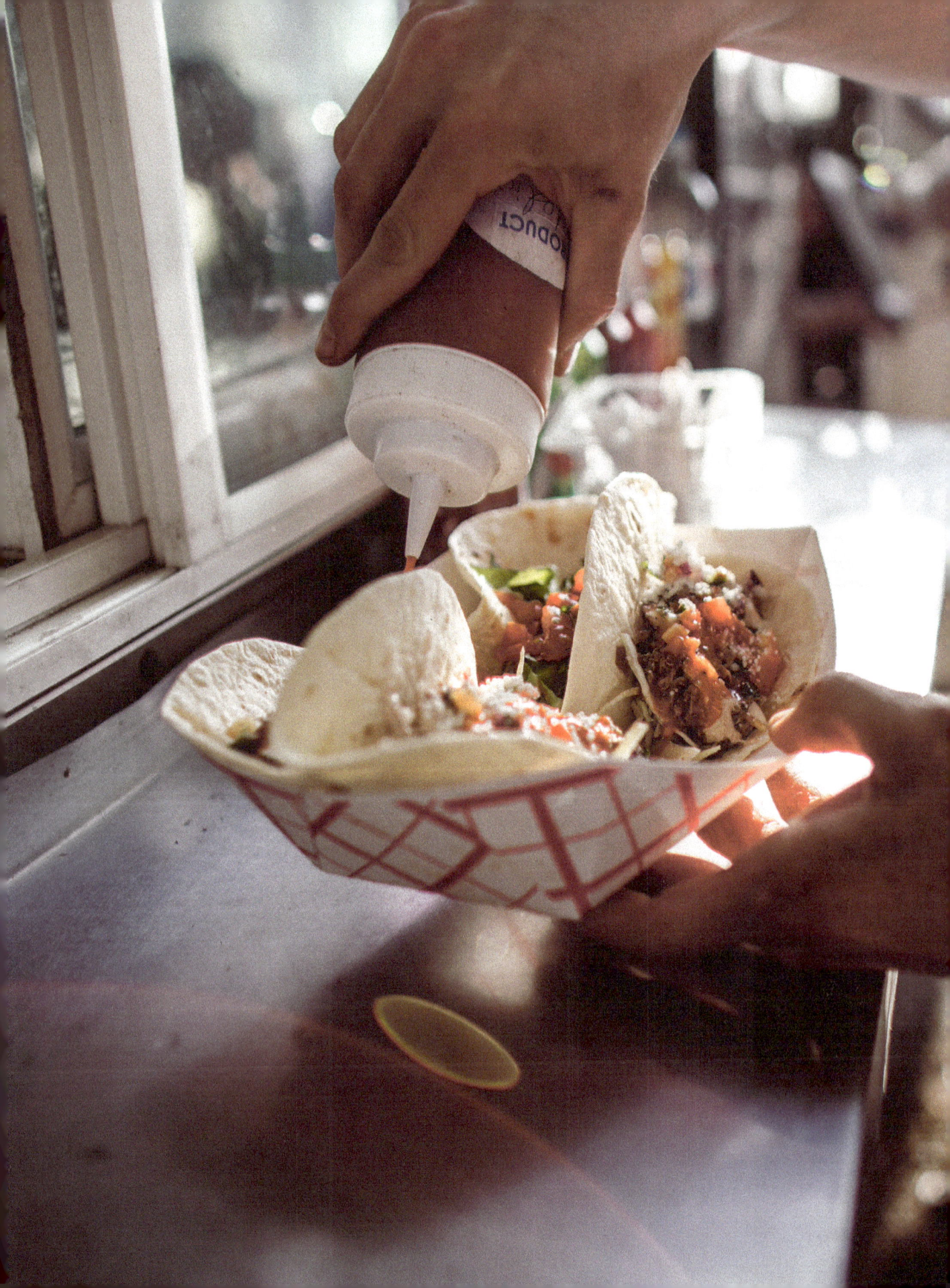

Bulgogi Tacos

Bulgogi Marinade

2 pounds pork roast, sliced

4 cloves garlic (or more to taste), crushed

1 yellow onion, diced

½ cup brown sugar

2 tablespoons sesame oil

½ cup soy sauce

1 teaspoons black pepper

Salt to taste

Sambal Aioli

2 cloves garlic, crushed

1 cup mayo

1 tablespoon sambal (a chili garlic paste found in the Asian Foods aisle of most grocery stores)

Salt and pepper to taste

Combine the Marinade ingredients in a bowl and marinate meat for 2-12 hours.

Place a tortilla on your assembly surface and spread a dollop of sambal aioli evenly over the surface.

Top the tortilla with shredded green cabbage, bulgogi and a fried egg.

Fold, eat, and enjoy!

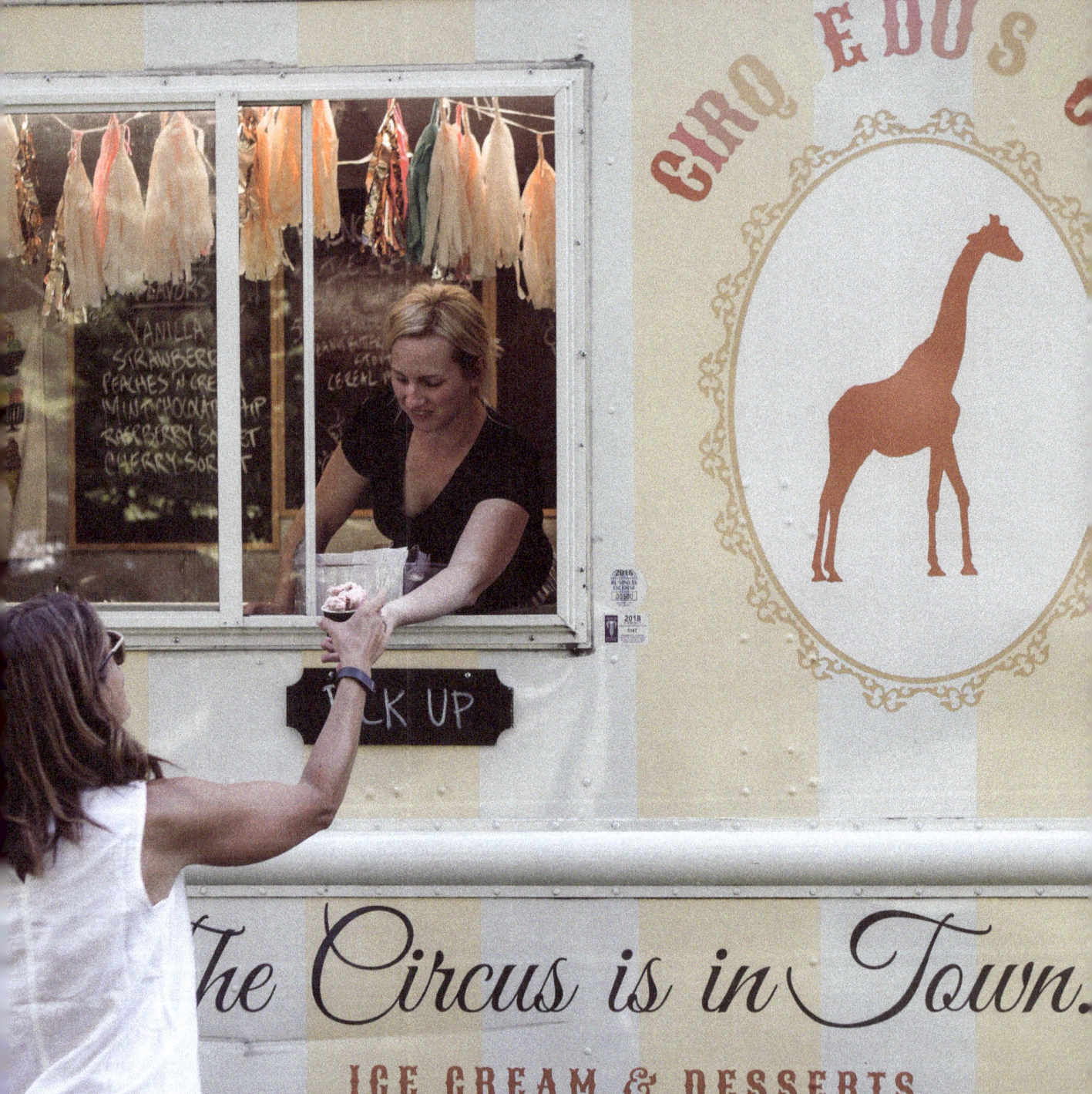

Cirque du Sucre

SOCIAL
cirquedusucre.com @CirqueduSucre @cirquedusucrekc

SUMMARY
Natasha Goellener's food truck Cirque du Sucre is one of Kansas City's most charmingly decorated vehicles. Belly up to the ordering window and you'll find a menu of fanciful housemade ice creams and baked goods just as swoon-worthy as the truck's facade.

STORY
Sometimes it takes a few wrong turns to find the right path. For Natasha Goellener, there were a few stops on her way to owning a food truck. On her first try, she developed one of the most professional food trucks I've seen in all my years writing about them. Take just one glance at her truck with its sophisticated pastel-colored circus stripes, serving window and awning dripping with fairy lights, logo designed to look like one of her almost-too-cute-to-eat animal crackers, and baked goods that look perfectly fitting for the French-inspired exterior design. The experience delivers to her customers is thoughtful and cohesive from first impression to first bite.

Goellener enrolled in the Kansas City Art Institute after high school, and quickly determined that this was not where she was going to thrive. She immediately felt like this was not her calling. So, she transferred to the University of Kansas to keep pursuing a higher education, but with no end game in mind quite yet. During the fall of 2004, her brother gifted her a beautiful book about wedding cakes merely because it made for great eye candy. Little did he know, that gift would steer his sister towards a fulfilling career creating confections.

Two weeks after receiving the cake book, Goellener had enrolled herself at the French Culinary Institute in New York City. The cake book elicited a drive in her, and she felt like she was now on the right path. As much as she was enjoying the culinary classes, she got homesick from time to time. In these instances, she'd make personalized cakes for family and friends. Just two and half years after receiving the book from her brother, Natasha had her own bakery in Kansas City.

Natasha never much cared for cupcakes, so they didn't make the cut on the menu. The French influence from culinary school, however, inspired Natasha's menu and even her food truck concept. "There are so many French pastries no one here had ever seen. When they think of French pastries, they think of pastries that are brown and ugly," Natasha said. French pastries are so much more than croissants, éclairs, and madeleines. Natasha wanted to introduce the more colorful side of the European treats. "In France they sell all sorts of marshmallows out of apothecary jars. In fancy restaurants, they'll even serve them tableside on a string." And just like that, Natasha had her menu: a rainbow of macarons, frosting-covered animal crackers with sprinkles, and charming batches of colorful cookies.

Today, Goellener's menu has evolved to feature fancifully flavored ice creams that are just as whimsical and tasty as her other specialties. But if you're lucky (or order ahead of time), you can snap up Cirque du Sucre's incredibly charming baked treats.

Q&A

WHERE IS YOUR FAVORITE PLACE TO VACATION?
Spain

WHERE IS YOUR DREAM VACATION SPOT?
Antarctica or Cape Town

WHAT ARE YOUR FAVORITE KC RESTAURANTS?
The Antler Room, Dos de Oros Taquería, Princess Garden, India Palace

WHEN YOU WERE LITTLE, WHAT DID YOU WANT TO BE WHEN YOU GREW UP?
A ballerina.

IF YOU COULD HAVE ONLY ONE DISH FOR THE REST OF YOUR LIFE, WHAT WOULD IT BE?
Tacos!

IF YOU COULD ONLY HAVE ONE DESSERT FOR THE REST OF YOUR LIFE, WHAT WOULD IT BE?
Fruit tarts.

WHAT ARE YOUR FAVORITE TV SHOWS?
Currently, it's Yellowstone, Stranger Things, and anything on Bravo.

WHO ARE YOUR FAVORITE INSTAGRAMMERS?
[Author and photographer] Claiborne Swanson Frank

WHAT ARE YOUR FAVORITE BOOKS?
My all-time favorite is Let the Right One In by John Ajvide Lindqvist. I like anything that is disturbing or has to do with vampires. Stephen King is great.

WHERE ARE YOUR FAVORITE PLACES TO SHOP IN KANSAS CITY?
Lauren Alexandra for my kids, and Hall's for me.

SAMPLE MENU

Chocolate Ice Cream
One of the three staples in our "circus," chocolate just makes everything better.

Milk Chocolate Hazelnut Crunch Ice Cream
Okay we lied, putting hazelnut and chocolate together makes everything better and we're sure you'll agree after enjoying the flavor of roasted hazelnuts with our rich chocolate ice cream.

Strawberry Ice Cream
Made fresh and infused with ripe strawberries, this popular flavor is one of the most requested by our customers.

Vanilla Ice Cream
Literally the foundation of any ice cream cone or banana split, our vanilla ice cream is hands-down the best around.

Dulce de Leche Ice Cream
Mixed and frozen using a thick, creamy caramel base, this amazing ice cream is popular with kids and adults alike.

Sweet Pea Ice Cream w/Mint
Looking for something unique? Try the naturally sweet flavor of our sweet pea ice cream - but don't say we didn't warn you about getting seconds afterwards.

Cucumber/Raspberry Swirl Ice Cream
Why settle for just one flavor? Get both the sharp citrus flavor of fresh-picked raspberries with the cool, refreshing flavor of cucumbers.

Sweet Corn Ice Cream
Be prepared: our sweet corn ice cream is delicious, but shocking. You'll be amazed at how creamy, yet so cold, it is and after a couple of bites you'll find yourself with a big smile.

Carrot Cake Ice Cream
Just like Grandma would always make for special occasions, our carrot cake ice cream has just the right amount of sweet and spice in it. Only ours is frozen.

Sweet Potato Ice Cream
This frozen version of the classic American Thanksgiving dessert is a hit with those who are pie lovers! Mixed and frozen with sweet potato puree, our spiced ice cream is a treat that can be tried year-round.

Avocado Ice Cream
Be adventurous and healthy! Our super-delicious treat uses real avocados for a healthy boost that you won't find anywhere else.

Basil Ice Cream
Vividly green and intensely flavored with freshly chopped basil, you'll be in for a uniquely smooth experience with our ice cream.

Black Sesame Ice Cream
Made with ground sesame, our midnight black-colored ice cream will give your senses a dusky, smoky flavor perfect for any occasion.

Horchata Ice Cream
Imagine the sweet, delicate flavors of cinnamon with a scoop of our super-smooth ice cream; it's the perfect treat for keeping you cool on a hot summer day!

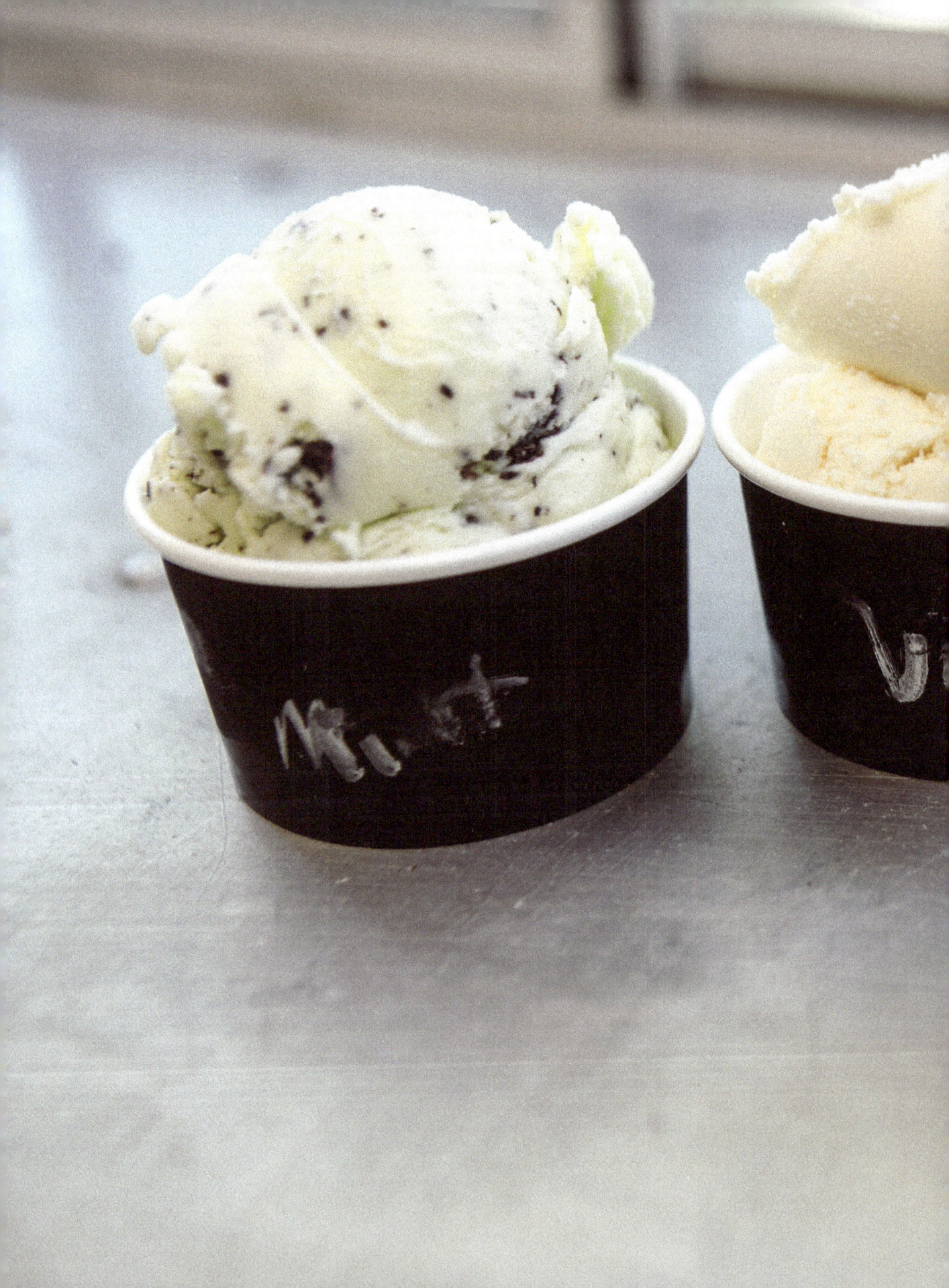

Coconut Ice Cream
Infused with real vanilla bean and coconut, our coconut ice cream will have you thinking of white sandy beaches in no time.

Peaches & Cream Ice Cream
Fruity and creamy, this popular ice cream flavor is at the top of our list to make. Made with fresh peaches and condensed milk for an unbelievable texture.

Banana Ice Cream with Honey & Cinnamon
Kids go bananas for this one-of-a-kind ice cream flavor - and we don't blame them! Made with fresh bananas and real honey, this is one frozen treat that will make a monkey out of anyone!

Strawberry Ice Cream w/Champagne Macaron
An upscale twist on the popular strawberry ice cream flavor, made with classic French macaron shells exclusively from Mulberry & Mott.

Ispahan Ice Cream
Inspired by the frozen treat in the streets of Paris, our Ispahan treat is packed with delicious fruit flavors. We strongly recommend pairing a scoop with our popular French macarons!

Melon Ice Cream
Big on flavor, small on the calories - you'll find yourself enjoying our refreshingly light melon ice cream again and again.

Roasted Cherry Ice Cream
Enjoy our unique olive oil ice cream garnished with roasted cherries and walnuts for an exotic and rich sensation.

Blackberry Sage Sherbet
Feel like a kid in the berry patch again with your family while enjoying

our fruity blackberry sage sherbet. Made with ripe berries and chopped sage, this is one scoop not to miss.

Campari & Grapefruit Sorbet
Searching for something a little more grown-up? Try our complex grapefruit sorbet that'll pack a brilliantly dry flavor with each bite you take.

Fresh Fruit Sorbet
Keep yourself thin - enjoy our low-fat alternative to ice cream. Just as delicious and decadent, but without the guilt.

Chunk Cookies
Wanting a sweet treat, but not the brain freeze? Our larger-than-life chunk cookies are the perfect choice. Available in a wide variety of flavors.

French Macarons
Available in a wide range of colors and flavors, this little cookie is our customer's most requested non-frozen treat.

Splits for Two
Cirque du Sucre banana splits are BIG. Bring your partner and/or your appetite! Made with our signature ice cream along with cherries, whipped cream and other garnishments.

Campfire Smores
Bigger is better with our homemade chocolate smores. Enjoy our delicious chocolate and oversized marshmallows, but without the assembly.

French Macaron Ice Cream Sandwiches
No introduction needed here—enjoy both the light crisp flavor of a French macaron with our rich, creamy flavored ice cream.

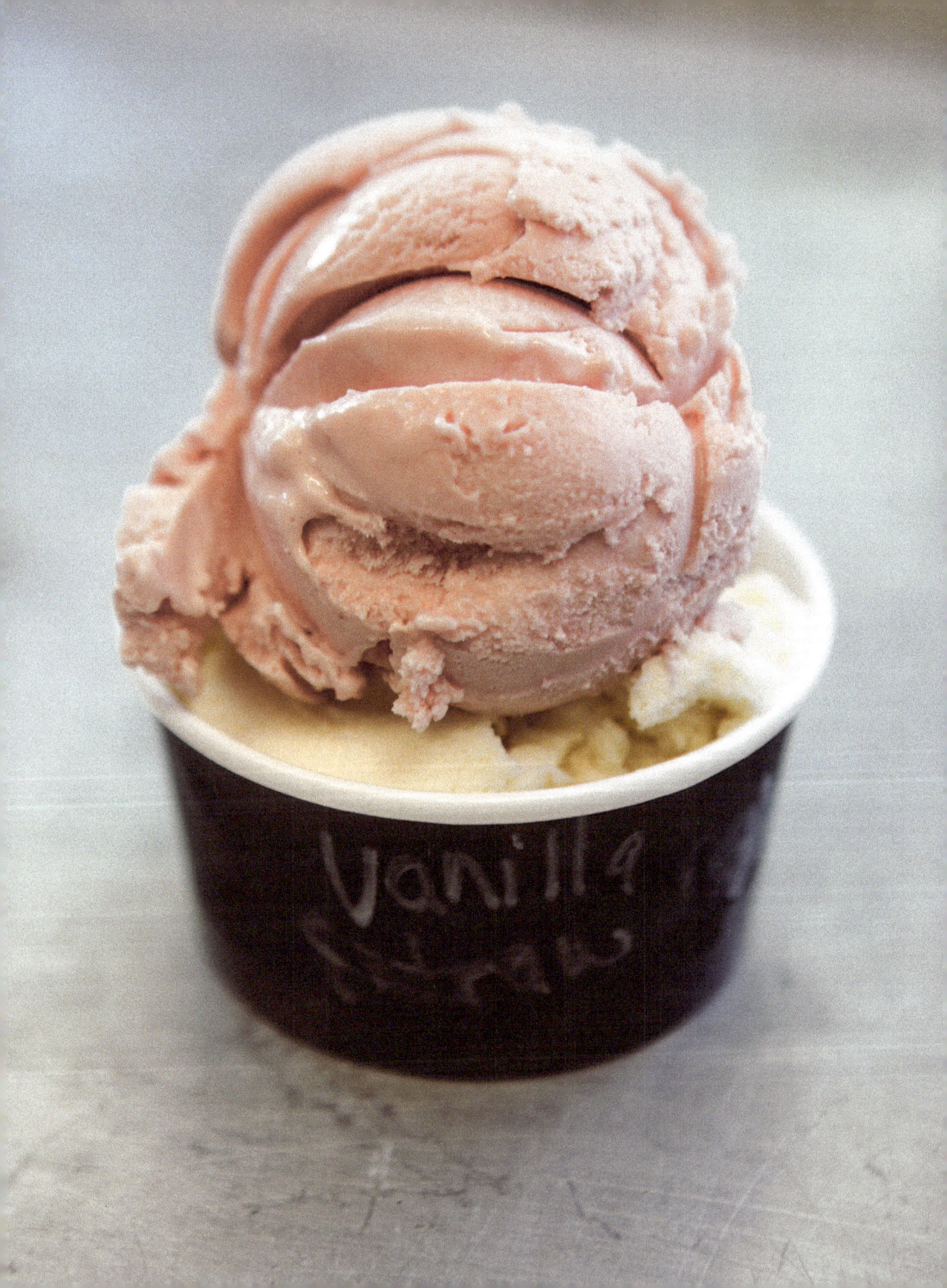

Blue Corn Waffle Cones

2 eggs

½ cup sugar

¼ cup salted butter, melted

3 tablespoons + 1 teaspoon milk

1 tablespoon vanilla

1/3 cup all-purpose flour

¼ cup blue corn meal

Whisk all ingredients together until batter is smooth. Note: You can add purple food coloring if you want a darker purple color.

Follow the instructions from the waffle con iron manufacturer to bake and form the cone.

CoffeeCake KC

SOCIAL
🐦 **@CoffeeCakeKC** f **@CoffeeCakeKC** 📷 **@CoffeeCakeKC**
🧭 **coffeecakekc.com**

SUMMARY
Co-owners Michelle Ferguson & Kim Niebaum bought this business from the original owners who operated the truck in Kansas City under the same name. They serve coffee, coffee cake, and pastries. Their classic coffees and refreshing smoothies are worth the trip alone, but their witty and often hilarious interactions with people keep the line growing and caffeine flowing.

STORY
Imagine you're sitting in your gray cubicle one day, daydreaming. While desk jobs offer perks like stability and set hours, sometimes you sit there staring at your glowing computer monitor full of formulas and deadlines, thinking there must be more to life. That was the case for long-time friends Michelle Ferguson and Kim Niebaum. And it turns out, they were very right: there was a big change-of-pace in their futures.

For a long time, the two friends discussed opening a food truck together. The hypothetical conversations turned to real conversations, and that turned into a lot of research. "Are we really going to do this?" they asked one another.

After a lot of planning and discussion, they decided to take the leap and purchase an existing food truck business in Kansas City. Buying an existing business had its advantages, they reasoned. They knew the truck was compliant with city codes, the truck concept was tested and successful (though they had ideas for making it more so), they had three years of financial records to analyze, they were able to ask questions of the truck's current owner, and there was bit of a fan base and Rolodex®

of clients that transferred to them. By buying the business, they were able to step over common pitfalls. In retrospect, Ferguson pointed out, she wished they had done some more homework when it came to the truck's mechanics by having it inspected by a professional. This would have alerted them to potential costly repairs that would soon pop up.

The momentous day of buying the business landed on Niebaum's birthday in 2015. Before launching into the daily grind with the truck, the two took a step back and decided a makeover was in order. Ferguson's graphic design background made for the perfect prep to redesign the vehicle with an updated look.

When it came to responsibilities, they split tasks based on each woman's strengths. Niebaum's accounting and office managerial background equipped her to take on all the finances that come with entrepreneurship and food trucks. Ferguson ran the truck full-time: managing the schedule, sourcing the ingredients, taking and making each order, responding to business inquiries and customer interactions on social media. When demand became so high that Niebaum needed to join full-time too, she jumped aboard. After a long period of planning, Niebaum circled her last day in the office on the calendar and notified her company. Later she realized that date had a special meaning: It was Ferguson's birthday!

Today, CoffeeCakeKC is a mecca for their regular customers. Ferguson and Niebaum often see their regulars in the distance, as they approach the truck. Since the ladies know their regulars' orders by heart, Ferguson and Niebaum start preparing the orders before the familiar faces even queue up. This reduces the wait time for their most loyal customers, and gives the customer the warm and fuzzies getting this VIP treatment and having a relationship with these local business owners.

If you catch these ladies when they're slammed, they have a fun way of sprinkling some fun onto the stress of a fast-paced kitchen: Instead of

writing your name on your cup, they'll give you a superhero name. "Batman, your espresso is ready! Green Lantern, your smoothie is coming right up!"

Now, when they are surrounded by adoring fans and sharing laughs with fellow food truck owners, they're glad they decided to join Kansas City's growing fleet of food trucks. Are the days longer and the work more stressful and physically demanding? You better believe it. Still, serving the city on wheels and being part of the growing movement brings with it a kind of gratification a desk job never did.

Q&A

WHERE IS YOUR BIGGEST PET PEEVE?
Niebaum: People arriving (very) late
Ferguson: Rude people

WHERE IS YOUR DREAM VACATION?
Niebaum: Bora Bora
Ferguson: Cuba

WHAT IS SOMETHING YOU APPRECIATE ABOUT YOUR BUSINESS PARTNER?
Niebaum: Michelle does all the event coordination, social media, and marketing.
Ferguson: Kim handles all the finances. I do know our credit card balance and I do not want to know!

DO YOU HAVE ANY PETS?

Niebaum: I have three adopted cats named Jack, Crack Boy, and Bacon Bit. We inherited Jack from a friend who could no longer take care of him and we love him to pieces. Crack Boy got his name because he's very active and wacky. My husband always wanted to name a cat Bacon, so he got to name this little guy!

Ferguson: Jack Russell Terrier and boxer named Lucy. They keep me company when I unwind at home, especially when my husband (who is in the military) is out of town for a while.

WHO IS YOUR FAVORITE INSTAGRAMMER?

Niebaum: Nathan Fillion

Ferguson: I am only on Instagram to follow KC food trucks and talk to our fans!

TV SHOW I LOVE TO BINGE:

Niebaum: The Walking Dead
Ferguson: Claws

FAVORITE LOCAL RESTAURANTS:

Niebaum: Longboards, The Majestic, Room 39
Ferguson: SPIN! Neapolitan Pizza, The Rieger, The Westside Local

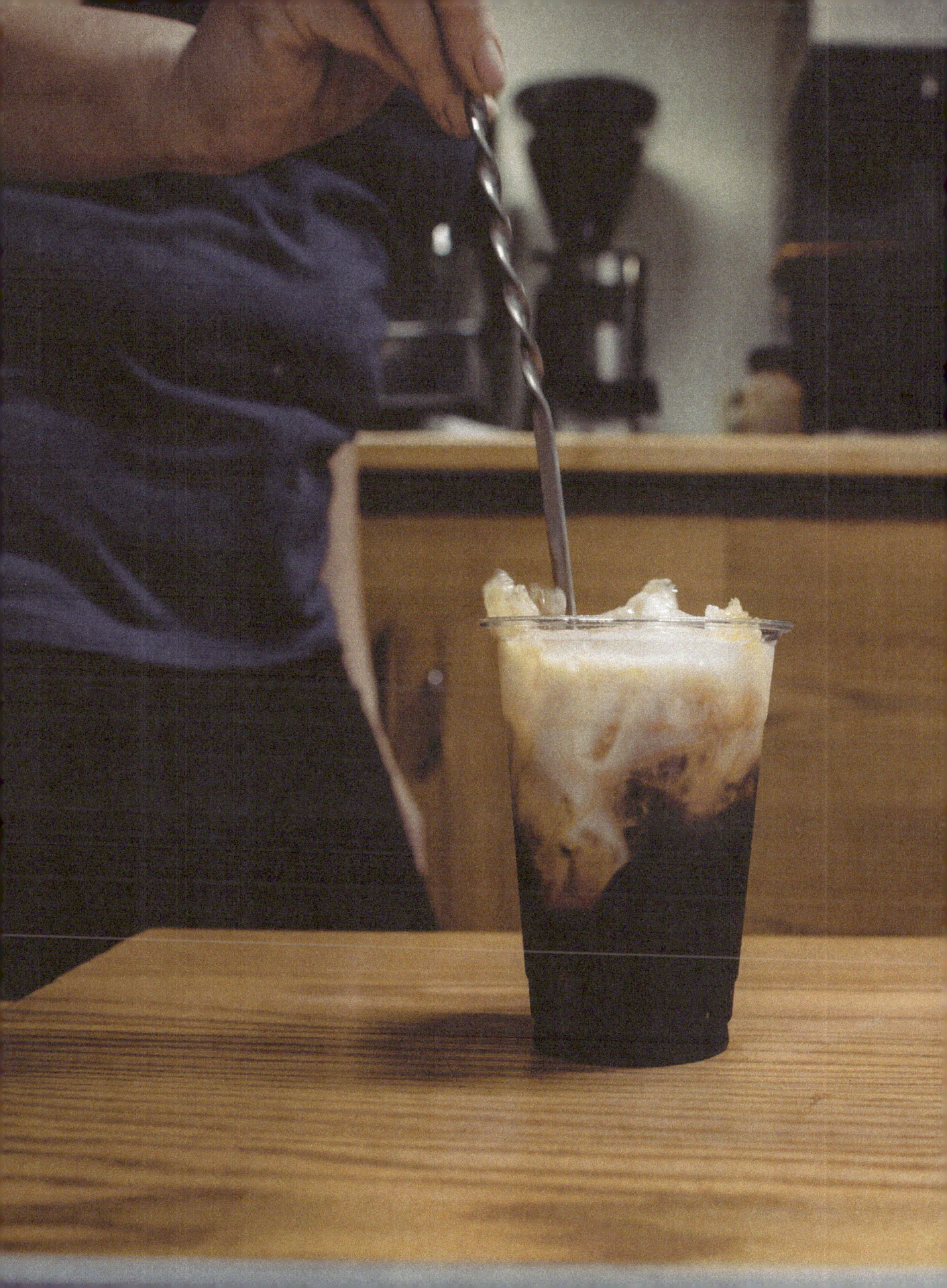

SAMPLE MENU

COFFEE AND ESPRESSO DRINKS
Featuring Mother Earth Organic Coffee and Espresso

Brewed Coffee
Double Shot Espresso
Cappuccino
Americano
Espresso
Latte
Mocha: caramel, dark chocolate, white chocolate, or mix

TEAS
Hugo Tea Organic Chai Tea Latte: A very traditional flavor, brewed in Kansas City
Dirty Diana: Organic or Sweet Chai + Espresso
Hugo Wonder Mint Herbal Tea: Natural minty sweetness with a smooth finish. Caffeine free
100 Year Black: Unequivocally smooth with flavors of warm honey and malt
True Jasmine: Maofeng-style green tea and summer jasmine blooms
Chai Latte Teas: A sweeter flavored tea with Eastern spices
Big Ben: Hugo Tea Grey Line + Vanilla + Steamed Milk
Berry Rooibos Herbal Tea: Antioxidant-rich rooibos with herbs and berries
Grey Line (Earl Grey): Crafted with bergamot oil sourced from Italy's Reggio Calabria
Da Ye Xi Green Tea: A unique, smooth and savory-sweet flavor

HOT CHOCOLATES
Mexican Spiced Hot Chocolate: rich chocolate with cinnamon and vanilla.
Pablo: Mexican spiced hot chocolate + espresso
Truffle Hot Chocolate: traditional, European-style chocolate
Truffle Shuffle: truffle hot chocolate + Espresso

FRAPPÉS AND SMOOTHIES
Baron (Pablo Blended)
Kinky Katie (Dirty Di Blended)
Coffee Toffee
Latte Freeze
Mocha Freeze
Truffle Freeze
Smoothies: Mango, piña colada, strawberry, strawberry banana, wild berry

FROM THE BAKERY
Cinnamon Swirl Coffeecake
Assorted Jumbo Muffins: almond poppyseed, apple cinnamon, blueberry, double chocolate, and banana
3 Women and an Oven Cookies: chocolate chip, snickerdoodle, and peanut butter
3 Women and an Oven Cupcakes: White Wedding, chocolate peanut butter, coconut key lime, and red velvet

Chocolate Chocolate Chip Muffins

Yield: approximately 12 standard muffins or 6 jumbo muffins

2 eggs

1 cup sugar

1 teaspoon instant espresso powder

1/2 cup canola oil

1 cup buttermilk

1 teaspoon vanilla

1/2 teaspoon salt

1 teaspoon baking soda

2 teaspoon baking powder

1/2 cup Dutch process cocoa powder

2 cups all-purpose flour

1 cup chocolate chips

Preheat oven to 425 F.

Using a whisk, combine eggs, sugar, and espresso powder in a large mixing bowl.

Whisk in canola oil, buttermilk, and vanilla until well incorporated.

Add salt, baking soda, and baking powder — whisk until just combined.

Carefully whisk in cocoa powder.

Fold in flour, one cup at a time, until most of the flour is incorporated.

Fold in chocolate chips and continue to stir until all flour is incorporated and chips are well dispersed.

Prepare your pan: grease muffin cups or line with cupcake papers. Fill cups 2/3 full with batter.

Bake at 425 F for 5 minutes.

Drop oven temperature to 375 F and continue baking 18-20 minutes, until muffin tops spring back when touched.

Remove from muffin pan and allow to cool on a wire rack.

Indios Carbonsitos

SOCIAL

- mexi-qtruck.com
- @indioscrbnstos
- @IndiosCarbonsitos

SUMMARY

Indios Carbonsitos is one of Kansas City's OG gourmet food trucks run by Adrian Bermudez. He serves up a fusion of traditional Mexican recipes and barbeque.

STORY

As Jill Silva mentioned in the introduction, the first known food truck to launch in the U.S. hit the streets of Los Angeles in 2008. In 2009, Kansas City's own Adrian Bermudez saw the hype about this truck in the news. He shared the vision for serving foodies in a mobile restaurant, and hopped right on the trend that introduced a booming new business model to American entrepreneurs. Bermudez is quick to point out there were other food trucks around, like Torre's Pizza and Jerusalem Cafe, but he was the first to offer a food truck with scratch-made food prepared on the truck.

Bermudez was born in Juarez, Mexico and grew up in Kansas City, in the neighborhood now known as the Crossroads. After attending Westport High School ("Go Tigers!" Bermudez exclaims), Bermudez pursued jobs in a variety of business sectors. (When asked what he studied in college, he jokes "women and chemistry!)

"I've always worked ever since I was a young boy, always hustling. I remember selling Now & Laters in school; I'd buy the packs and sell each one individually," Bermudez recalls of his first entrepreneurial endeavor. "I've worked in different restaurants, most notably Antoine's on the Boulevard, The Bristol, The Colony Steakhouse as busboy, bar back, you name it. As a young adult I worked for Transamerica as a

case manager, then at Insurance Designers KC for a few years after Transamerica was bought out and, eventually, I moved to working at the Christian Foundation for Children and Aging (which is now called UNBOUND) for eight years as a manager of the call center team." As is the story for many food truck owners, at some point the imagination wanders. Daydreams turn into Google searches and truck sketches. Oftentimes it comes from a love for food or need for creativity that their day jobs aren't tapping into enough.

Bermudez said he has always had a passion for food, and it started with his father, a homemade non-weather-fearing grill-master. He would be grilling delicious food no matter the forecast and, as we all have experienced in the Kansas City region, that could mean anything from extreme heat with awful humidity to sideways sleet and snow storms.

His love for quality, scratch-made food felt incompatible with what Kansas City had to offer at the time. Bermudez constantly felt let down by the food. "Many times I would go to a restaurant or eat at a stand or truck and realize that the food I would make at home, quite frankly, was better than what any of them was offering," Bermudez says, recounting why he decided to start a food truck. "Many times I'd be invited to parties and would end up cooking things they forgot to make or would be talked into manning the grill for them. This one time I was wearing all white - pants, shirt, a t-shirt, shoes, etc. and got talked into grilling at the party. Once we got home I had to throw everything out because I had grease and whatnot all over my clothes. This is when I decided to start charging for my food and services."

When he told his friends and family that he was thinking of starting a food truck, they weren't exactly enthusiastic about the idea. The job doesn't come with benefits, the hours are very long, not to mention the costs involved. "They all thought I was nuts. Happily I can now say I am glad I did not listen; I was on the forefront of what is now the food truck craze."

It was important to Bermudez to forge ahead. He knew there was something to the idea. "The truck is a means for me to express myself in food as I have done since I was young, only now I get to touch so many more people with it."

So, he began his meticulous search for the truck. Some entrepreneurs get so jacked about the idea, they pounce on a vehicle before fully understanding what they need it to do for them, and what health and safety codes it needs to meet. Though food truck specific regulation did not exist in Kansas City at the time, Bermudez hedged his bets by waiting for a catering truck to come available. "I found the truck in Arizona, a woman posted on craigslist she was selling it so I pounced on it since it was exactly what I was looking for. My tip for others is to first figure out how your setup is going to be in the truck, and what kind of truck you want. I was fortunate enough to get a truck that was built to cater instead of getting a Dorito's truck, gutting it, and building it to my liking."

The inspiration for the truck was a no-brainer. Bermudez and his father loved eating street food, especially when they were in Mexico. "I have vivid memories of this. When creating my menu I draw from these memories to try and create or recreate those dishes I love so much. Of course, I have to put my own spin on them."

The name Indios Carbonsitos has a family story to go with it as well: "Growing up, my father would refer to us as 'cabrones,' which is a bad word, but basically means 'badasses' or 'bad boys.' Carbon means 'charcoal' or 'grilled.' My nickname growing up was 'Indio,' which means the Indian, since I was very dark and had very long hair (yea, unlike now that I'm bald). I have always been all about my kids so I had to tie them in somehow. So that's why I named it Indios Carbonsitos as if a child would have named it. The "sitos" part is a misspelling - it should be with a 'c' in correct Spanish grammar, but I remembered the Stephen King movie Pet Sematary and how it is spelled like a child would. So, Indios Carbonsitos basically means bad Indian kids playing with fire. The logo actually started as the faces of all three of my kids on a cartoon body running around a fire and playing with a pig on the spit."

Integrating his sons into the business has been important to him well beyond just including them in the artwork. When I asked him what he hopes they learn from helping him with truck, he said, "They have learned humility, the cost of a buck earned, and how to manage money. Of course, they've also learned to cook alongside their old man."

The most popular sandwich is named after his son Akcel, who he credits with its creation, "It's our riff on the cheesesteak. It's carne asada marinated steak we cook on the griddle along with strips of red bell peppers (I think green are nasty and are flavorless), slivers of onion, strips of jalapeno for heat, a little of our house rub, then once cooked, we put it on a hoagie bun with Chihuahua cheese (similar to a white cheddar) on the bottom to get melty. If you are like me and love the heat, you can have it with Diablo sauce on top, which is pretty spicy....this sandwich was actually created by my middle son Akcel. He loves Philly cheesesteaks but loves our food more, and on a dare from a friend he created it on the fly so the next day we tried it out at an event, and the rest is history."

One of the things Bermudez loves most is seeing customers' first hand reaction when trying an Akcel or a torta ahogada, or really any other menu item. "I can't hide... I am giving a piece of myself to the people through food. It's satisfying to the soul. The hardest part is waiting through the winter for food truck season to start again."

Weddings offer a wonderful setting to interact with customers in a leisurely setting. There was one in particular that sticks out to Bermudez, "The clients were the most down to earth people. The wedding was done outside and the bride and groom were a little late coming out to eat, so the guests all started saying it was okay with the bride and groom for everyone to start eating. A few minutes maybe into serving everyone, I looked up and saw the lovers hand in hand in the middle of the line waiting their turn to order their food! Of course I ran out of the truck and grabbed them and escorted them to the front of the line so they could get their food. It's their party, of course they

should eat first. Then towards the end of the night they both came over and hugged myself and my kids, thanking us for the most memorable food they could have imagined."

In the eight years that have passed since his soft launch in 2010, Bermudez has learned a lot of lessons about owning a business and enjoyed a lot of memories thanks to the Kansas City community. And, he did so with a healthy dose of humor. Even in our interview, he was cracking one-liners right and left. "Lots of folks gravitate to me because I'm always in a good mood and see life as a kid would most of the time. Never did I ever think about becoming a comic; I'd probably suck."

Among his greatest accomplishments he counts the recognition he gets from his customers in the community, and "getting respect from my peers - not only food truckers but chefs from restaurants." And, I'm guessing, the unforgettable memories and legacy he has created for his sons.

Q&A

ARE YOU AN EARLY RISER OR NIGHT OWL:
Night owl (I'm naturally an insomniac)

DO YOU HAVE A SWEET OR SAVORY PALATE?
Both - if you try my food you will see that I tend to have a little sweet and savory in all my items.

BURNT ENDS OR BRISKET?
That's actually a trick question right? Brisket produces burnt ends so I say brisket because you can have the fatty sexiness of the burnt ends but also the yummy flat pieces that are perfect for a Flaco burger.

WHAT IS THE LAST BOOK YOU READ?
Stephen King's Pet Sematary

WHERE IS YOUR DREAM PLACES TO VACATION?
Places I haven't been - Mexico City and the pyramids, I have to go soon!

WHAT ARE YOUR FAVORITE THINGS ABOUT LIVING IN KANSAS CITY?
Food diversity is getting better and better; we aren't just a BBQ destination anymore

WHAT ARE YOUR FAVORITE LOCAL RESTAURANTS?
Joe's KC, Blue Moose, anything Celina Tio touches! I'm there.

WHERE ARE PEOPLE MOST LIKELY TO RUN INTO YOU AROUND TOWN?
Parks, a local bar, food truck festivals (not only do I love making the food, I love eating it too).

WHAT DO YOU LIKE TO DO WHEN YOU'RE NOT WORKING?
Research food, what's being done around the country

FAVORITE TV SHOWS:
I'm a comic book nerd, so any of the superhero movies or shows are my go-to

WHO DO YOU ADMIRE?
Rick Bayless, he is not only a great chef but he constantly returns to Mexico to continue to learn

FANTASY DINNER PARTY, YOU'RE HOSTING. WHO ARE THE GUESTS?
The best Mexican chefs in the world. In order to be the best, I gotta continue to learn from the best.

WHAT ARE THREE WORDS YOUR FRIENDS WOULD USE TO DESCRIBE YOU?
Strange, funny, loving

WHAT FOOD WOULD YOU CHOOSE FOR YOUR LAST SUPPER:
Spicy sweet mole with Mexican rice made by my mother. No other one comes close, not even my own.

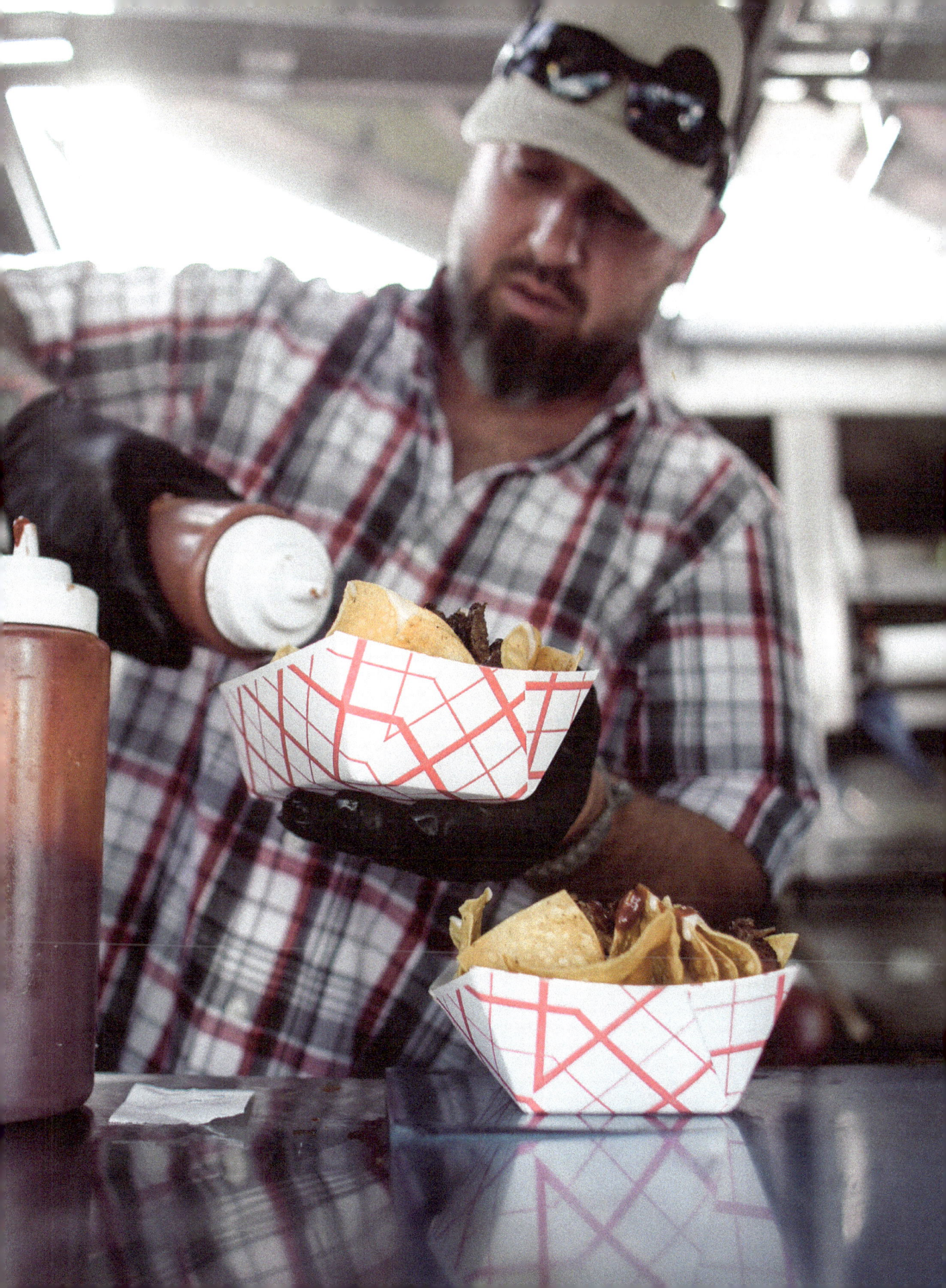

SAMPLE MENU

Torta Ahogada
Mexican sandwich — slow-braised pork accompanied by refried beans, avocado, pickled onions. Then this is submerged first in a tomato-based sauce, followed by a spicy sauce (mild, medium or hot).

The Akcel
Our Mexi-Q version of a Phillysteak. We use marinated carne asada steak, melted Chihuahua cheese, topped with strips of jalapeños, onions, and red bell peppers, all atop a toasted hoagie bun.

Cubano Sandwich
Slow-roasted pork shoulder in mojo marinade, griddled sliced ham, a slather of mustard, pickle slices, Swiss cheese. As a side, we have yucca fries with a lime wedge.

Strawberry Pecan Tamales
Our signature item that sounds strange but is delicious. Macerated strawberries and bits of pecans are mixed together into a fresh ground corn masa and steamed to perfection. Garnished with a drizzle of a strawberry cream.

Sloppy Fabi
Our version of the Sloppy Joe, only made with our own Mexican spices, diced red and green bell peppers and jalapeños, as well as a sweet tangy sauce and a slice of Chihuahua cheese on top of a burger bun.

Asada/Tinga Sopes
Pinto beans on top of a crispy-fried sope and a portion of asada/tinga, cotija cheese, and your choice of sauce.

Flaco Burger
Fresh ground chuck, hand-formed and grilled to perfection, topped with smoked cheddar, smoked brisket, Applewood smoked bacon, and our house BBQ sauce.

Chicken Tinga Tacos
These tacos are very traditional, but of course made with our own twists. Our recipe won us a throw-down in 2017 with a very big hitter that we won't mention. We grill chicken breast and smoke over cherry wood with our house blend of spices, then we add the chunks into a chipotle sauce. We add caramelized onions and mushrooms too.

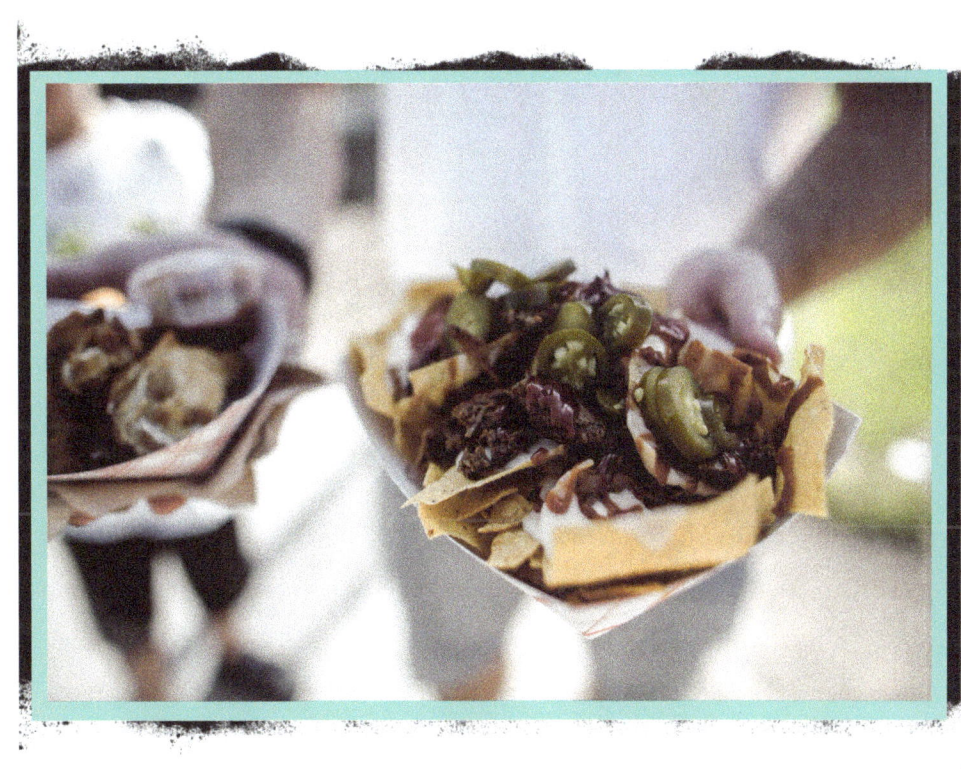

Tortas Ahogadas

Makes 8 sandwiches

Pork Carnitas

1 (3-pound) pork roast

2 tablespoons canola oil

1 teaspoon cumin

1 teaspoon black pepper

1 teaspoon chili seasoning

1 bay leaf

1 (14.5-ounce) can low-sodium chicken stock

In a large sauté pan, brown the outside of pork roast in canola oil over medium-high heat. Transfer browned pork roast into the crock of a slow cooker. Sprinkle cumin, black pepper, chili seasoning, and bay leaf over meat. Pour chicken stock over all. Cover with lid and cook on low heat setting for 8 to 10 hours. Remove lid and shred pork with two forks, taking care to remove any visible fat before shredding. Replace lid and allow meat to cook in juices for another hour.

Sauce

2 (15-ounce) cans tomato sauce

2 teaspoons cumin

2 teaspoons salt, divided

2 teaspoons black pepper

6 teaspoons ground oregano

6 garlic cloves, finely minced

4 teaspoons white vinegar

2 cups water

1 white onion, finely minced

4 chile de arbol peppers, less if you prefer a milder sauce

Pour tomato sauce into a saucepan and season with cumin, 1 teaspoon salt, black pepper, oregano and garlic cloves.

Simmer over low heat slowly for 30 minutes, stirring occasionally.

While sauce is simmering, pour vinegar and water into a separate saucepan. Add minced onion and bring to a boil over medium-high heat. Remove from heat, add peppers and allow to steep for 15 minutes, or until the water turns a reddish-brown color.

Transfer contents of saucepan with peppers to the bowl of a blender and season with remaining 1 teaspoon salt.

Blend mixture until it becomes smooth and add to simmering tomato sauce mixture.

Simmer an additional 15 minutes, stirring occasionally.

Sandwhiches

1 (16-ounce) can refried beans

8 bolillos, or French rolls, split lengthwise, leaving a "hinge" on one side (see note)

2 red onions, thinly sliced

2 avocados, each pitted, peeled, and sliced into 8 pieces

4 limes, each cut into wedges

Cayenne pepper, if desired

Place refried beans in a microwave-safe dish and heat in microwave until warmed through.

Spread warmed beans along the inside bottom of cut bread.

Using tongs, add about 1/3-pound of prepared pork carnitas on top of beans.

Ladle sauce over meat and garnish with sliced onion and 2 avocado slices.

Squeeze a wedge of lime over all.

Close sandwich and place on serving plate. Ladle more sauce on top of sandwich until it runs onto the plate.

Top sandwich with more onions and garnish with additional lime wedge.

Sprinkle cayenne pepper on top for maximum heat, if desired.

Repeat process using the remaining ingredients.

Note: A bolillo roll is the traditional bread on which a tortas ahogadas is served. Bolillo rolls resemble a football. Bermudez buys his bread at Osuna Bakery in Kansas City, Kansas.

Jazzy B's

SOCIAL

🌐 jazzybsdiner.com 🐦 @JazzyBs1 **f** @JazzyBdiner

SUMMARY

Brandon Simpson is an OG in Kansas City's food truck scene. He launched Jazzy B's gourmet food truck in 2010, just as the craze was gaining momentum nationwide. He serves up classic Kansas City-style BBQ while keeping the menu fresh with surprises. This veteran food truck owner also co-leads the fabulous and free semi-annual food truck workshops at the Mid-Continent Public Library.

STORY

Simpson is one of the key figures in Kansas City food trucks. He has been on the road since 2011, and has helped many food trucks get started on the right foot. Don't be fooled by his short Q&A responses below, he likes to chat – when the time is right. We caught up with him when he was busy, but if you meet Simpson out in the wild when he isn't serving an unending queue of customers, he'll chat your ear off! This is what makes him a long-standing, successful part of the food truck community: he takes business seriously, but is also very personable.

Simpson considers both Waterloo, Iowa and Kansas City, Missouri as his hometowns. After graduating from Grandview High School in Missouri, he went on to pursue his studies at Kansas State University and Northwest Missouri State University.

He made a career of selling pianos, but got to thinking about opening up his own food joint. He set the goal of opening a restaurant, though was not sure where to set up shop. Just as the food truck craze started to pick up a bit of steam in the U.S., he thought this unconventional business could help him identify the optimal spot to open his brick-and-mortar restaurant. Simpson's menu inspiration comes from "Just me playing in the kitchen,

wanting to change folks minds of what BBQ can be," he says. Simpson helps co-lead the Mid-Continent Public Library's full-day food truck seminars, and once told the crowd that Kansas City helped choose his menu. He was referring to the fact that he tested menu items that he thought up while tinkering around in the kitchen. Now, his top selling items are brisket tacos, crab cakes, "Armadilla eggs," smoked fried chicken, burnt ends, and shrimp po' boy.

There were many times Simpson thought of throwing in the towel. He said, "There is always something. Most of the time I was just worn out." At the end of the day, what keeps him motivated to stay in the game is his two kids.

Q&A

DO YOU HAVE MORE OF A SWEET OR SAVORY PALATE?
I would say both, depending on my mood

ARE YOU AN EARLY RISER OR NIGHT OWL?
In this business you have to be both to get the job done

PHONE CALL OR TEXT?
I prefer call, but texting helps me remember

WHEN DRIVING, DO YOU LISTEN TO MUSIC, PODCASTS OR NOTHING?
Music, always

WHERE IS YOUR FAVORITE PLACE TO VACATION?
Anywhere warm!

WHERE IS YOUR DREAM VACATION SPOT:
 Some little remote village with awesome food

WHO INSPIRES YOU?
My wife and kids

WHAT DO YOU DO WHEN YOU'RE NOT WORKING ON YOUR RESTAURANT OR TRUCK?
Work on the farm, or watch TV

FANTASY DINNER PARTY, YOU'RE HOSTING. WHO ARE THE GUESTS?
My two grandmothers.

YOU CAN ONLY EAT ONE DISH FOR THE REST OF YOUR LIFE. WHAT IS IT?
Anything from the sea

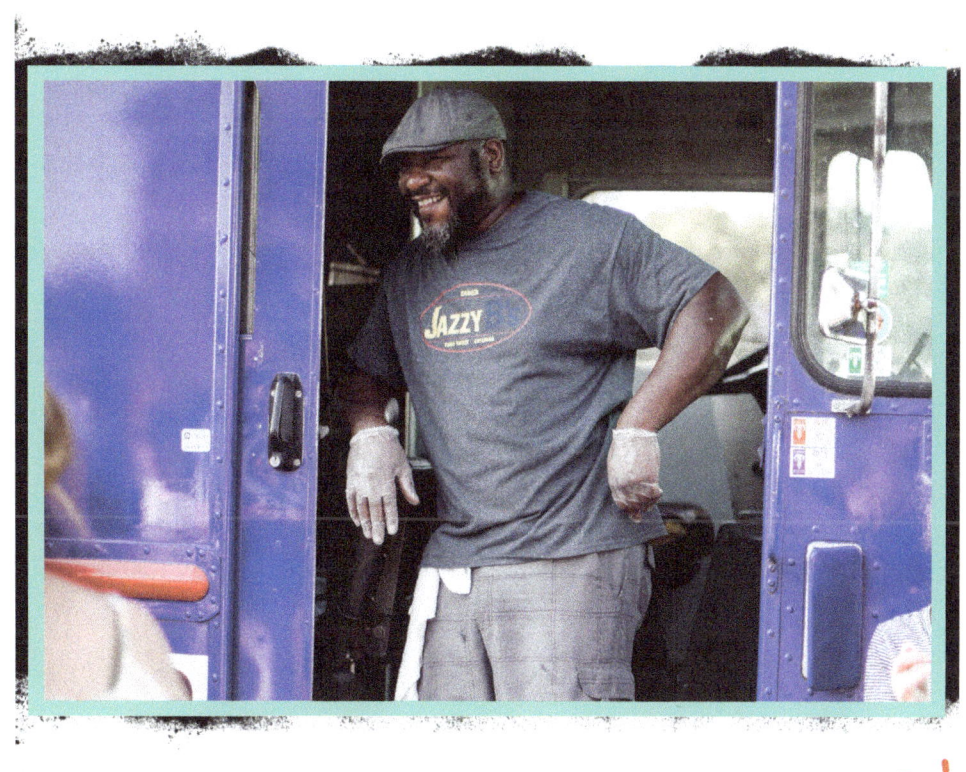

Bacon Jalapeño Poppers

This is my take on Simpson's famous Armadilla Eggs. For the real deal, find Jazzy B's diner or food truck.

6 jalapeno peppers

4 ounces cream cheese, softened

2 tablespoons shredded cheddar cheese

6 bacon strips, halved widthwise

1/4 cup packed brown sugar

1 tablespoon chili seasoning mix

Preheat oven to 350 F.

Cut jalapenos in half lengthwise and remove seeds; set aside. In a small bowl, beat cheeses until blended. Spoon into pepper halves. Wrap a half-strip of bacon around each pepper half.

Combine brown sugar and chili seasoning; coat peppers with sugar mixture. Place in a greased baking sheet.

Bake at 350 F until bacon is firm (about 15-20 minutes).

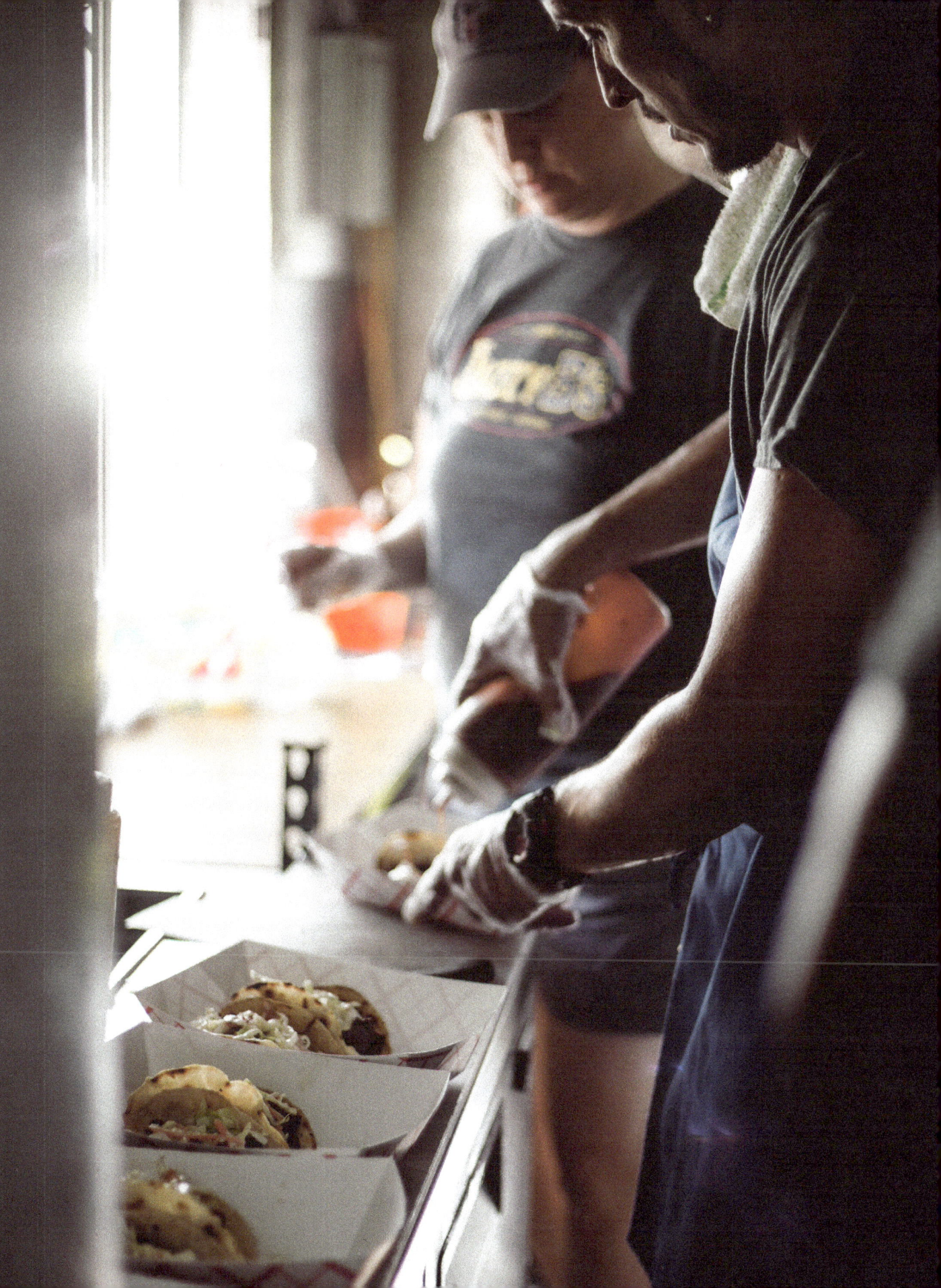

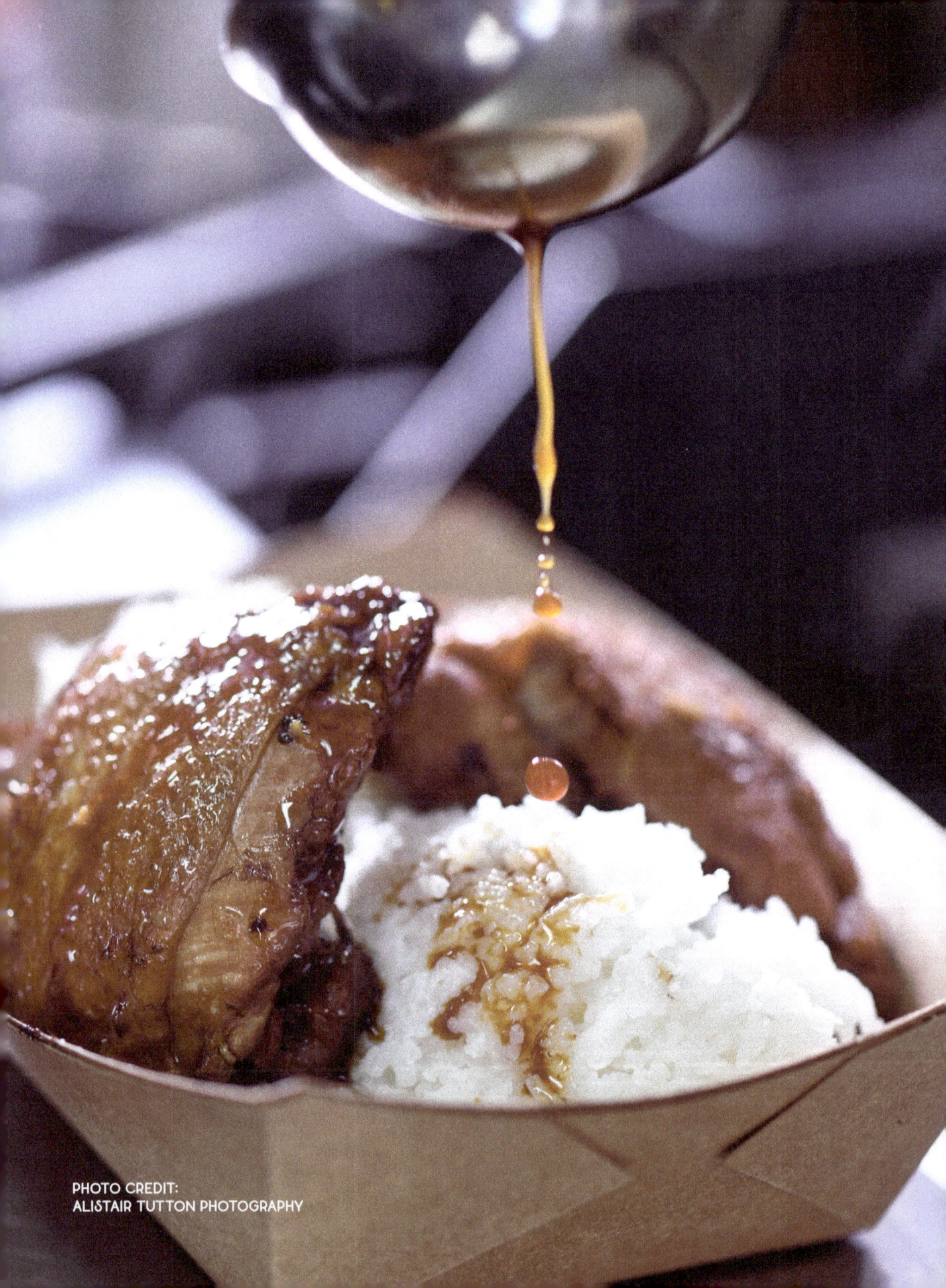

PHOTO CREDIT:
ALISTAIR TUTTON PHOTOGRAPHY

KC Pinoy

SOCIAL

🐦 @KCPinoy 　　f @KCPinoy 　　📷 @KCPinoy

🧭 kcpinoy.com

SUMMARY

KC Pinoy is an authentic Filipino food truck run by Chef Chrissy Nucum.

STORY

If you ever have the blues, spend five minutes with the owner and chef responsible for the super popular KC Pinoy truck, and you'll be giggling with her before you know it. Though Nucum is notoriously quite shy, it just takes a question about her menu (or comedian Jo Koy) for her to erupt in stories and smiles.

"When I first moved here, the Sprint Center was still being built. The whole Power & Light District was a ghost town, boarded up, lots of empty buildings. There weren't as many restaurants. I used to have bagels shipped from Jersey because I couldn't find a good bagel here!" Nucum remembers.

Nucum was born and raised in the Metro Manila area of the Philippines. Her family is from Pampanga, an area known for good cooks. "It's kind of like the Italy of food," she grins. Nucum earned a degree in psychology at the University of the Philippines, then moved to the U.S. starting out in Bloomfield, New Jersey then moving to Kansas City in 2007. She worked a series of jobs, from recruiting and human resources roles at a private jet company, to temp and sales positions at a Kansas City internet security firm. She recalls having a tough time finding a good job in Kansas City, then it took some time to warm up to coworkers culturally. "They'd ask how my weekend was and I'd give them a one-word response. That was East Coast-style; they weren't into small talk."

Nucum definitely acclimated well to the chatty Midwest way. When she began dating in the U.S., she also started a blog to tell of her tales of one-drink dates that never seemed to go anywhere. To say Nucum was an early adopter in the blogosphere is an understatement. (Unfortunately her dating blog is now unpublished, much to my dismay.) Her first date with her now-long-time boyfriend was at the late Harling's on Main Street.

While her boyfriend was away for work in Boston, Nucum found herself in a situation she is not a fan of: alone in the dark. "I'm afraid of the dark, so I stayed up with the lights on watching the Cooking Channel. They had a food truck show on about food truck owners in Miami. I Googled 'how do you start a food truck' while I watched. There were tons of articles and YouTube videos on the subject, such as the Business of Food Trucks class here in Kansas City. They have a two-hour video and I watched it start to finish, just getting up to get water. This was the light bulb moment for me," Nucum remembered. "I did research on Kansas City regulations, the local fleet, what food is being offered in food trucks here. I finally went to bed, then woke up the next day and told my boyfriend I wanted to start a food truck. That was in June. On the 4th of July weekend I asked a chef friend how hard it is [to work in the industry]. The chef said it's all about your mindset and setting your expectations. I took a free workshop from the SCORE organization at University of Missouri – Kansas City. There were 18 other budding small business owners. When I got home, I filed for my LLC"

Nucum always loved and enjoyed food, and her fondest memories with family involved cooking. "Life in the Philippines revolves around food. The joke is at breakfast you're talking about where to go to lunch, and at lunch about what to do for dinner," Nucum jokes. At first she thought about doing her food truck part-time so she could also make a paycheck, but soon thereafter decided she had to be all in.

The truck concept started out with a condiment: atsara, which is pickled papaya, it is on every dish she puts out. All recipes are Nucum's

grandma's, she says, "I wanted to stay away from Filipino classics that non-Filipinos know like lumpia and pancit (a noodle dish). I wanted to introduce KC to traditional foods they haven't tried."

Her first day out was First Friday in the West Bottoms. "I had no idea what we were signing up for or how much to prep," she recalls. "We had a line two blocks long, and ran out of food. We ran out of rice! So embarrassing for Asian truck," she laughed. "That's never happened since. Still, people bought the meat just to taste the food. It was insane how many people showed up. It was so nice to see a long line. My biggest worry was no one would come!"

Chicken adobo is now the most popular item on KC Pinoy's menu. "People ask for it when it's not on the menu. Nucum compares her secret ingredient to an Italian family's gravy. It's the same recipe her Grandma made when she grew up, and BOY did it take a big effort to get the recipe from her grandmother! Like many grandmothers, Nucum's granny kept her recipes to herself. "She was the only person who knew the pickling ingredient ratio for the atsara. I visited her in 2012 and asked her to share it. It was like pulling teeth to get it. I told her to pass it down so it doesn't get lost, and I'd keep it a secret too. Grandma had to think about it. Finally she wrote it down. I had to convert everything from metric. Now I am the official family atsara maker in the U.S. and ship it to New Jersey for family."

When she moved here, Nucum says there were no Filipino restaurants. Now, there's at least three to serve Kansas City's growing Filipino population. "There are a lot of Filipinos in Kansas City who miss home cooking, and a lot of second-generation Filipinos who never learned to cook it but appreciated authentic Filipino food. It is fun to educate people on Filipino food. Kansas City folks will try anything if it looks really good." When thinking of how this group affected her business plan, she said "Many Filipinos are such good cooks, they rarely eat out. I had to adjust my business plan and menu so it appealed to Filipinos and non-Filipinos alike." When thinking of traditional Filipino dishes that may strike the average Kansas Citian as odd, she recounted, "There is a chopped up pigs ears dish

called sisig. The dish started out from Pampanga (where her family is from) near the Clark Air Base. "The kitchen in the air force would throw out pigs' heads. A woman decided that was wasteful, so she collected the heads and grilled them, chopped them up, and served on a sizzling plate. Sisig means to snack on something sour. Southeast Asian cuisine is sweet and sour. In a Filipino home you either have a spicy vinegar or garlic vinegar, and soy sauce. Back in the day there was no refrigeration so they pickled things to prepare the food." When you visit KC Pinoy, you will see a smorgasbord of these infused vinegars and soy sauce.

One of KC Pinoy's first big supporters was the Filipino Association of Kansas City, a group of 500-600 members based out of Overland Park. They would hire Nucum to cater events and she credits them with being very encouraging. "They always invite me to participate in their Taste of Philippines event," she added.

Also encouraging to Nucum is what she calls her "repeat offenders," or her loyal group of fans who mark the days on their calendars when she will be serving up food at public events.

As Nucum is crossing the three-year threshold of her business plan, she said in some respects she's ahead of her plans, as she's already planning to open a restaurant. Some expensive truck repairs have set her back in 2017, her third year, but she's cautiously proceeding, keeping an eye out for the right space.

When asked if she has any tips for budding food truck owners, she recommends, "Always surround yourself with people who know their sh*t. I hired a line cook that has worked the line in a restaurant. It's amazing to learn from people who know what they're doing. Also, always have a towel ready to dab your sweat from your brow. You do not learn that watching TV cooking shows."

After three years on the road, one moment still fills Nucum with pride, "We went to a Montessori school in Platt County that invited us for

events. One item we served was a purple yam and cheese ice cream that comes in a little cone. A little girl was sitting on her dad's shoulders and wanted the ice cream. The following year, the little girl came back and her dad said she was waiting all year for the ice cream again."

Q&A

FAVORITE PLACE TO VACATION:
Maui. It reminds me of home (minus the 22 hour flight). I am turning 40 in 2019, and am hoping to go to Barcelona, with but the restaurant, we will have to postpone that trip.

DREAM VACATION SPOT:
Italy! I've never been. I've been told I need to try Mexico. I have travelled all around Asia because it was cheap from the Philippines.

A FAVORITE RESTAURANTS IN THE KANSAS CITY AREA:
Bunn Mee Phan in Gladstone. They are on North Oak, but moving to bigger spot. It's the best bahn mi I've had outside of Vietnam. They do pâté and head cheese. They're unapologetically Vietnamese. Also, Pancho's for cheap, delicious Mexican food. It's my 24-hour guilty pleasure.

A TV SHOW YOU'VE LOVED TO BINGE OR A GUILTY PLEASURE TV SHOW:
I am an awful baker, so I love watching baking competitions like The Holiday Baking Competition. They have 10 master bakers making beautiful pastries. I am going to Philippines for three and half weeks as research for my restaurant; I'll be meeting with restaurant owners and chefs to get some inspiration on restaurant design and menu. I want to learn how to make Filipino breads so I also enrolled in baking class.

WHAT WAS THE LAST COSTUME YOU WORE FOR HALLOWEEN?
Ina Garten - I had the pearls, chambray shirt with popped collar, the whole nine yards! If I ever win the lottery, I will buy the house next to hers so I can be her neighbor.

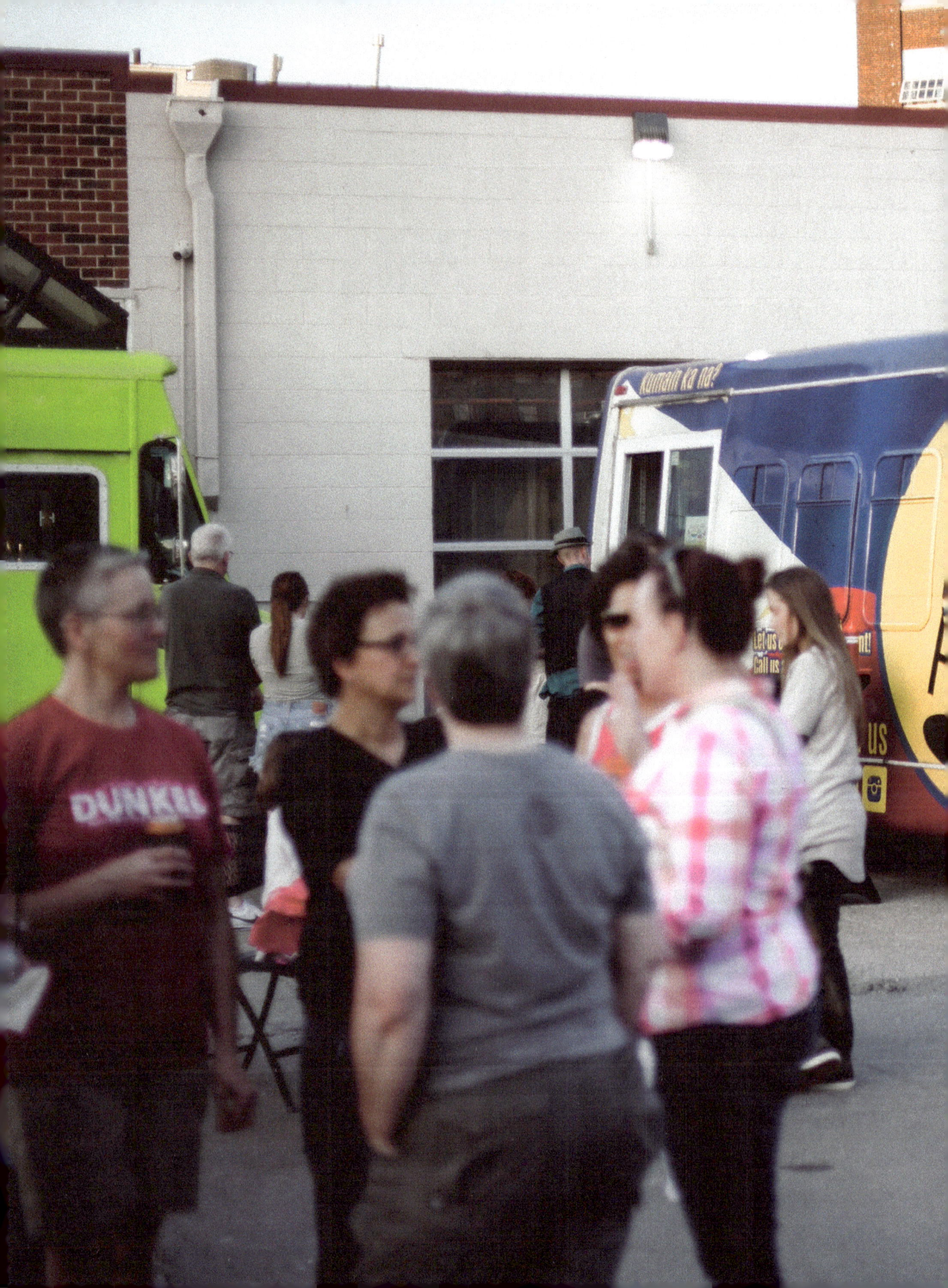

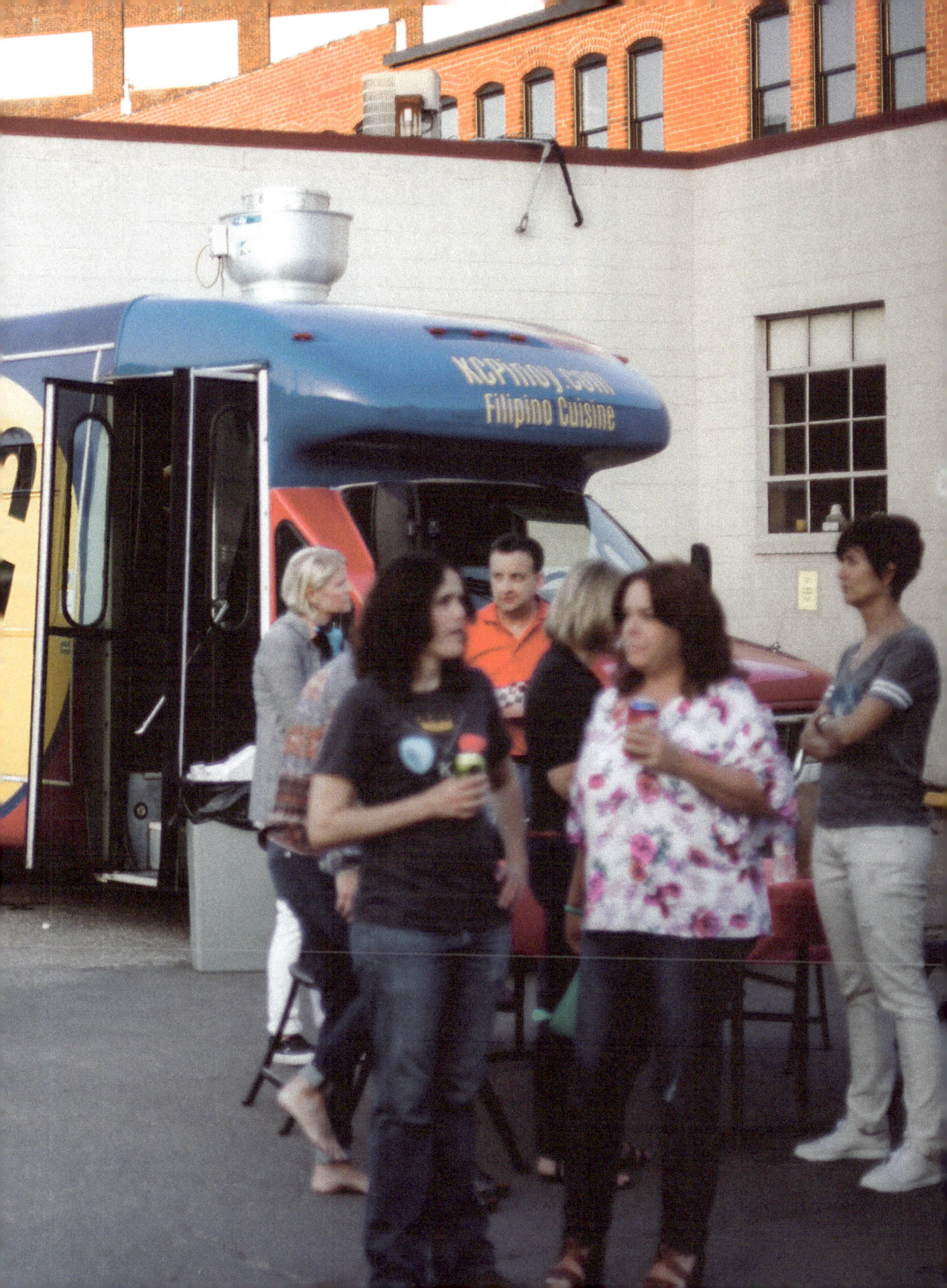

LAST PODCAST YOU LISTENED TO:
Filipino comic named Jo Koy - he stopped by my truck once. It was my first year on the road and he was in Kansas City. I put a call out on the KC Pinoy Instagram for people to message him to come to the truck. I lost it when he actually showed up at my window; I couldn't speak!

WHAT IS YOUR SUPERPOWER?
I have the superpower of sarcasm. The superpower I'd like to be is Flash so I can work even faster.

WHAT IS YOUR SPIRIT ANIMAL?
The sloth. I would love that life. It's not my life at the moment; I have no time for down time right now.

PET PEEVE:
When someone says "I'd love your life working at lunch hour for 2 hours!" Whenever someone says that I think they do not know the half of it, spend 2 hours just washing dishes after work!

FANTASY DINNER PARTY, YOU'RE HOSTING. WHO ARE THE GUESTS?
Ina Garten, Hillary Clinton, Ruth Bader Ginsburg, Nina Simone, (first female president of Philippines) Corazon Aquino.

FAVORITE COFFEE SHOP:
Thou Mayest by Grinders

WHAT DO YOU CONSIDER YOUR GREATEST ACCOMPLISHMENT?
When non-Filipinos correctly pronounce my food. My goal was to share love of Filipino food with those who would not have known about Filipino food, so that's a sign of progress. Also, I am now part of a group of Filipino cooks and chefs in the area.

WHAT KEEPS YOU UP AT NIGHT?
My biggest worry is getting a phone call that someone has gotten sick from my food. I am very safe with food and I haven't ever gotten that call. Also the logistics of opening a restaurant.

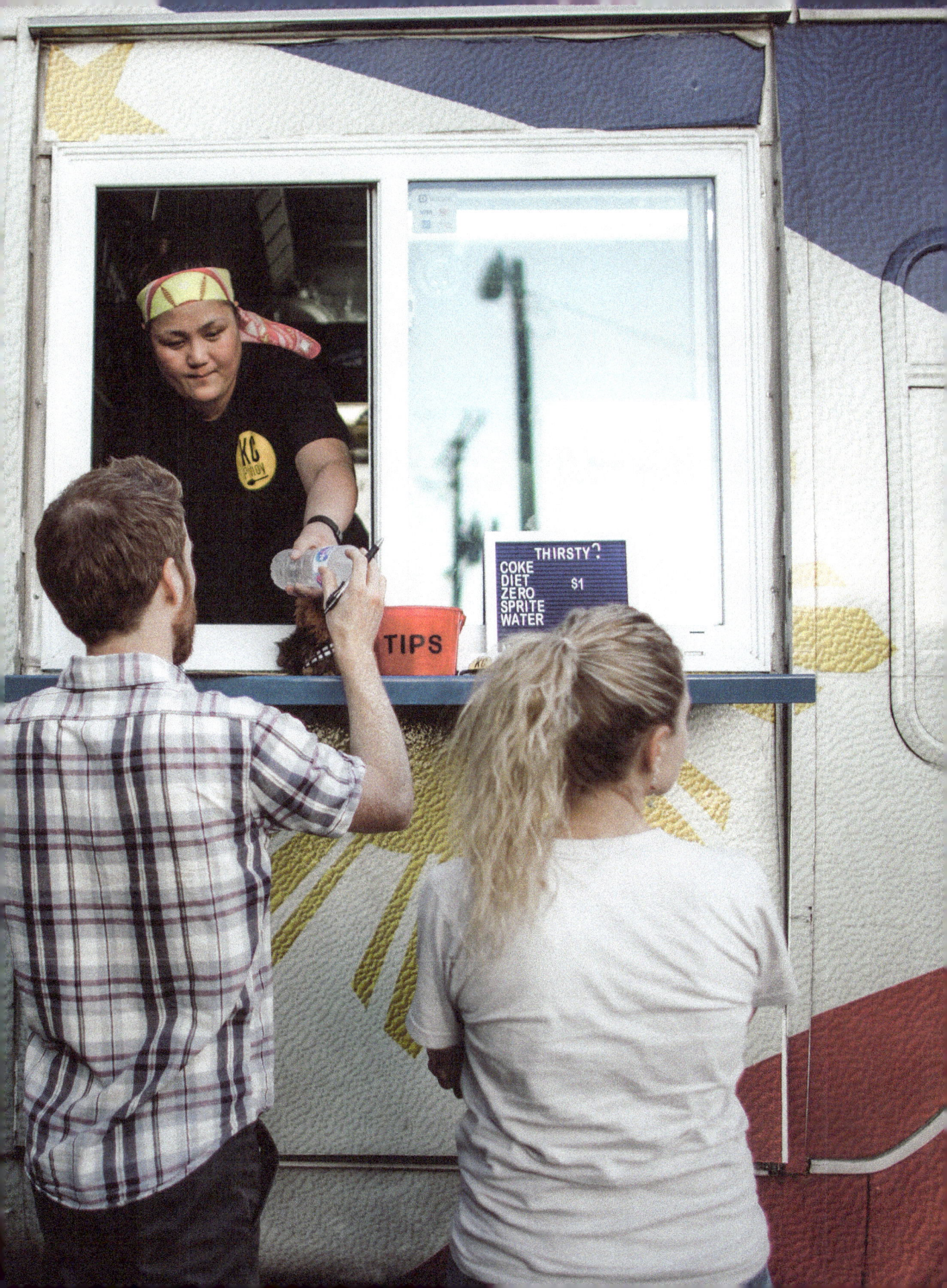

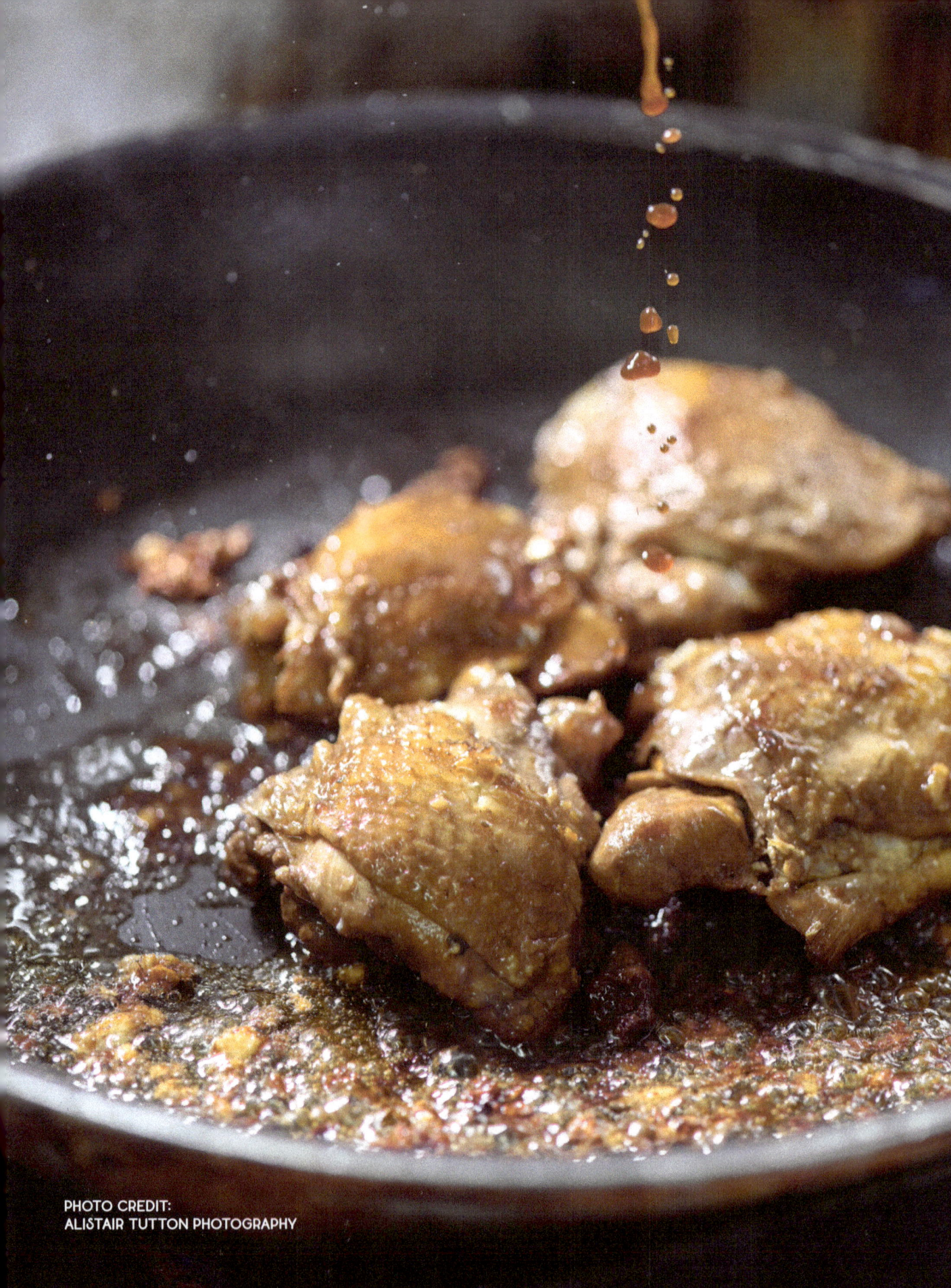

PHOTO CREDIT:
ALISTAIR TUTTON PHOTOGRAPHY

Chicken Adobo

This is KC Pinoy's #1 selling menu item

1/2 cup soy sauce

1 cup vinegar

2 bay leaves

1 teaspoons whole black peppercorns

1/2 teaspoon ground black pepper

1/2 teaspoon dried oregano

6 whole garlic cloves

6 garlic cloves, crushed

1 pound bone-in chicken thighs, skin/fat trimmed

½ cup of water

Combine soy sauce, vinegar, bay leaves, peppercorns, ground black pepper, dried oregano, and six crushed garlic cloves in a bowl.

Place chicken in a large pot, pour seasoning mixture over it, stir, and cover. Cook under medium-high heat. Bring to a boil.

Add 1/2 cup of water, stir, and bring to a boil. Simmer over medium-low heat.

Cook chicken until tender (30 minutes, stirring every 10 minutes).

Remove chicken from pot. Place on a plate.

Strain sauce — make sure that all peppercorns, bay leaves, and garlic have been removed.

Sauté 6 whole garlic cloves in canola oil until soft. Add chicken and pan fry until golden brown. Add adobo sauce and cook until sauce is reduced by half.

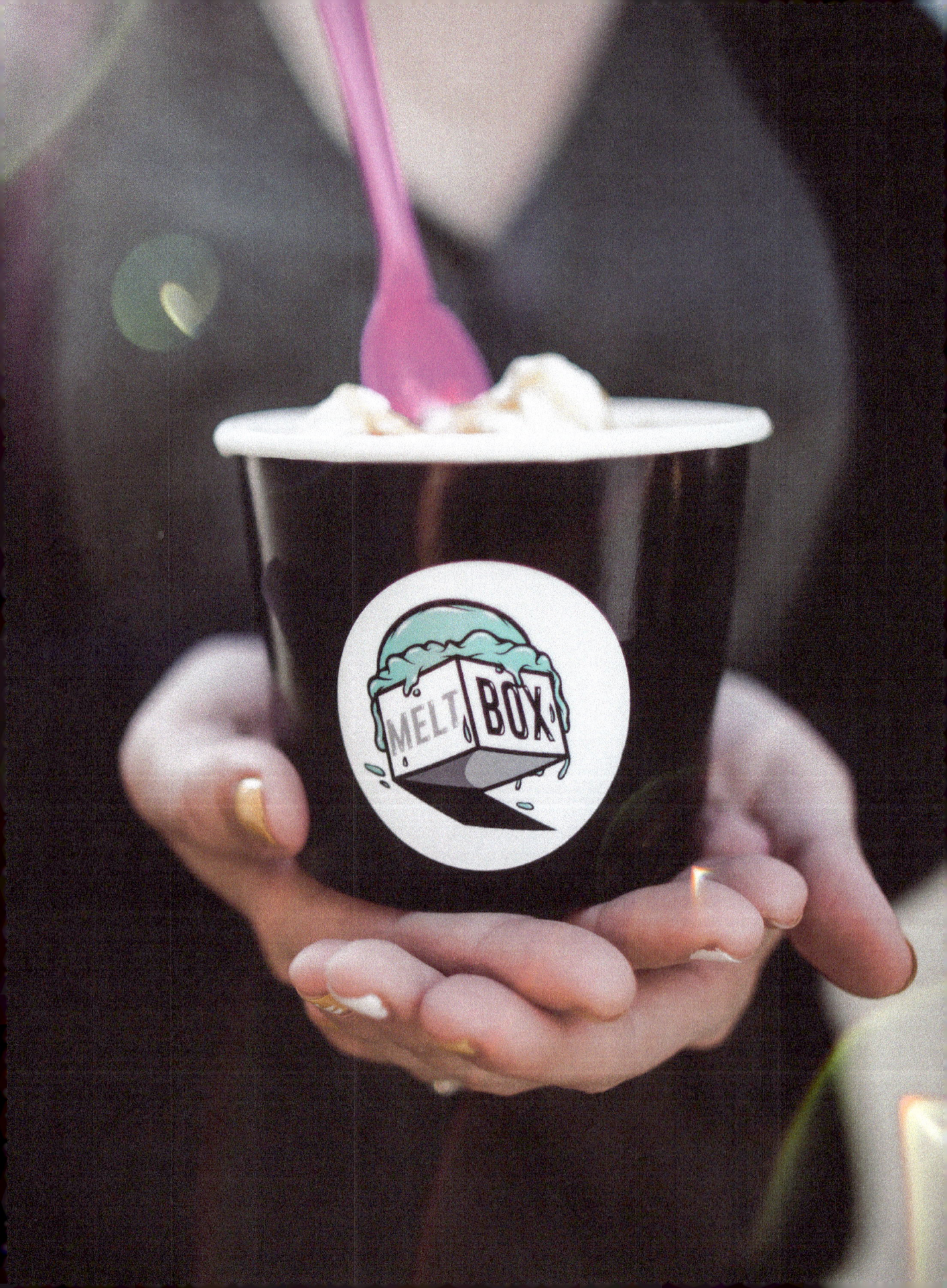

Melt Box

SOCIAL
🐦 @meltboxkc f @meltboxkc 📷 @meltboxkc
🧭 meltboxkc.com

SUMMARY
Melt Box is one of Kansas City's most Instagrammable food trucks, making grilled ice cream sandwiches that look like an empanada. The ice cream is sandwiched between sweet buns, sealed on all sides, grilled, then drizzled with whimsical toppings. The truck is owned by Parkville native Justin Tanner and Olathe/Overland Park native Chris Carrier.

STORY
If you ever need a shot positivity, chat up the boys of Melt Box KC. They are two people you want to spend time with just so their refreshing optimism rubs off on you.

Their success is, in some ways, perplexing. Neither Tanner nor Carrier has a degree in culinary arts, spent time in food service, or even considers themselves foodies. Their decision to launch the truck occurred in the span of just three text messages. That said, their past experience did lend itself to this style of business: Tanner owns an auto collision repair shop and Carrier has a degree in small business and entrepreneurship. Bingo. These buds wanted to work together, put their skills to use towards what seems like a natural fit.

Tanner had a one-year-old child and full-time business to take care of, and Carrier had a child on the way. The two spent a year building the truck in the spare time they could squeeze in. Start to finish, it took a year and a half to get the truck on the road in May of 2016.

The one (key) element that was missing was the food. What would they serve? Tanner is an avid traveler and came across sweets shop in Europe that stuffed sweet buns with ice cream. It is definitely not something

you see every day here in the U.S. Tanner used this as inspiration, then added some flair: he supersized the treat and add playful mix-ins into the ice cream, as well as drizzles and toppings to sprinkle on top. He and Carrier nicknamed this signature treat the Melt Monster. Fun fact: each one takes about three minutes to make and is totally customizable.

When you first see the truck, the design itself is extremely impactful. It represents everything their menu does: extreme whimsy, imagination, and color. Tanner's good friend and customer Laedan Galicia is a graphic designer; Galicia outfitted the business with unforgettable graphics.

"We have a good concept, let's roll with the truck. See where it takes us," the two agreed once they landed on the concept.

Only 30 percent of their sales come from their signature Melt Monster ice cream sandwich, but it's the truck's most photographed item on social media. Dishes like this that look so unique and colorful are naturally shared a lot, which what led many Kansas Citians to seek out the truck soon after launch.

The hipper and younger the crowd, the more Melt Monsters they sell. Though with your more mixed crowd, they sell more scooped ice cream. The guys are diligent about sourcing top-notch ingredients. In fact, it's not just their Melt Monster that's famous, the sweet buns that make them are from highly coveted Dolce Bakery. The ice cream comes from America's dairy capital: Wisconsin.

The flavor combinations and names they've imagined for their creations do not disappoint:

Yippee Skippee: peanut butter ice cream with salted caramel ripples, brownie chunks, and chocolate covered pretzels

S*#t Just Got Serious: smooth salted caramel ice cream brimming with rich sea salt fudge and salted cashews

Munchie Madness: sweet cake batter ice cream swirled with a salted caramel ripple and brimming with Oreos, M&M pieces, and peanut butter cups.

The truck launched in May of 2017, and the food truck season typically only lasts through October-ish. So, they had just six months on the road to test their concept before their first season came to an end. "After about a month and a half, we knew we had something special," said Carrier. The two maintained full-time jobs during their first season; the truck was a side hustle but they are enthusiastic about growing as long as Kansas City keeps up the mutual love-fest.

Tanner and Carrier said there was certainly a learning curve during those first six months. Presentation was something that took some trial-and-error. On a more basic level, learning inventory and operations were big (with an emphasis on the inventory, they say). Even with all these obstacles, they were seeing signs of success from the get-go.

"A lot of people overthink it," Carrier and Tanner said of what makes a great food truck concept. The way they wrapped their minds around it was by thinking of the business in terms of its various parts: great food, a reliable vehicle, consistent marketing, assigning each one to whichever partner was most suited for managing it. Once they divided out responsibilities, they said it was key to trust their business partner and treat them with kindness and patience, especially while they were both still learning.

If the success keeps up, Carrier and Tanner have thought about expanding their fleet or potentially opening up a brick-and-mortar shop. For now, they're enjoying getting to know their budding business.

Q&A

WHAT'S YOUR FAVORITE PLACE TO VACATION?

Justin: California and Wyoming
Carrier: Family vacations in Florida

WHO INSPIRES YOU?

Tanner: Chris always smiles and doesn't take much convincing because he trusts me. It's a big component in our relationship, and in our partnership. Trust is very important.

Also, my parents. You have to stay positive. There are days I want to smash my head into the wall and days I feel fantastic about my businesses. Mom and Dad are not business owners, but they are hard workers and raised me to be aggressive about my dreams.

Mom is a no BS kind of person and taught me to live with a fire inside me, which is what fuels my businesses. My dad is a hard worker and good influencer on how to be a good man, save money, and be good to your family.

Carrier: I'd have to say my parents too. My mom owns her own business, and my dad has worked at the same company for 30 years. Super hard workers. Their philosophy was do whatever you want, and success will follow. They're my moral support when things get really tough (and they do).

Not to be cheesy, but Justin inspires me too. He is a business owner, now has two businesses, and a real entrepreneurial spirit.

WHAT'S YOUR FAVORITE LOCAL RESTAURANT?

Tanner: Succotash for breakfast, brunch, and lunch. Port Fonda. Bier Station.
Carrier: Grinders

WHAT'S YOUR GO-TO GUILTY PLEASURE TV SHOW?

Tanner: Stranger Things, Making a Murderer
Carrier: Breaking Bad, House of Cards

WHAT WAS THE LAST COSTUME YOU WORE ON HALLOWEEN?
Tanner: Last year I was Gru from Despicable Me because my kids love that movie.
Carrier: It was so long ago I can't remember! Definitely rounding in on 20 years costume-free!

A FAVORITE INSTAGRAMMER YOU FOLLOW
Tanner: Entrepreneur and self-professed car nerd Andy Frisella, Randall Pich, founder and CEO of Live Fit Apparel
Carrier: Car builders, Andy Frisella, Jocko Willink, Gary Vaynerchuk, and Andy Nguyen of Afters Ice Cream.

LAST PODCAST YOU LISTENED TO?
Tanner: Andy Frisella's business podcast MFCEO Project and Gary Vaynerchuk's podcast
Carrier: True crime podcasts like Criminal and Sh*t Town. Also, lifestyle podcast The Minimalists.

PET PEEVE
Tanner: Lazy people, and lack of work ethics. Everything revolves around work in my brain. Downers on Facebook and Instagram. Trolls!
Carrier: Lazy people FTW. Also, people who do not clean spoons. *gives Justin the side-eye*

Sweet Buns

1/2 cup milk

1/2 cup sugar

1 1/2 teaspoon salt (can use less)

1/4 cup butter, melted

1/2 c warm water (105-115 degrees)

2 package active dry yeast (approximately ¼ ounce)

2 large eggs, beaten

4 1/2 cup all-purpose flour, may need a bit more or less, see directions

Additional butter for coating bowls used and brushing on tops of baked rolls

Scald milk (bring just to a boil and remove from heat immediately).

Stir in sugar, salt, and butter. Set aside and allow to cool to lukewarm. In a large bowl mix warm water and yeast. Stir until dissolved. Stir in lukewarm milk mixture, beaten eggs, and half the flour. Beat until smooth.

Add remaining flour gradually, mixing as you go. Note: You may need a bit more or less than the total 4 1/2 cups called for in the recipe, depending on the humidity and other factors. Your dough should be elastic and slightly stiff but not dry.

Turn dough out onto a floured board and knead until smooth and very elastic. This usually takes 8-10 minutes.

Butter the inside of a large mixing bowl. Put dough in bowl and turn dough over a couple of times to coat it all with the butter.

Cover bowl and place in a warm place so it can rise. It will take about 1 hour to double in size. At that time, punch dough down and turn out onto a lightly floured board to shape.

Pinch off about 2-3 tablespoons of dough and shape into a ball.

Place each one in a buttered muffin tin or baking pan, barely touching each other - do not crowd rolls.

Cover prepared rolls and allow to rise in a warm place until doubled in bulk, again about 1 hour. Rolls should now touch each other.

Preheat oven to 375 F when rolls are about 10 minutes from being ready for baking.

When ready to bake place rolls in oven and bake for 20-25 minutes, or until lightly browned. Brush tops of rolls with melted butter immediately when removed from oven.

Allow rolls to set for at least 10-15 minutes before eating.

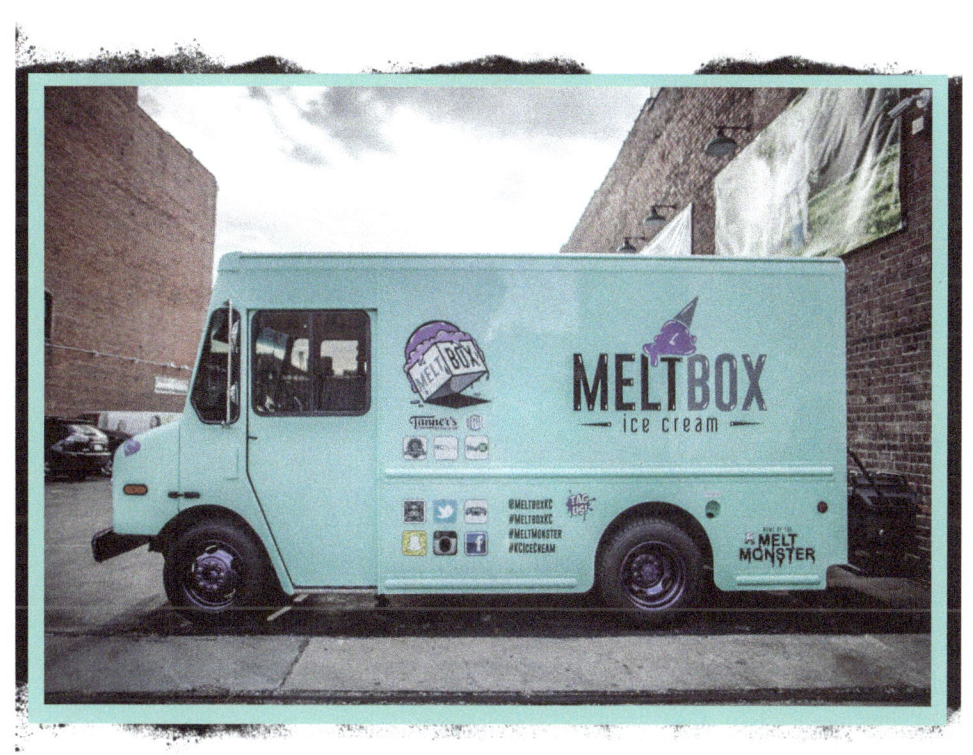

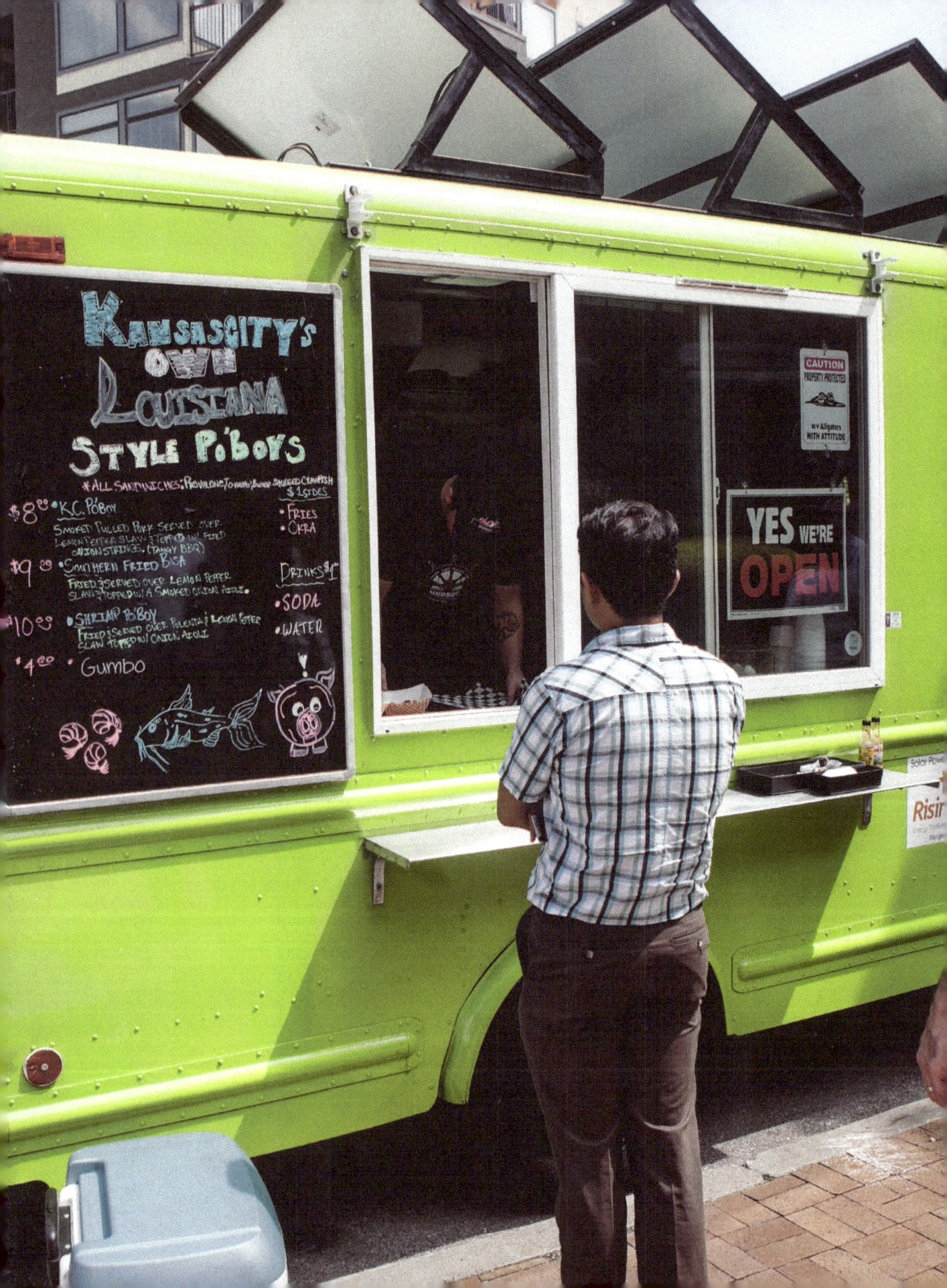

Mudbug Mobile Madness

SOCIAL
🐦 @mudbugmobilemad f @mudbugcajunpoboys 📷 @mudbugmobilemadness
🧭 mudbugmobilemadness.com

SUMMARY
Chef Chris Jones is best known in the Kansas City food truck scene for his solar-powered truck. Jones never considered himself much of a tree hugger, but he's a problem solver. With hopes of owning his own business and sharing his scratch-made Louisiana dishes with the community, a food truck seemed like the right way to do it. It was a long and winding road to get the truck permitted with innovative renewable energy, but he persisted. Jones could teach a master class in how to turn lemons in lemonade. Or a lemonade stand. Or a lemonade food truck and restaurant. This immensely kindhearted chef is no stranger to the hustle of the food service game, but his life changed after the untimely death of a dear friend.

STORY
Jones hails from Shreveport, Louisiana. Once he learned some cooking basics as a kid, Jones never stopped cooking. After years of catering for friends, family, and his church congregation, Jones developed a career plan.

"I always knew I wanted my own business - truck or restaurant. I had my own timeline. By 25 I wanted to be a sous chef. By 30, an executive chef, and by 35 own my own restaurant," he recalls. "At 26 I made executive chef. Then the housing market crashed and I lost a lot of money. That was baby Jesus saying, nope, not the time [to open a business]!"

To accomplish that plan, Jones moved to the "Paris of the plaines" at the age of 22. He worked at local eateries Hereford House, Pierpont's at Union Station, and a Golden Corral. Six years after moving to Kansas City, Jones met his now wife, an Arkansas native named Traci. "She

had three jobs when I met her. She was a part-time server [where I was working]. We courted for a few months," Jones smiled. He credits Traci for helping him to adjust to Kansas City winters, the likes of which he hadn't ever seen in Louisiana. "She helped me learn to drive in the snow!"

While the Great Recession put Jones' business ownership goals on hold, a close friend lost his life in a car accident.

"I had to assume responsibility for his business, including two restaurants. I didn't go through stages of mourning because I was responsible for his 270 employees. When the business sold, it killed me. I went into severe depression because I was finally able to mourn," Jones said. "Life's too short. When I lost Ben, his company changed and my future changed. It was a flash before the eyes and basically I've resisted all this timing taking that next leap of faith."

While battling depression, Jones knew he had to make a major change. "If I had kept going at that pace, I would still be down and out. I had to get focused on something. I went all-in four years ago." In 2014, Jones decided it was time to revisit building his own business.

And away he went! Jones delved into the research and design of his food truck business. Things were moving along smoothly enough until he approached a local business to build a generator cage for his truck. A generator cage would attach the high-end generator to the truck and help prevent the power source from being stolen. That was the last step; once he had the generator cage installed he could hook it up and be in business. Except that's not what happened.

When he consulted a couple local fabricators to help build the cage, they strongly warned him against it for a variety of reasons. "I thought to myself, 'How did I get here with nobody telling me I was screwing up?'" Jones asked himself. Jones wasn't screwing up. He was following typical food truck design plans, but these vendors urged him to reconsider

the power source. "I may have had a few too many beers while I sat and thought about how to solve this problem." While this power source works for most food trucks throughout the United States, Jones dreamed up an alternative that may be more cost-efficient and energy-efficient in the long term: solar power.

A few intense Google deep-dives later, Jones was admiring the design of some solar-powered trucks on the west coast. Many of those trucks had generators as a back-up source of power, but Jones didn't want that. Instead, he invested in a giant solar-powered battery that could power a small house for a day and a half.

"I got laughed off the phone by half a dozen engineers who didn't want to touch the project," he grins. It just so happened, he met an engineer from his home state of Louisiana who embraced the challenge. Keith Murphy with RisingSun EPC was on board.

It took time to work out the logistics of designing and installing the solar-powered food truck (six months, to be exact). There was a learning curve for both Jones and Murphy since this was uncharted territory for both of them.

While Jones and Murphy were figuring out how to power the food truck with solar panels, Jones has to make a living. "I did a few catering jobs to make ends meet," Jones said. However, financial responsibilities kept piling up. "I decided I needed to open a brick-and-mortar restaurant in 30 days. We opened on January 2, 2017."

Jones found out that his truck would be ready just one week after he launched Mudbugs restaurant in North Kansas City. Jones' attention was consumed by the restaurant, so it was another five months until the truck's maiden voyage. However, Jones was proud of the progress they made integrating renewable energy into the vehicle, even when comparing it to similar vehicles.

"We would look like the Flintstones next to the state-of-the art California trucks," Jones laughs. "I wanted the panels to always be standing up." That said, their solution was far from an old school, clunky system. The manufacturer of the components is a competitor of Tesla, and the very visible panels were intentionally not hidden like most solar trucks; Jones wanted them to be visible to attract passers-by and invite questions about their energy source. Jones received government subsidies for going solar, and said he will be running on free, clean energy after three years in operation. He even had a power station installed in his home that would replenish the battery in just a couple hours.

It wasn't until he went to the city that he got caught in a web of red tape. The city insisted that he use a generator for backup. They asked him what he would do if the solar power failed. Since the system was meant to power a small house for a couple days, and he'd be running a truck for less than half a day, Jones wasn't concerned. However, he asked them what other trucks do when their primary energy source runs out. They close up shop, right? He would do the same. Still, the city insisted that a backup generator was necessary. This back-and-forth persisted for a while, and Jones was getting desperate.

One day, Mayor Sly James caught wind of Jones' plans to run a solar-powered food truck and tweeted public praise for the innovative idea. The next day, Jones got a call from the health department giving him the green light to start serving.

Jones knew from the beginning what his truck concept and menu would be. He puts a creative spin traditional Louisiana dishes like po' boys and gumbo. It turns out, Kansas City has an appetite for anything he serves up. "Stingray, crawfish, shark, alligator, you name it," Jones exclaimed. Yes, even alligator. Today, Jones is managing both a successful restaurant and food truck. "We outgrew the restaurant in just eight months. We moved into a brand new build-out," Jones recounts of the hectic timing. Jones modeled the new restaurant after the food truck. "The

ordering window is greet station in both the truck and in restaurant. It's all meant to be
consistent so I can control labor costs, operating the restaurant just like the food truck. Every staff member is cross-trained to take orders, cook, etc. Teenagers and grown-ups alike. It makes for a great team, and guests appreciate it because they feel like they're getting above and beyond the norm."

At his truck, Jones says he could never feed 200 people in an hour because everything they on the menu is fresh and made from scratch. "It takes three mins to execute a meal. We can execute ten meals in three minutes." Based on his track record, customers are willing to wait for that fresh food, and they keep coming back. Jones advertises a weekly special based on what's fresh at the fish market, and when he runs out, that's it.

"Food trucks are a different game than restaurants. You have it beaten into you [in restaurants] to never run out of food. Food trucks are the opposite. At the end of the crowd, if you run out of food, and that's a successful day." Still, Jones says there have been times where he'd pack the truck to serve 150 people and only serve eight.

Like any owner of a service-based business, there are good days and bad. "We have chosen to make our livelihood by serving others. It's our job to try to help the angry couple," Jones says. Great customer service is core not just to his business, but to who Jones is a person.

"Here at our restaurant we have a lot of young people. I manage by empowerment. I allow them to spread their wings. Through selective hiring, we are able to retain staff. They like being part of something that's unique," he says of how he manages his staff. "Happy staff, happy guests. Great food and humble service."

Q&A

DO YOU HAVE ANY PETS?
We have Morkie named Lou, short for Louisiana, and two boxers, Nellie, and Zoe

WHAT ARE YOU DOING WHEN YOU'RE NOT WORKING?
Jones laughs and laughs; I got this response a lot from food truck owners since they're always working. I'm either at the restaurant, opening one, reviewing one, or eating at one.

DREAM VACATION SPOT:
Anywhere right now!

FAVORITE PLACE TO VACATION:
Ireland, we went there on Spring Break about six years ago

FAVORITE SPORTS TEAM:
I don't watch a lot of sports, but since I'm from Louisiana I root for the Saints

CHOCOLATE OR HARD CANDY:
Hard candy

COKE OR PEPSI?
Coke

SOMEONE WHO INSPIRES YOU:
A good friend that I lost named Ben Shively. He passed just before I began this journey. With the growth of his restaurant business, he remained humble the whole time.

FAVORITE TV SHOW:
I don't have much spare time to watch TV, but we do watch some Netflix.

FANTASY DINNER PARTY, YOU'RE HOSTING. WHO ARE THE GUESTS?
Tupac Shakur

IF YOU COULD ONLY EAT ONE DISH FOR THE REST OF YOUR LIFE, WHAT WOULD IT BE?
Mexican food

IMAGINE YOUR RADIO IS STUCK ON THE CHANNEL YOU LISTEN TO THE MOST. WHICH ONE IS IT?
Anything that plays music by [R&B singer] Tank

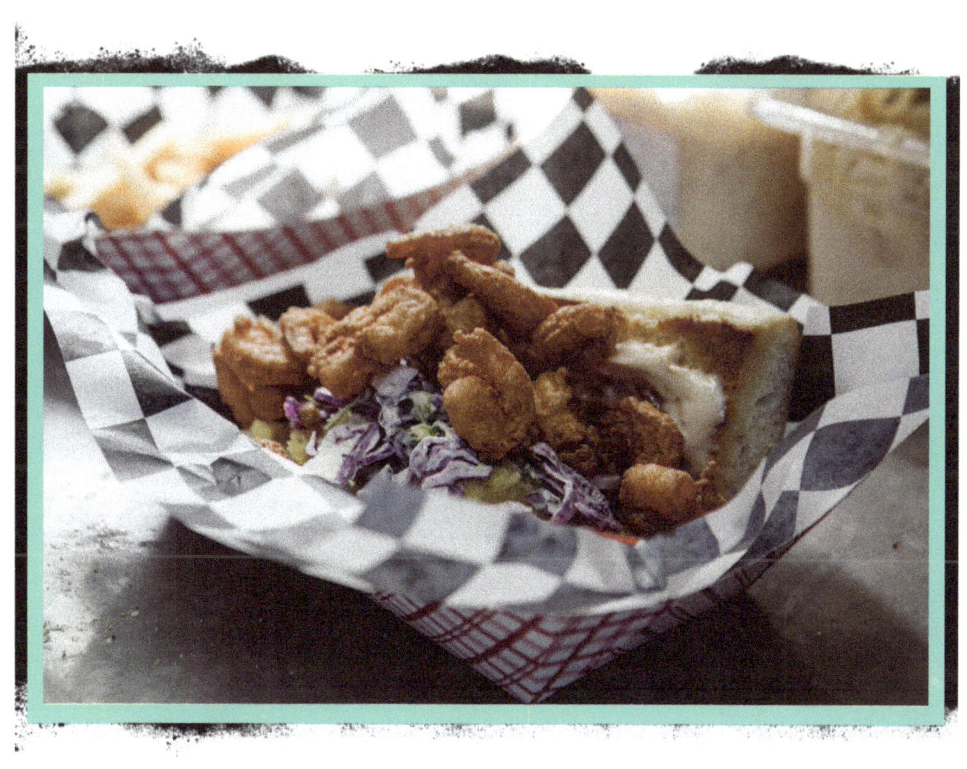

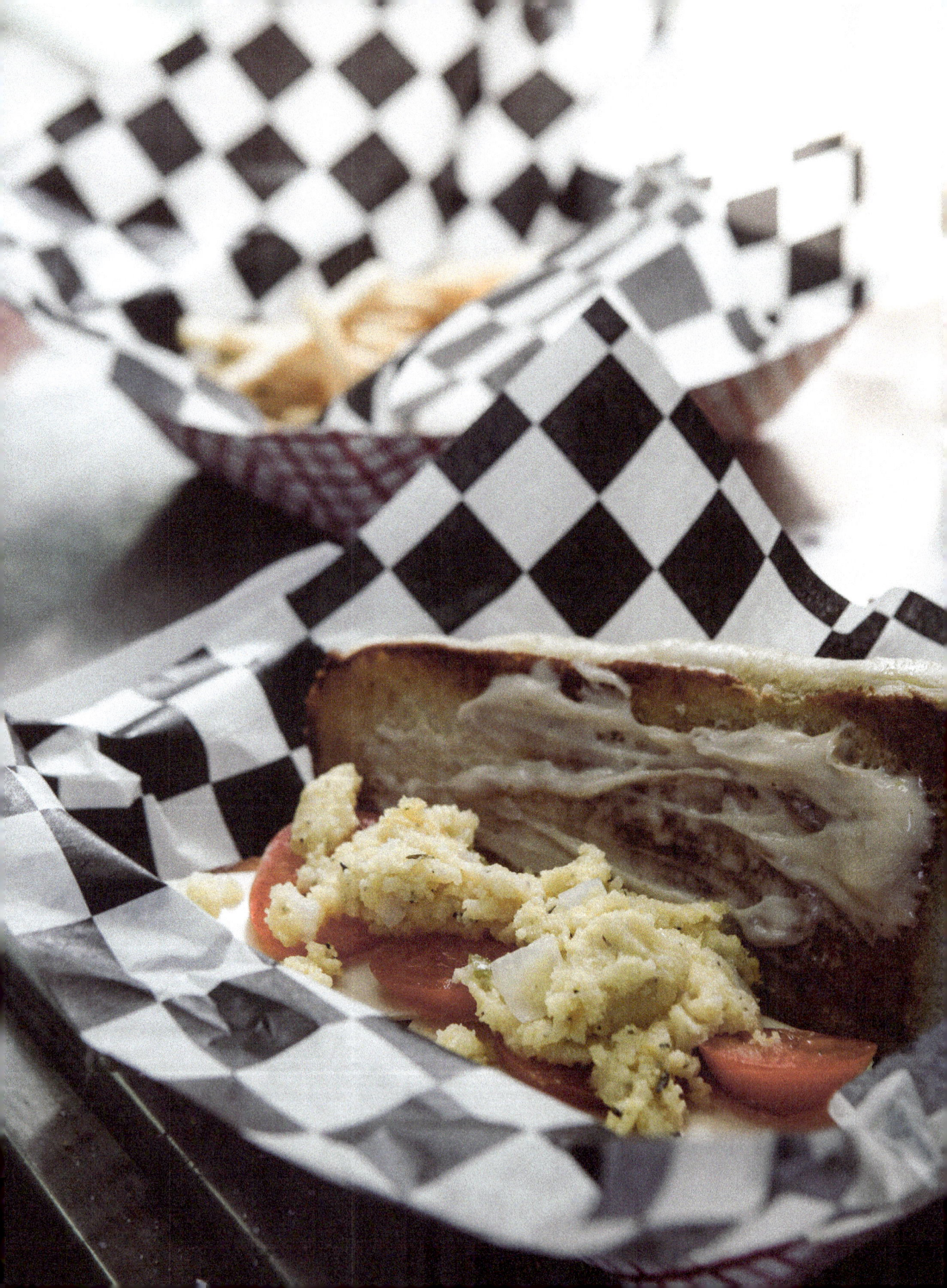

SAMPLE MENU

All sandwiches come with provolone cheese, tomato, and butter-sautéed crawfish (mudbugs).

KC Po'Boy
Smoked pork shoulder over a lemon pepper slaw. Topped with onion strings and tangy barbecue sauce.

Southern Fried Basa
Served over lemon pepper slaw and topped with smoked onion aioli.

Shrimp Po'Boy
Fried and served over polenta with a lemon pepper slaw. Topped with smoked onion aioli.

Gumbo: chicken and andouille

Seafood jambalaya

Side of okra

Polenta

8 cups water

2 cups cornmeal

2 tablespoons butter oil

1 tablespoon thyme

1 tablespoon garlic salt

1 teaspoon garlic pepper

1 tablespoon chicken base

1 onion, diced

1 bell pepper, diced

1 clove of garlic

2 ounces heavy cream

Boil onion and pepper until tender (approximately 3-4 minutes).

Add oil, thyme, salt, pepper, chicken base, and heavy cream.

Once boiling again, stir with a whisk and add cornmeal slowly.

Continue to stir until thick.

Slaw Dressing

1 quart mayo

1 tablespoon garlic salt

1 teaspoon pepper

4 tablespoons sugar

1 tablespoon vinegar

2 tablespoons lemon juice

1 teaspoon lemon seasoning

Combine all ingredients. Cover and refrigerate until needed. Toss with shredded cabbage and carrot to make coleslaw.

Plantain District

SOCIAL

🐦 **@PlantainDistKC** f **@PlantainDistrict** 📷 **@plaintain_district**

🧭 **plantaindistrict.com**

SUMMARY

Plantain District was the Cuban-inspired food truck brought to you by Rachel Kennedy. Their Cubano sandwich, as well as their plantain chips with a secret dipping sauce, earned Plantain District rave reviews and a cult following. Kennedy closed her food truck to pursue a plan to help fellow aspiring food entrepreneurs; she launched The Iron District, a shipping container food court in North Kansas City.

STORY

If you're looking for some solid #WCW inspo, look no further than Rachel Kennedy of Plantain District. Though she took her food truck off the road in 2017, she is already planning an inventive, exciting business to help our local food entrepreneurs get their start.

One of the reasons why fans gush about her food is also part of her business that gives her the most pride: they never open a can of anything. They make their own mustard and pickles, squeezed lemons and limes for days, and do everything in their power to make their food from scratch.

Kennedy opened up about having trouble with pregnancy a while back (she and her sweet husband are now blessed with two beautiful girls). While her road to motherhood was different than what she had anticipated, she's happier than ever and learned a lot along the way. She immersed herself into nutrition during this period of her life and came out the other side with a lot of research and knowledge she ended up compiling into a book to help other women in her same situation. This is where her steadfast dedication to scratch-made food began, and why it is core to her business.

Kennedy also has a degree in business and was dreaming of putting it to use while solving a problem: she wanted to bring an authentic Cuban sandwich made the good ole' fashion way (completely from scratch). But she didn't want to do it at a restaurant. "In a restaurant you have to be a ball-buster," she explained. "With a food truck, you can be yourself. We [women] have to prove ourselves. We get talked down to. It's hard." Kennedy and I talked about the old adage Michelle Obama referenced in a speech about women and minorities having to be twice as good and twice as fast to get half the distance.

One lesson Kennedy carried over from business school and applied to her menu was product testing. The product of any food truck is its food, and she approached it just like Fortune 500 companies approach their own product development: test and refine, test and refine, test and refine. Over and over and over until you get it right.

"I run menu items through a rubric," she explains. "Financial and marketing ruberics. Then, if it makes business sense, I test the idea. No matter how great of an idea you think it may be, you don't know until you test it. You also have to research who is and is not doing what you are planning on doing. If someone is already doing it, you have to ask yourself how you can improve upon it. No one in Kansas City was doing Cuban sandwiches like we remember them, so we aimed for that but also listened to the results from tests to improve them."

One surprise that came out of menu testing was that testers actually preferred Cuban sandwiches that did not have mustard. Since the mustard was not a fan favorite, they went to the drawing board to figure out how they could improve upon it. They created a green, herby secret sauce that fans love so much, they order a cup of it on the side as a dip for plantain chips. It is creamy like mayonnaise but is not mayo-based. (I tried to get my hands on the recipe for you. No cigar. You'll have to track down Kennedy at The Iron District to get a taste of it!)

Kennedy's truck is different than any other truck on the road in that no one else was doing Cuban food (also, it was a former SWAT truck). There are not even many restaurants in the area. (If you search Yelp for Cuban food in the area, you may get mostly Mexican and Spanish restaurants in the search results.) While this differentiator made Kennedy's truck a unique and interesting offering, not all Kansas Citians knew quite what to make of it. "Kansas City was kind of vanilla and not super ethnic," she remarked. "All of the young talent coming into KC with the new startups, that's helping."

Though she had concerns about how receptive Kansas City would be to this ethnic cuisine, word travelled fast about her homemade menu and fans flocked to her truck. She credits extensive testing for this success as well as the fresh ingredients, but also customer service: "Customer service is so important. It's way more than problem solving or fielding questions, it's listening." She said she would talk with customers as much as she could, and would even step outside the truck to gather feedback while her crew was taking care of the cooking. She found opportunities to get feedback from strangers and paying customers, not just friends and family.

The success she saw with the truck stoked her to dream about her next step, but that wasn't going to be a brick-and-mortar. "Opening a restaurant was never on our radar due to costs, overhead, and your back is against a wall," she explained. "We love the open-ended opportunity the food truck and shipping containers bring."

Shipping containers? She spilled the beans about the business: a lot in Northern Kansas City that would be home to renovated shipping containers. Each container would be a different restaurant. Some would be permanent, but there would also be regular leases and even very short-term leases for entrepreneurs who want to test their menu in the wild but are not ready to launch a full-time business yet. Many food truck owners report start-up costs between $25,000-100,000. Though there were a couple trucks in this book who may have been way under that level of investment, this range isn't atypical. This shipping container concept

could allow entrepreneurs to start at even a lower investment with lots of built-in guidance from the lot owners. This would allow the renter to focus on their food since Kennedy sorted out a host of ordinances, operational set up, and more.

When talking about who inspires her, she mentioned Beauty of the Bistro food truck owner Sidney Fish. "I emulated her," Kennedy smiles. "She has business principles, and she is great at what she does."

"We started the truck because we wanted something of our own. We didn't do it for money," Kennedy says. "Food trucks are physically hard work. I've never worked so hard in my life. But I also never had so much fun doing anything. We are family."

Kennedy continues to innovate and bring new, exciting concepts to the Kansas City food scene. Whatever she does in the future, I hope it always includes serving her secret sauce.

Q&A

WHAT IS YOUR FAVORITE PLACE TO TRAVEL?
Anywhere beachy with warm weather, Florida

WHAT IS SOMETHING ON YOUR BUCKET LIST?
Write children's books to support a cause. Grew up reading classics.

WHAT ARE SOME LOCAL RESTAURANT YOU LOVE?
Q39, Novel, Jarochos

WHO IS SOMEONE YOU ADMIRE?
James Herriot, who wrote All Things Bright and Beautiful. He was a veterinarian in Scotland in early 1900s. He is so hilarious.

DO YOU HAVE ANY PETS?
I had a great dane who was 14 years old, and passed away in September of 2017. I got him from a shelter at 2-3 months old. At his six-month appointment, he was up to my waist. His name was Scooter. He travelled with us to Ocean Beach, San Diego. He was so good with kids, even at 10 years old.

WHAT SELLS OUT FIRST:
Cuban sandwich. In a close second comes our plantain chips and special secret dip.

WHAT HAVE YOU TESTED THAT KANSAS CITY WASN'T READY FOR?
We thought about that beforehand and tested everything. We never had anything on the truck that wasn't a home run because we tested diligently before any menu item made it to the truck.

COOKING HACK YOU RECOMMEND:
Make pickles yourself! It's not as hard as it seems.

SECRET INGREDIENT:
We do not use anything from a box or can. We go through a LOT of fresh citrus juice. I'm there with bags and bags, juicing and juicing.

Plantain District Cuban Sandwich

Roast Pork (recipe follows)

Salt-cured ham

Local Swiss cheese

Scratch-made pickles

Cuban bread

**Mojo sauce (save some from marinade) or ghee*

**We use our famous sauce for the Cuban sandwiches; however, since the recipe was developed by us and it's our secret sauce, a Mojo sauce is a good alternative.*

Layer all components, brush ghee on both sides of sandwich and press in a plancha or panini press for a few minutes or until cheese is melted. The secret to our Cuban sandwich is using the highest quality ingredients and making items from scratch, such as the pickles and sauce.

Roast Pork

One 8-pound bone-in pork shoulder roast

1/2 cup minced garlic

2-3 tablespoons kosher salt

2 teaspoons dried oregano

Yellow onion, diced small

2 oranges, juiced

1 lime, juiced

1 lemon, juiced

2/3 cup olive oil

Score the pork, fat side up. Note: "Scoring" means to make shallow cuts on the surface.

Combine garlic through citrus juices in a blender or Vitamix. Slowly stream in olive oil. Save about 1/4 cup of marinade to add to sandwiches as sauce. Add pork and marinade to a large plastic bag and marinate, overnight if time permits.

Preheat oven to 350 F and let pork come to room temperature.

Roast pork in a covered non-reactive pan for 4 hours. Uncover and continue cooking for 30 or so minutes to brown skin.

Use pan juices to add to meat after slicing.

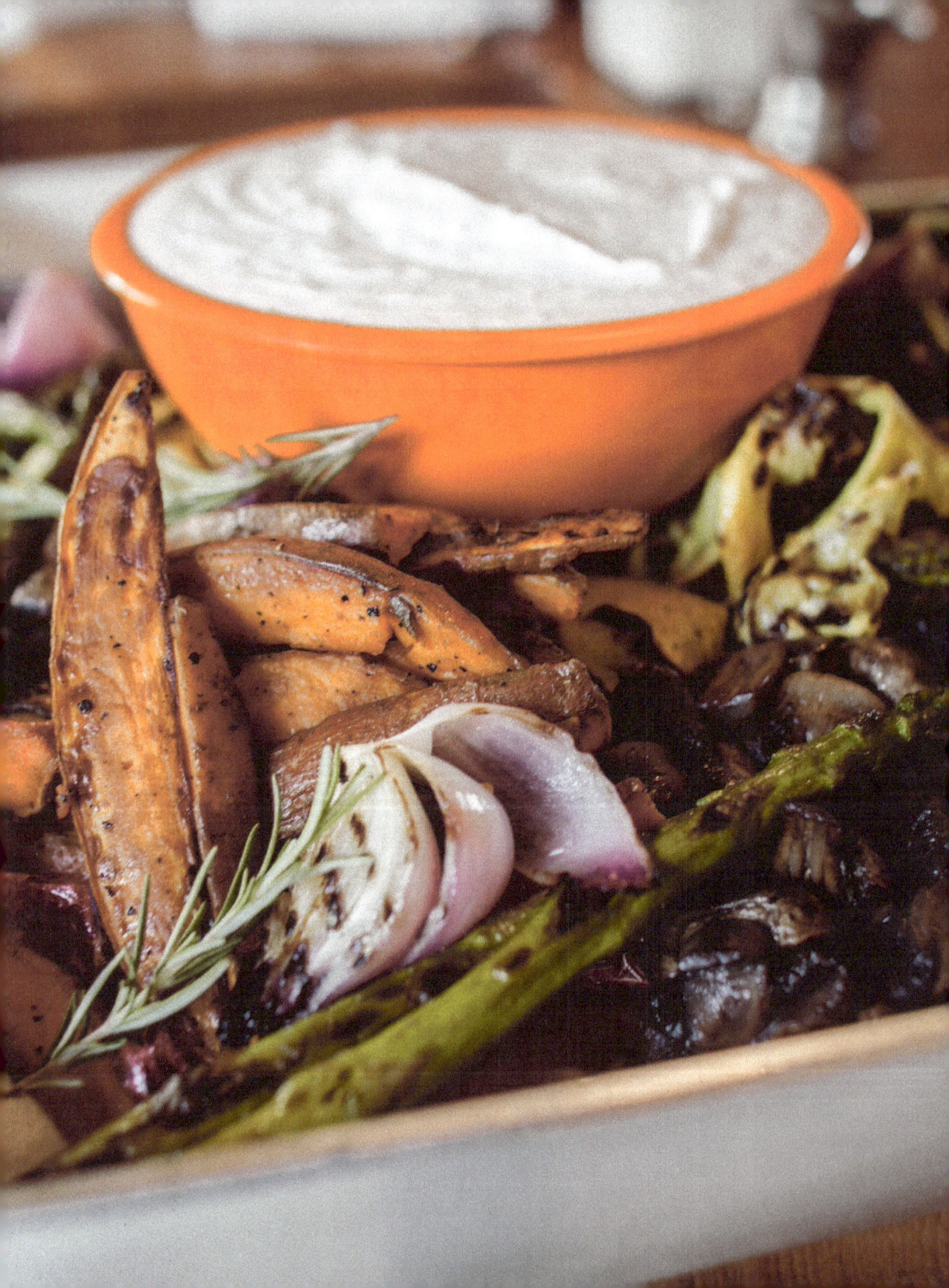

Mojo Sauce

This is a classic Mojo sauce. It's not Kennedy's secret sauce but would go well on the Cuban sandwich.

8 cloves garlic, minced

1/3 cup of fresh orange juice

1/3 cup of fresh lime juice

1/3 cup olive oil

1/2 teaspoon dried oregano

1/2 teaspoon cumin

Kosher salt and freshly ground black pepper to taste

Place garlic in a mortar and pestle. Add 1/2 teaspoon of salt and work into a smooth paste.

In a small bowl, whisk together garlic, sour orange juice, oil, oregano, cumin. Season with salt and pepper to taste.

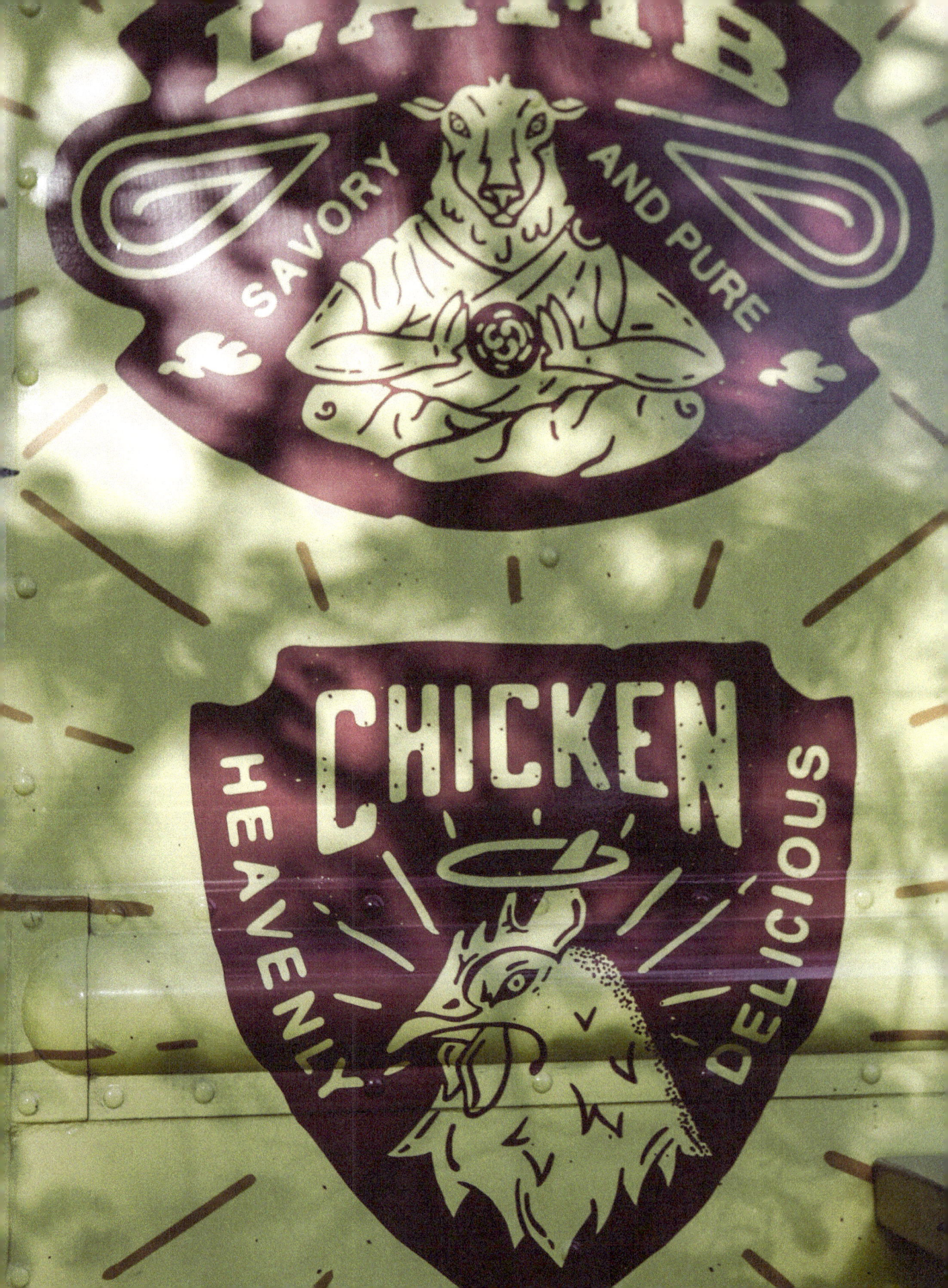

Pita for Good

SOCIAL

🐦 **@pitaforgood** f **@PitaForGood** 📷 **@pitaforgood**

🧭 *pitaforgood.com*

SUMMARY

Pita for Good is a Mediterranean-style food truck run by lawyer-turned-food entrepreneur Mark Van Blaricum. He serves up fresh, healthy, gourmet noms from a beautifully designed truck.

STORY

It isn't often I hear a food truck owner say they ditched practicing law to start a food truck. But if you've been to Pita for Good, you may be glad owner Mark Van Blaricum made that choice.

Van Blaricum is a native of Pratt, Kansas and has an enviable list of degrees from the University of Kansas: business administration (1999), law (2002), a master's degree in health services administration (2008).

"I've done private law practice, health care risk management and compliance, and was worn out by staring at a screen all day every day," Van Blaricum remembers. Sitting in front of a computer and reading page after page after page of legal language certainly sounds like it could be draining, especially for a creative type. However, it isn't apparent if Van Blaricum always thought of himself that way or saw the exit sign to a more fulfilling path.

Luckily, Van Blaricum has a supportive family who seemed to have recognized his creative talents and encouraged him to develop them further. He says, "I've always dabbled in the kitchen. I tried recipes over and over on my wife and daughters, and it was actually their suggestion that I do something with it.

"I fell in love with the Mediterranean while traveling around Europe in 2003, and just couldn't readily find the same stuff when I returned to the USA. The Turkish people at the Ethnic Enrichment Festival always serve the best kebabs and salads, and I certainly have taken inspiration from them. [The name] Pita for Good is open to interpretation. For me, I try to use the best ingredients, have fantastic customer service, and introduce this kind of good food to people who haven't tried it before. We donate to KCUR [public radio] and KCPT [local PBD station] pledge drives and do other philanthropic gigs. I'm personally on several non-profit boards and committees, etc. Finally, it's good to hear the word 'good' in the midst of all this turbulence."

There's no shortage of creativity in the design of Pita for Good. In fact, it's hard to miss with it's citron yellow-green exterior. It's embellished with a style of illustration that looks inspired by a henna tattoo, with deep red and orange accents. The hero of the design is a whimsical elephant who appears to be meditating with a spatula while donning a sariki. There are even hand-drawn elements in oft-ignored areas of the truck's canvas, such as around the headlights.

Kansas City is fortunate to have a deep well of creative talent, thanks to being home to Hallmark. "I know a lot of former Hallmarkers; they are good to know. I asked one I know well if she could design a concept for a food truck; she said she couldn't but knew someone who could and referred me to Whiskey. The rest is history. I love those guys," he said. "Whiskey Design pulled the ideas out of my head and ran with them. What they have created continues to amaze me. The looks I get driving down the street still tickle me."

Van Blaricum announced his plan to launch the truck to extended family at a wedding in May of 2015, and Pita for Good hit the road in April 21, 2016. The Mid-Continent Public Library class on the Business of Food Trucks was a "huge help," and Van Blaricum also connected with Brandon Simpson of Jazzy B's food truck, one of Kansas City's first trucks. He describes Brandon, as "one of a handful of owners that were

indescribably helpful to me and others who were entering the truck scene." The menu is full of whole, unprocessed ingredients cooked fresh-to-order on the truck. "I don't think most people realize how challenging it is to source local ingredients here in KC," Van Blaricum says of his food. "I do my best to source locally, because I strongly believe in that cause. My lamb is locally raised, and I work with local farmers and urban growers to source fresh herbs, onions, garlic, and tomatoes when they are in season."

Van Blaricum's truck was built from scratch ("like the food I serve!" he said,) by what was MAG Specialty Trucks. "I think it was an old FedEx truck with 200,000+ miles on it."

One contributing factor to Pita for Good's success is their ability to appeal to a variety of customers. "Our lamb is the biggest hit with omnivores. Just the fact that we can serve vegetarians and vegans makes us a big hit with anyone looking for those alternatives."

Van Blaricum is proud to know he has "added a 'healthy' food truck to the fabric here, though I've never really marketed it as such. I've honestly had more than one person tell me 'This is the best meal I have ever eaten in my entire life,' and to me, that makes it worth it.

"With all the good comes some bad, and handling negativity with grace and understanding is extremely important, too," Van Blaricum says, sounding as zen as his mystical elephant mascot. "Once in a while a customer will be upset about anything and take it upon his or herself to go to social media and vent. I'd rather repair a situation in real time and give someone free pitas for life than have that happen, but that's rarely possible. I used to take the negative pretty hard, but I never question the validity of a complaint. I look at those now as opportunities for improvement; I'd be crazy not to."

When asked what he wants his daughters to take away from his food truck business, he said, "People skills! In this age when young people have to go out of their way to develop them, my daughters see what a smile or a joke

can do, even in stressful situations. They've 'helped' me on board and see the importance of listening, eye contact, speaking up, and respecting everyone. You can't beat that experience."

When asked if he ever thought of throwing in the towel, Van Blaricum said "Absolutely. If someone says they haven't, they're not being straight with you. Last October, my generator wasn't working, I'd had several lackluster events in a row, I'd done 70+ events to date and was utterly exhausted, and things just felt off. Then, our last scheduled event of the year goes absolutely perfectly on a sunny late-October day, the season ends, and all is right in the world again. Yin and yang, or however you look at it."

And when times get really tough, Van Blaricum has a savings bank of memories that he can dip into when he needs a smile. "The Strawberry Swing Indie Craft Fair each May is always memorable. Last year in particular, our day started with an 8-year-old boy battling leukemia working a little shift on the truck. It was his dream to work on a food truck or play for the Royals…just like me. Then we went on to have one of the busiest, most enjoyable days of all time. I got choked up recalling it all to my wife later that night." Thisis what keeps our favorite food trucks (and local businesses, for that matter) in business: yes, our patronage, but also when we share the little moments of joy that bring us together as human beings.

Q&A

DO YOU HAVE MORE OF A SWEET PALATE OR SAVORY?
Savory all day long and twice on Sunday.

ARE YOU A NIGHT OWL OR EARLY RISER?
I don't stay up too late and I don't wake up very early, so neither.

WHAT IS YOUR FAVORITE PLACE TO VACATION?
I love to travel, vacation with my family, golf, climb mountains, travel abroad, whatever. Any time we get the chance.

WHAT IS YOUR DREAM VACATION SPOT?
Istanbul, Turkey and Bandon Dunes, Oregon. I'll check one of those off later this year.

DO YOU HAVE A FAVORITE SAYING?
"It's easy to grin when your ship comes in and you've got the stock market beat. But a man who's worthwhile is a man who can smile when his shorts are too tight in the seat." - Caddyshack.

WHO IS SOMEONE WHO INSPIRES YOU?
My wife, Jackie. I love her authenticity (among many other things). It is what makes her great at her job.

DO YOU HAVE ANY PET PEEVES?
Integrity is a big thing for me. Say what you mean and mean what you say.

WHAT ARE YOUR FAVORITE RESTAURANTS IN THE AREA?
I love Q39, The Antler Room and the (fairly) new Third Street Social in Lee's Summit is a sleeper that most people probably don't know about. It's long overdue in Lee's Summit, but better late than never.

WHAT IS YOUR GO-TO GUILTY PLEASURE TV SHOW?
I don't know if there's too much guilt here, but I'm a Royals fanatic. If I'm not at the game, I'm watching or listening to it.

WHO ARE YOUR FAVORITE INSTAGRAMMERS:
Pete Souza - the American photojournalist and the former Chief Official White House Photographer for Ronald Reagan and Barack Obama.

WHAT IS THE LAST PODCAST YOU LISTENED TO OR BOOK YOU READ?
Somebody recommend me a good podcast, please! I devour books. I read and read and read whenever I can. Anything good, any topic, mostly nonfiction. I just read a book called We Have No Idea, a physics book about the universe and how little we know about it. Absolutely fascinating.

FANTASY DINNER PARTY, YOU'RE HOSTING. WHO ARE THE GUESTS?
All of my food truck helpers, friends, and family. I'd be nowhere without them.

IF YOU COULD EAT JUST ONE DISH FOR THE REST OF YOUR LIFE, WHAT WOULD IT BE?
I just told my daughters this the other day! The answer is chips and salsa (salsa bar, that is, with at least five different salsas available). The. Rest. Of. My. Life. Yes.

WHEN I NEED INSPIRATION, I...
find something to read.

IF I DIDN'T OWN A FOOD TRUCK, I WOULD...
own a little Mediterranean restaurant.

SAMPLE MENU

Pita Sandwiches
Warm pita bread served with your choice of chicken, lamb kofta or vegetarian falafel. Topped with tzatziki, smoky harissa sauce, pico de gallo, hummus, tabbouleh and toum (garlic sauce, when available).

Plates
Your choice of lamb, chicken, or falafel, or any combination of the three. Served with pita bread and full servings of hummus, tzatziki sauce, tabbouleh, and salad du jour.

Sides
Tabbouleh - parsley and quinoa salad
Greek Salad - Cucumber, cherry tomato, bell pepper, olive, and feta cheese in sumac vinaigrette
Piyaz - savory Turkish white bean salad
Pita & hummus - with smoky harissa and an olive

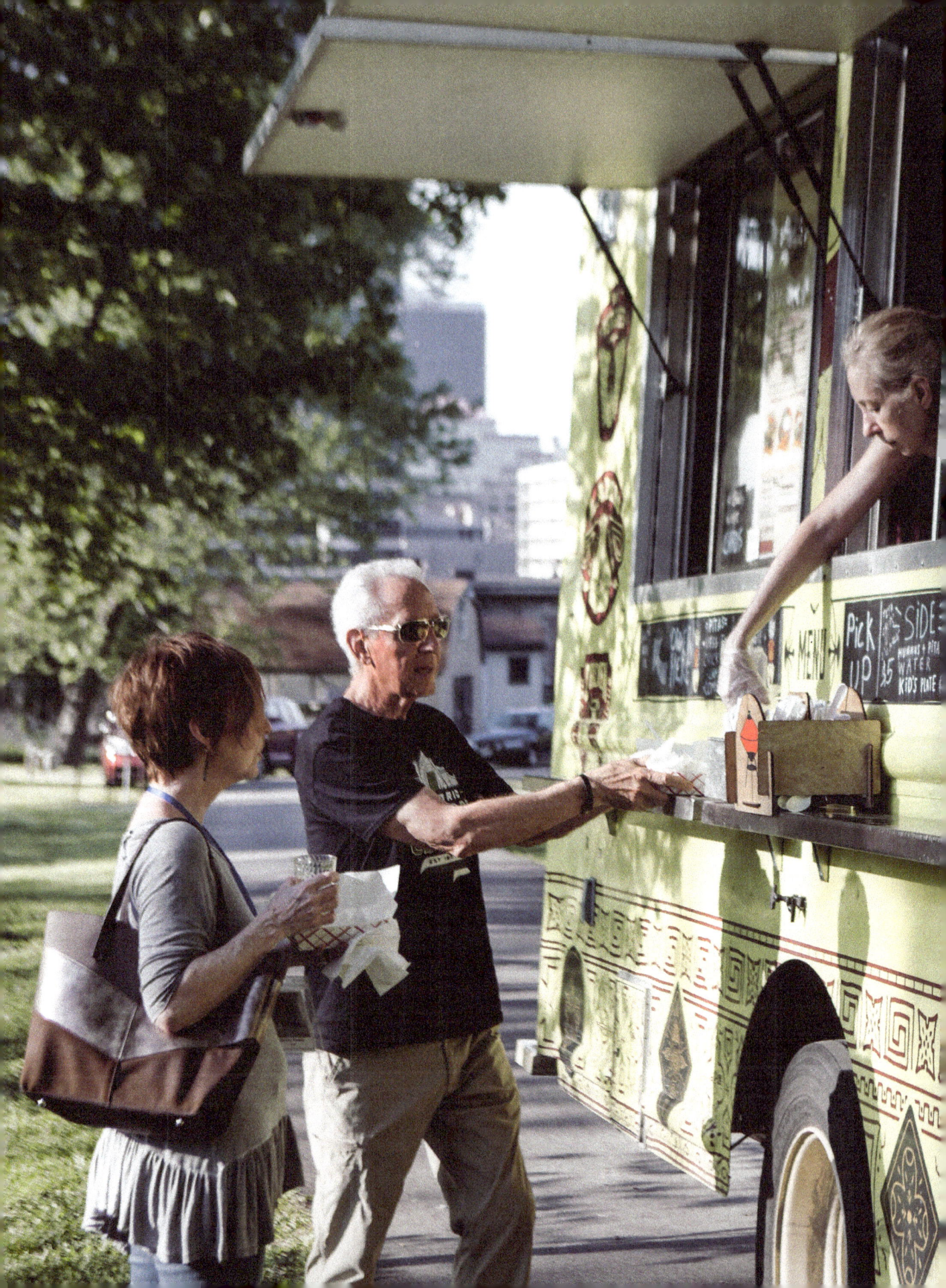

Grilled Lamburgers

Yield: 6-7 patties

1-1/2 pounds ground lamb

1/2 cup white onion, finely chopped

2 tablespoons fresh mint, finely chopped

1 tablespoon finely chopped garlic

1-1/2 teaspoons (scant) kosher salt

1/2 teaspoon ground cumin

1/2 teaspoon coarsely ground black pepper

Mix all ingredients together with your hands in a bowl and form into 6-7 patties.

Grill over medium-high heat until just cooked to medium (about 5 minutes per side).

Remove from heat and let stand for a minute, then serve with any or all of: warm pita bread, hummus, hot sauce, tzatziki sauce, and tomato relish.

Pita for Good Harissa Sauce

5 ripe tomatoes

2 cloves garlic

1 tablespoon smoked paprika

1 teaspoon kosher salt

1 tablespoon red wine vinegar

¼ cup olive oil

Red pepper flakes to taste

Bring ½ cup of water to a boil.

Remove from heat and add optional red pepper flakes.

Leave for 10 minutes then drain out pepper flakes.

Place all ingredients (except for the olive oil into) the bowl of a food processor.

Mix slowly in the food processor, adding a little olive oil at a time until fully incorporated.

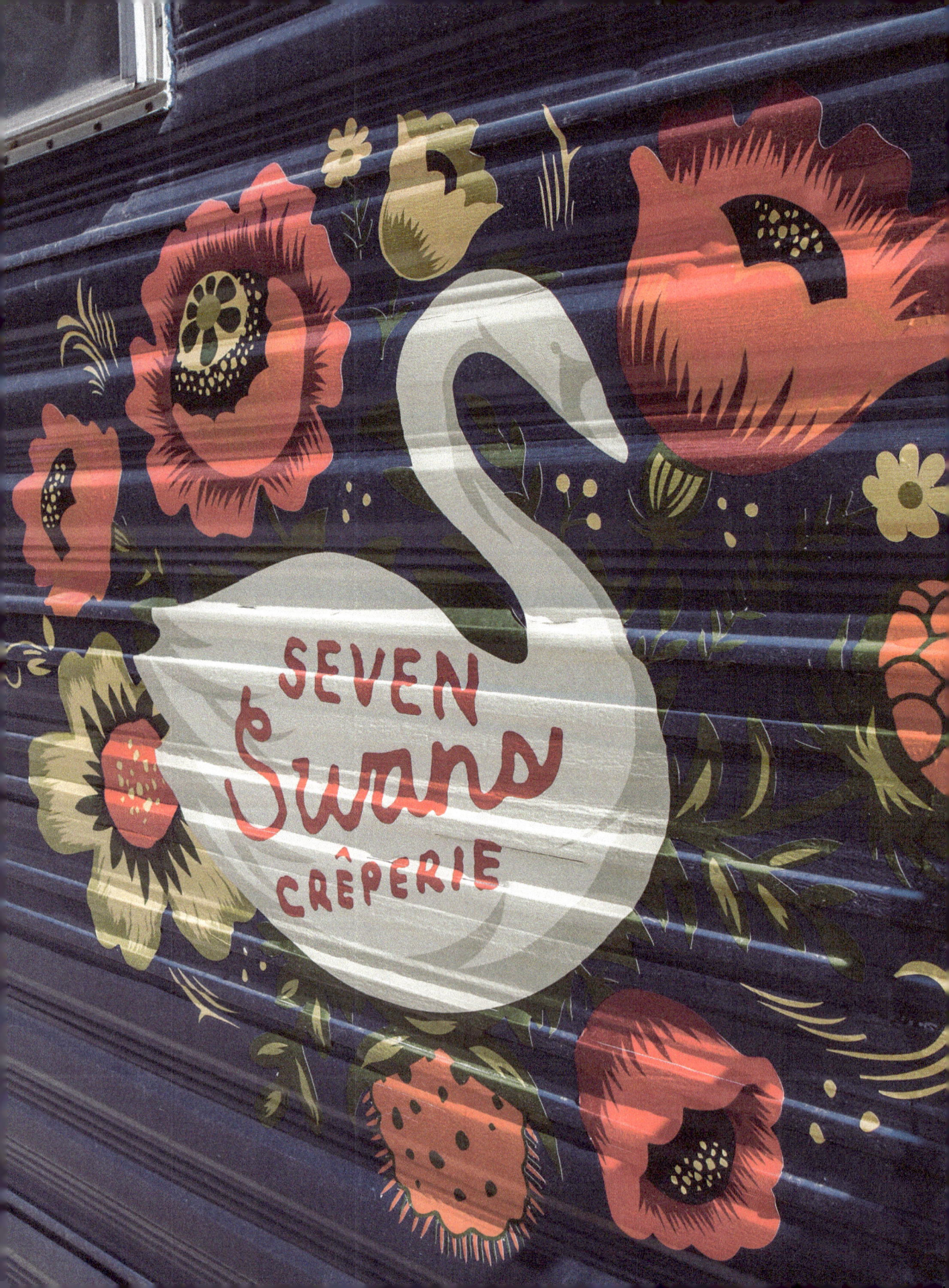

Seven Swans Crêperie

SOCIAL
@SevenSwanscCeperie **@sevenswanscreperie**

SUMMARY
Seven Swans Crêperie is Kate Bryan's matte black trailer with floral flourishes, featuring delicious fresh-made crêpes.

STORY
This gorgeous little crêpe trailer has been 15 years in the making. Sort of. Owner Bryan started dreaming of a brick-and-mortar crêperie 15 years ago. Truth be told, owning a food truck did not appeal to Bryan. They seemed utilitarian. Still, the idea of starting her own business nagged at her often, and she felt she was in the right place to do it.

When it comes to small businesses in Kansas City, back in the day Bryan describes the area as a "wasteland," but now believes the city is ripe for small businesses. "It's an entrepreneurial city. When you see small businesses flourishing, you know something good is going on in the city. Driving down the street, there's so many of my favorite places that did not exist six years ago. It helps when a city has a very instilled sense of pride. When I was in Milwaukee, the pride revolved around the art scene, radio, and sports. In Kansas City, the Royals' win was a turning point. For me, this city has been an accelerant, not a hindrance.

Bryan wrote a couple business plans for boutiques, managed a children's boutique, and worked at Paper Source. She felt her dream building up inside her, growing in a sense of urgency. "I was tired of talking about it and dreaming it. It was now or never," Bryan said to herself.

And with that, Bryan started pursuing her dream of starting a crêpe shop. She hunted for the perfect space, found it, and it slipped through her fingers. She pulled herself up by the bootstraps, went back at it,

found another incredible space, and yet again the deal fell through. "I felt the universe was redirecting me," Bryan recounted.

She took a step back and reevaluated her options and revisited the idea of pivoting to opening a food truck instead of a brick-and-mortar. From that point on, things started running a bit more smoothly. "One of my stipulations to opening a truck was that it would be a neighborhood joint," Bryan says.

Bryan started doing her due diligence. She took a FastTrac class from the Kauffman Foundation, which the foundation describes as, "a flexible course with a solid framework to support you as you start a business and begin your journey to success. This immersive course is designed to provide information, tips, exercises and tools to help you think about your business idea."

Bryan also reached out to Morgan Perry from the Mid-Continent Library. Wise move, given Morgan is a font of knowledge for all things food trucks and starting a small business in Kansas City.

While deeply considering the business of a food truck, Bryan kept feeling like a truck just wasn't her. Then, she came across food trailers and that felt like a better fit. A couple of friends said they'd help her design it, and 24 hours later she was the proud owner of a 1979 vintage camper. "I naively thought I could launch in a couple months, but it took a lot of help from people with a lot of knowledge."

KC Home Trailer was a big part of her trailer build-out. They specialize in all things trailer. "They were really knowledgeable and that was a turning point to 'this is going to happen,'" Bryan explains. "I painted the trailer myself, and the logo decal came from a friend."

Despite her thorough research, Bryan says "I felt super unprepared, like I was starting from ground zero. I had no experience in food trucks

or even food. Every step seemed daunting and impossible but I pushed through. I function a lot on instinct, but there's a lot of preparation that goes into running a business; it requires a lot of research and preparation. Then there's the side where I get to take that and make it into a business and make it my own. I have to rely on my own instinct as well."

While she may have felt ill at ease about the technical parts of the truck, her creativity flourished when it came time to develop the truck concept and menu. "The truck name is inspired by Russian fairy tales," Bryan explains. "I studied abroad in St. Petersburg, where they make blini (crêpes); they're on every street corner. St Petersburg is a super beautiful city, even in winter. I wanted the business to reflect the hominess and a Russian folktale vibe."

There is a poem by Rainer Maria Rilke, an Austrian poet, called The Swan. It's about belonging. A swan looks awkward when it walks, but when it's in the water it totally transforms to being graceful. I want my business to be a place of belonging and community, and I personally reflected on my own journey to find my way. One day my mom was taking a walk along Lake Michigan while we were discussing this; she never ever has seen any swans there, then all of a sudden seven of them appeared. That's where the name of my business comes from."

As for the menu, that seemed to come naturally as well. "At every event I do a different savory and sweet option on top of the standards, like ham and Swiss cheese. Pumpkin custard, almond marzipan custard, blood orange marmalade, for example." The seasonal and inventive ideas kept on coming. "They're more of comfort food crêpes, less traditional."

When it comes to ingredients, Bryan tries to source locally. Thankfully, for meat she has a lot of good options, such as The Local Pig and David's Pasture. Dairy items often come from Green Dirt Farm Creamery, and she plans on tapping the great resource that is Bethany Harris of Kansas City cheese truck Ash & Bleu for more local dairy sources.

A year and a half after she made the decision to start a food truck, she was on the road. "Once the permit came I was so ready to go. Two days later I posted my first stop on my neighborhood Facebook page. It was bonkers how long the line was, and for four straight hours there was a line. It was a big confirmation. It lifted a weight off my shoulders. Every week since, that has happened," Bryan says, beaming. She has been a Hyde Park resident for six years and thought it would make a perfect spot for a truck. "It is so nice to serve breakfast while people bring blankets to enjoy the crêpes in the park, kids play on the swing set, and neighbors come out of their homes."

The details make it an experience and not just an exchange of food for money, she says. The best moments of this are with people. One time at the Brookside Farmer's Market, I has just served a crêpe with sweet potato hash and mushroom gravy. This woman came back and was like 'What did I just eat?!' It was so great. It was one of the most gratifying moments of my life. Then there was a family who came to Hyde Park, they were on a bike ride and stopped at my trailer with three kids, and it was like they had just stepped into heaven. The kids were covered in Nutella crêpes and became starry-eyed. Now it's a family tradition every Sunday for them. The parents get savory crêpes, the kids get Nutella. Its my wildest dream come true."
 The immediate warm embrace from her community was encouraging, but she still had a lot to learn. She says, "The first couple months I did not know I was going to make it, mentally and physically. There was so much guess work. In the beginning I made a decisions that this would be fun and restful, and if it started tilting or I started over-thinking and being neurotic, then I needed to simplify, simplify, simplify until I was at ease."

Bryan has not done any traditional food truck events yet, because they just do not feel like her jam. Instead, pop-ups at local businesses and farmer's markets are serving her well.

Still, the new trailer seems to have had more success than hot dog requests. When asked to sum up her three months on the road, Bryan says "the first word that comes to mind is fortifying. I do not think I knew how capable I was. I was held back by fear for so long. It has been a really incredible process for me. All the clichés are starting to ring true. You want to start telling everyone to follow their dreams. You genuinely can do what you put your heart and mind to. I needed to prove that to myself. By doing it I was telling myself it was possible.

There was a point where there was no turning back. Since opening I haven't looked back for a single second. It's an incredible thing to work for yourself. It's wildly fulfilling.

"When I finish up every day I feel giddy, the kind of giddiness you feel as a kid but forget about as an adult. Creating not just great food but an atmosphere around it - it's kind of what I live for."

Q&A

WHERE IS YOUR FAVORITE PLACE TO VACATION?
Italy

WHERE IS YOUR DREAM VACATION SPOT?
Greece, I've never been to the Mediterranean. That's on my bucket list.

WHAT ARE YOUR FAVORITE RESTAURANTS IN KANSAS CITY?
Thou Mayest Coffee Roasters in Hyde Park.

WHAT IS YOUR GO-TO GUILTY PLEASURE TV SHOW:
Mozart in the Jungle, The Crown

LAST YOUTUBE VIDEO THAT GAVE YOU THE FEELS:
Swans Dancing Together After Reunion. I saw the clip right after I had just bought myself a mug of two life-long partner swans.

FAVORITE INSTAGRAMMERS:
Illustrators, @jane_Newland

LAST PODCAST YOU LISTENED TO:
Quiet by Susan Cain - about introverts in a world where people do not stop talking. [I listen to a lot of] business podcasts these days, such as On Being.

FANTASY DINNER PARTY, YOU'RE HOSTING. WHO ARE THE GUESTS?
Sufjan Stevens (he has an album called Seven Swans, that's not where the name came from), my closest friends. I do not have a lot of celebrity fascination.

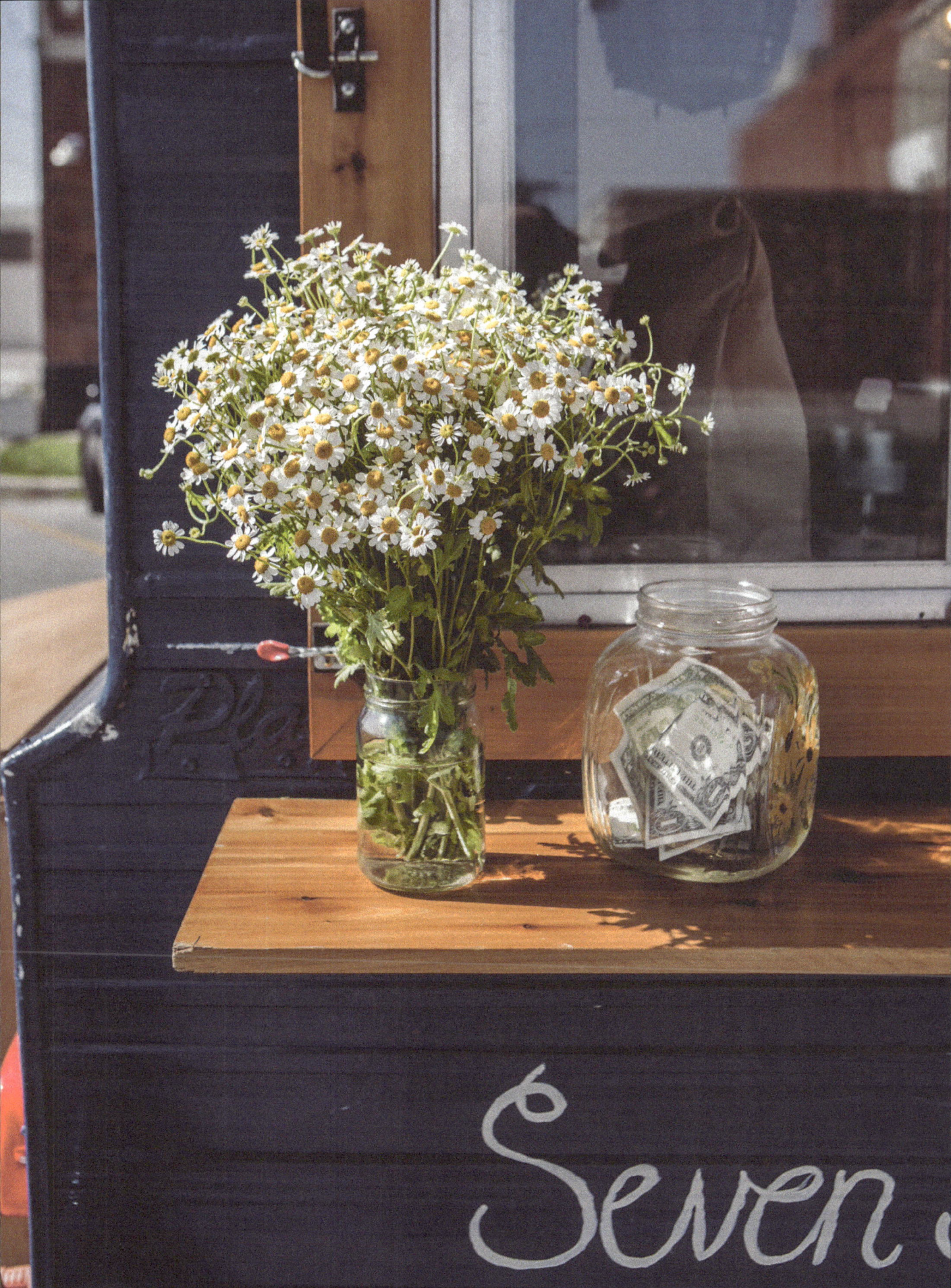

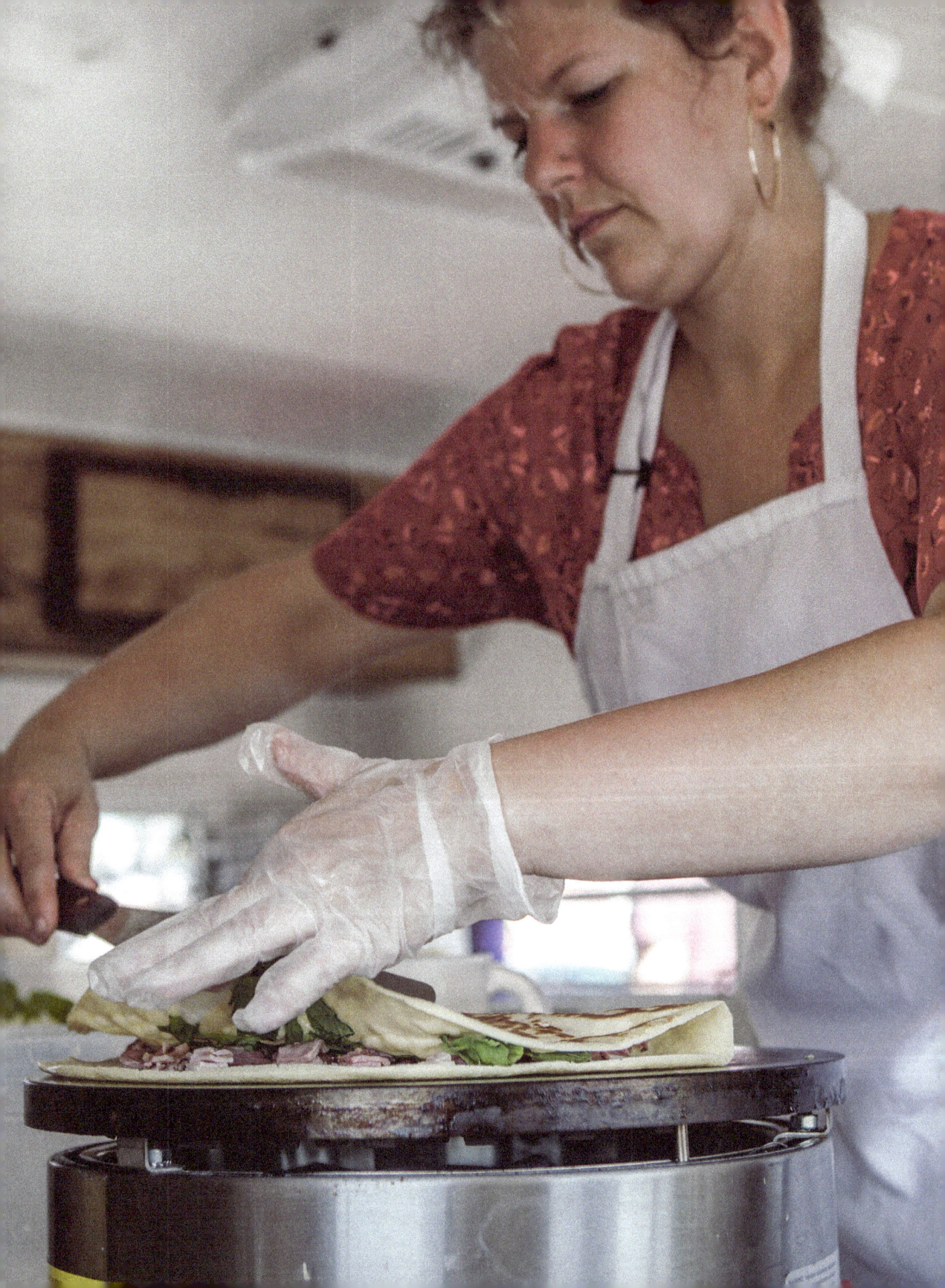

SAMPLE MENU

SWEET

Homemade chocolate hazelnut spread, bananas. Made with organic coconut sugar and whipped cream

Homemade peanut butter with cardamom and ginger, topped with plain yogurt, pure maple syrup, and candied ginger

Homemade lemon curd with whipped cream

SAVORY

Sweet potato hash with onions, mushrooms, kale, porcini mushroom sauce and cracked egg

David's Pasture ham, grassfed Swiss cheese with arugula, and whole grain mustard

Whisky Bacon-Maple Jam

Recipe courtesy of Sarah G, blogger and recipe developer at GoldLiningGirl.com. Seven Swans owner Kate Bryan said, "I use this recipe often and it's amazing!"

1 1/2 pounds of bacon (reserve 3 tablespoons of bacon grease)

1 medium yellow onion, chopped

1/2 medium purple onion, chopped

2 teaspoons minced garlic

10 shallots, finely chopped

1/2 teaspoon chili powder

1 teaspoon paprika

1/4 teaspoon salt

1/4 teaspoons pepper

1/2 cup maple whiskey

1/2 cup maple syrup

1/4 cup balsamic vinegar

1/2 cup packed brown sugar

In a large skillet, cook bacon over medium-high heat until crisp.

Drain on paper towels, and discard all but 3 tablespoons of drippings.

Crumble bacon into 1/4-inch bits, and set aside.

Add the yellow and purple onion to the skillet.

Cook on medium until soft, golden, and nearly caramelized, about 7-8 minutes.

Add the garlic and shallots, cooking until soft, about 4-5 minutes.

Add the chili powder, paprika, salt, and pepper to the skillet, stirring to combine.

Remove from heat, and add the maple whiskey and maple syrup.

Return to heat, allow to bubble, and cook for 2-3 minutes, stirring constantly, or until thickened.

Add balsamic vinegar and brown sugar to the skillet.

Cook an additional 2-3 minutes, stirring constantly, or until sugar is nearly dissolved.

Reduce heat to low, and stir in the crumbled bacon.

Cook for an additional 8-10 minutes, stirring occasionally.

Remove from heat and cool.

El Tenedor

SOCIAL
eltenedorkc.com @ElTenedorKC @ElTenedorKC

SUMMARY
El Tenedor (or, the fork, in English) is an food truck serving authentic food from Spain, owned and operated by Chef Carmen Cabia Garcia.

STORY
In all my years nerding out on food trucks and visiting every one that I could find, I've never found a truck serving authentic food just as you'd eat in Spain. Sure, there are trucks that serve tapas-style small-portion meals, or take some inspiration from paella, for example. But a true Spanish food truck is a rare gem, and we have a stellar one right here in Kansas City.

I spent a lot of time studying in all parts of Spain. It's hard to find Spanish food that truly tastes authentic. I know a lot of people who know an authentic cuisine will say the same: there are many who try and few who succeed. The first time I tried Chef Garcia's food my hopes were high, but in the back of my head I was preparing myself for food that was only partly reminiscent of the home cooking I enjoyed across the peninsula.

In all my time living and travelling across Spain, the closest thing I found to street food was pre-packaged ice cream stands and open-air restaurants on the beaches that made giant paellas and grilled seafood and veggies. Why? Tapas is why. They are, in a way, fast food. You walk into a tapas bar, grab a couple items waiting for you on plates lined up around the bar, wash it down with a caña (beer), then go on your merry way. If you were really on a mission, you could be in and out in a few minutes. Often times friends hop from tapas bar to tapas bar to eat, or stay seated at a single location and nosh over the course of a few hours. Either way, the quick-serve style dulls the need for grab-and-go street food.

Furthermore, Spaniards take meals seriously. A professor once told me the idea of eating while you commute somewhere is a foreign concept to many Spaniards. Meals are usually savored and enjoyed with friends, coworkers, or family. Again, this dulls the need for grab-and-go street food.

While many reading this may already know, many Americans do not know the difference between Spanish food and Mexican/Tex-Mex food. In Spain, most foods are prepared with just olive oil, salt, and pepper. There are a few staple sauces, but Spanish food is considered great by so many for its commitment in bringing out the natural flavors of a food, not masking them with sauces and condiments. Vegetables are often prepared on the grill with just olive oil and a sprinkle of salt. Salads are dressed with olive oil, vinegar, and (you guessed it) salt. Eggs abound in Spanish cuisine.

Characteristics and items that are...

NOT TYPICAL OF FOOD FROM SPAIN:

NACHOS
BURRITOS
CEVICHE
SPICINESS
MELTED CHEESE
CRUMBLED SPICY CHORIZO
STANDARD PORTION SIZES
TORTILLAS
(THE FLAT ONES, LIKE THE ONES YOU ROLL A BURRITO IN)

TYPICAL OF FOOD FROM SPAIN:

EVOO & SALT ON EVERYTHING
CURED HAM
CURED CHORIZO
MANCHEGO CHEESE
BAGUETTES
SMALL PORTIONS
FAMILY-STYLE ENTREES.
TORTILLAS
(THE QUICHE-LIKE ONES)

With all that said, it's more common to find Spanish-inspired food in the U.S. versus authentic tapas. Ok. End Rant.

Chef Garcia is an accomplished Catalan chef who had her culinary training in Barcelona. If you think of Spain like the U.S., the region of Catalonia would be like a state, and its capital Barcelona. This area is world-renownedfor culinary innovation. Part of this fame comes from Chef Ferran Adria, the father of molecular gastronomy, the chef-scientists who create things like avocado foam and food that seems like it's from a science fiction novel. Chef Garcia describes her style as having traditional Spanish culinary roots blended with those of various world cultures. Garcia brings to life, her love for food, culture, discovery, and travel. The food that comes out of her food truck look like they're being fired out of a restaurant with linens.

This truck is one of the more mysterious of the trucks in Kansas City, as it is a bit harder to find. Though you can find where the truck will be by following the trucks Facebook page, it doesn't seem to make as many stops as other trucks. Chef Garcia was even hard to track down for an interview. That begs the question: Where in the world is Carmen Cabia Garcia?

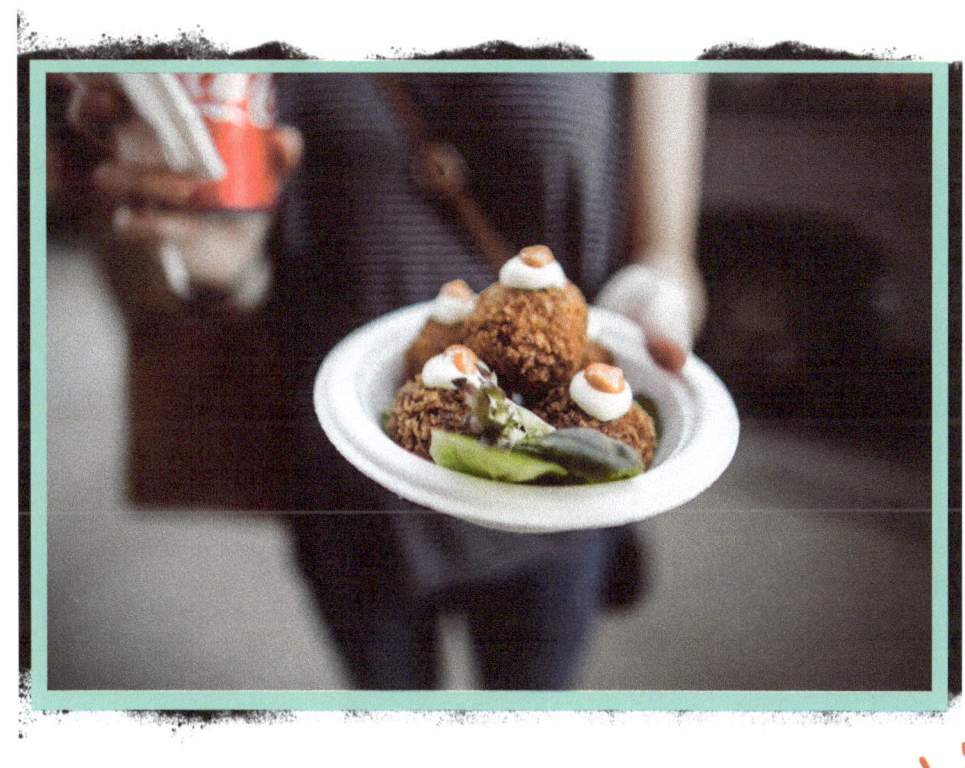

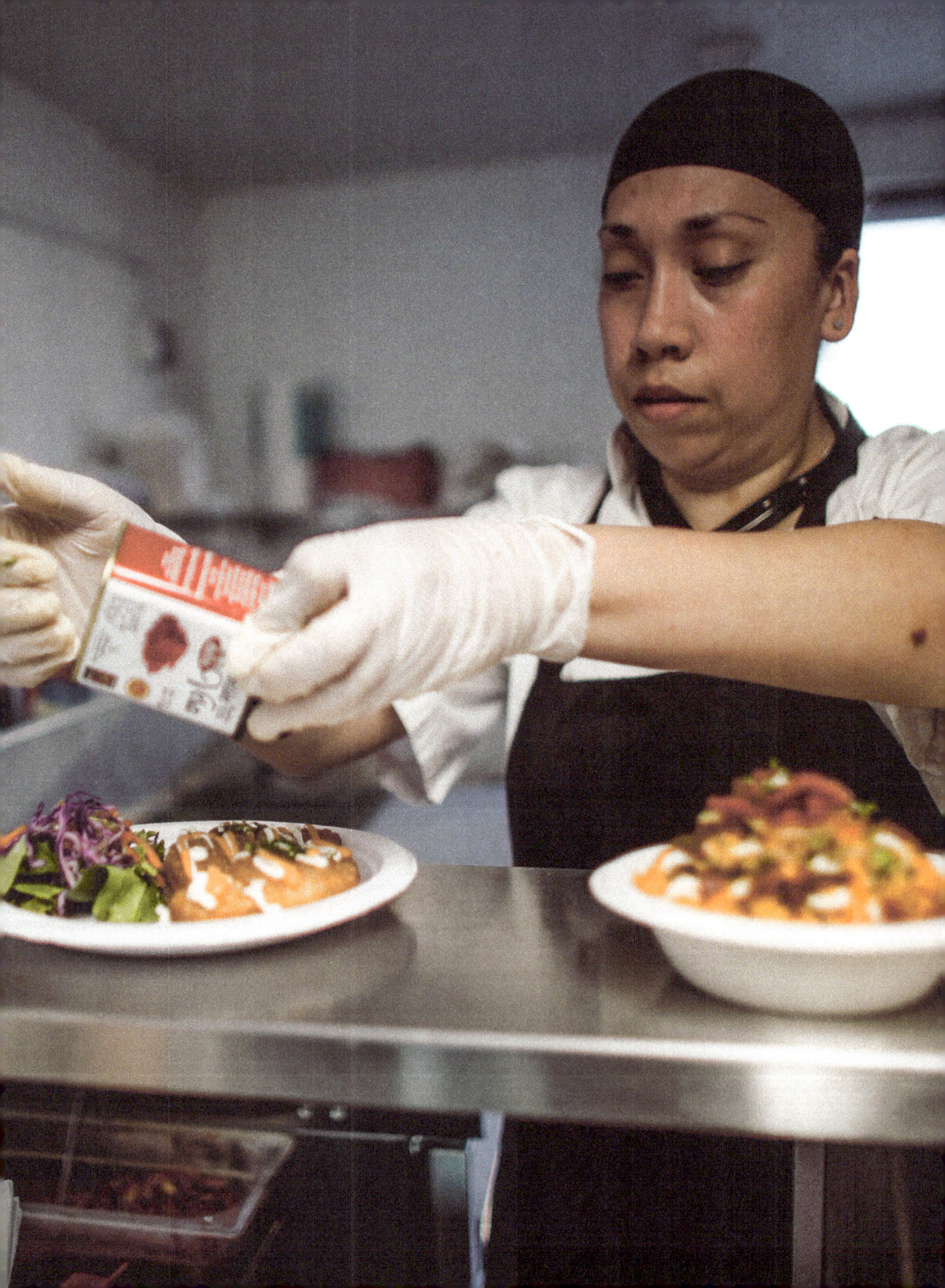

SAMPLE MENU

Paella de Montaña:
Spanish rice, saffron, chicken, pork, chorizo, green & red peppers, aioli

Calamares Fritos:
Catalan style fried calamari

Empanadas de Chorizo:
Turnovers stuffed with home-made chorizo & Manchego cheese

Croquetas de Pollo:
Traditional Spanish chicken & bacon fritters

Setas al Ajillo:
Sautéed mushrooms with garlic & parsley in a white wine reduction

Seafood Paella

1 pound of fresh prawns, cleaned and peeled Note: Use the shells and heads to make fish stock, or use store a bought broth.

1 handful of sea shells, clams, and mussels Note: clean with plenty of water to remove any sand residue.

1 pound of calamari, cleaned and chopped

2 cups of rice

4 cups shrimp broth

1 pound of squid (cuttlefish)

1 onion, chopped

2 cloves of garlic, chopped

½ red bell pepper, chopped

½ green bell pepper, chopped

1 medium tomato, chopped

4 cups broth (homemade fish stock or a store-bought alternative)

½ cup peas

1 bouquet of fresh parsley leaves, chopped

Olive oil

Salt

Pepper

½ teaspoon of saffron

In a paellera, or a large frying pan with a tall rim, fry in olive oil, onion, garlic, pepper, and tomato.

Add a little pepper and salt.

Add the squids and then the sea shells. Let them cook for a few minutes. You will see that a broth begins to be made; this is fine.

Add the 2 cups of rice and stir to mix everything. Add broth and stir well.

Add saffron threads and boil for about 3 minutes.

Even with liquid in the paella pan, add the fresh peas, prawns and the parsley. Taste and add salt and pepper if necessary.

Let cook until the liquid has evaporated. Place a few strips of roasted sweet red pepper on top as garnish, along with some prawns in their shell.

Lower the heat and cover.

Let cook for 15 minutes and taste the rice. If it is ready, remove from the heat and drizzle a bit of olive oil on top to give it even more flavor.

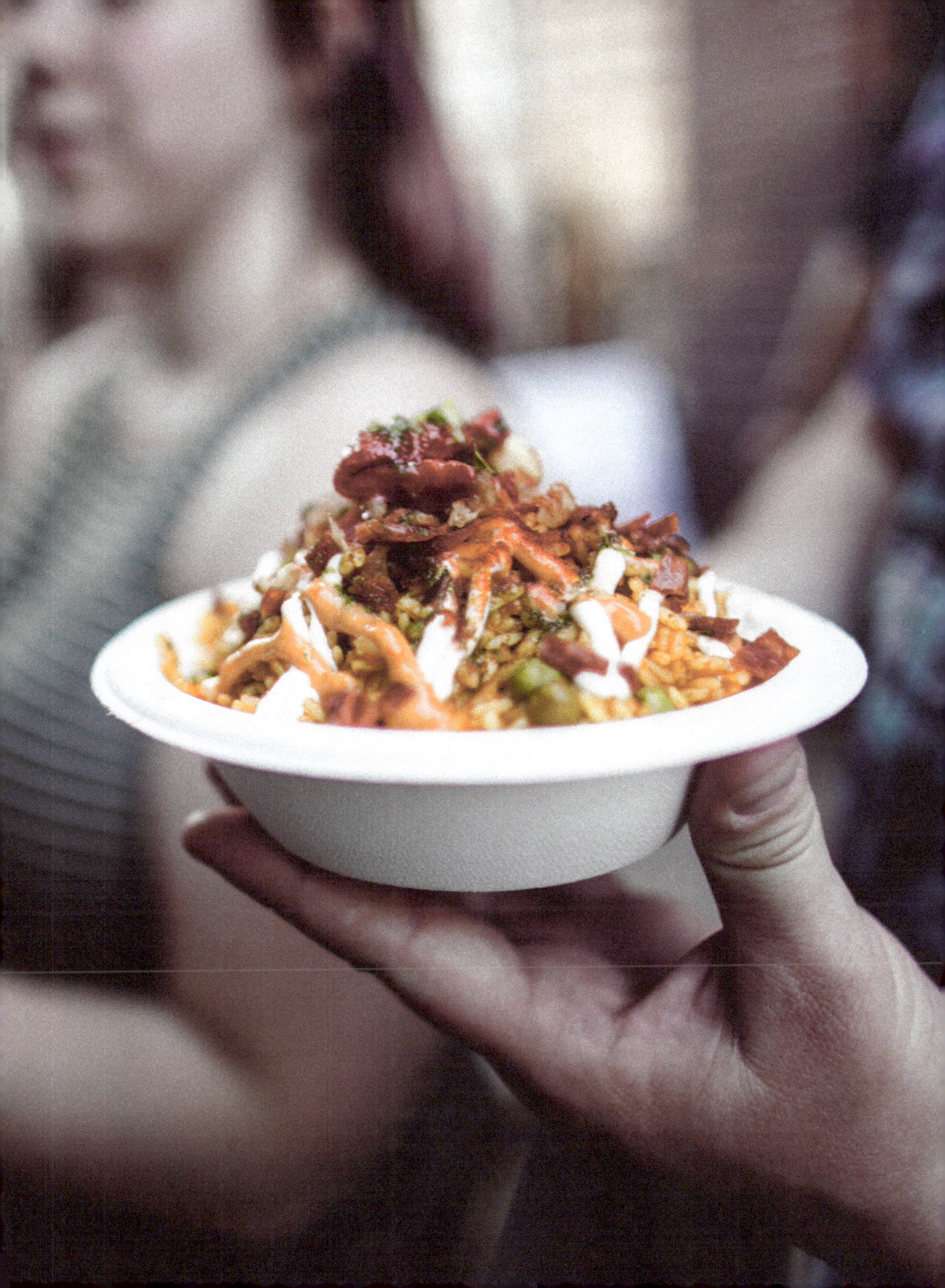

ABOUT THE AUTHOR

Alex Levine is a marketing executive based out of the Kansas City area. She relocated to Kansas City in 2015 from New York City, and is a Chicago native. She has lived in Los Angeles, Salt Lake City, Washington D.C., and Spain.

Alex began blogging about food trucks in 2011 while living and working in Fulton Market, Chicago's meatpacking district, and there were just a dozen trucks on the road. Her blog drew traffic primarily for its truck reviews and locator feature.

Q&A

SWEET OR SAVORY PALATE?
Savory all day! Then again, I cannot say no to a cherry Jolly Rancher, salted caramel anything, or birthday-cake flavored treats.

NIGHT OWL OR EARLY BIRD?
Definitely a night owl. Much of this book was written between 10pm-3am.

BRISKET OR BURNT ENDS?
Burnt ends!

FAVORITE PLACE TO VACATION:
Spain, especially San Sebastian

DREAM VACATION SPOT:
Tahiti, Seychelles or anywhere with over-water huts. Also, I'd love to go glamping somewhere cool but I'm still Google deep-diving the best options.

SOMEONE WHO INSPIRES YOU:
Michelle and Barack Obama. They have such class and poise, and carry themselves with pride while treating others with respect. Also, #relationshipgoals.

FAVORITE KANSAS CITY RESTAURANTS:
Chelly's Cafe, a divey Mexican joint in Waldo. When I need a takeout Chinese fix, New Peking in Westport is my jam. I have a very specific order so they know me now.

GUILTY PLEASURE TV SHOW:
You may judge me hard for these, but I'm okay with that: Below Deck, 90 Day Fiance, and true crime shows. I love Netflix originals like The Crown, The Fall, Wentworth, and the new Queer Eye. I'm currently watching The Americans but only let myself watch it while I work out in order to motivate me to get to the gym (it works).

FAVORITE INSTAGRAMMERS:
Hi-larious Brit-Aussie mom @JetSetMama, interior designer Mike Harrison of @MikeHarrisonArt, cool Target finds at @TargetDoesItAgain, Sarah Fortune and her CVS-obsessed little one named Iris, celebrity men's stylist Ilaria Urbinati, and a bunch of Hallmark artists.

LAST PODCAST YOU LISTENED TO OR BOOK YOU READ:
I religiously listen to Lovett or Leave It (thanks for the reco, Lana) and 99% Invisible. I consume a lot of audiobooks, most recently: Born a Crime by Trevor Noah, The 4 Disciplines of Execution (excellent business read), Who Thought This Was a Good Idea by Alyssa Mastromonaco. I re-read all of Malcolm Gladwell's books a lot.

FANTASY DINNER PARTY, YOU'RE HOSTING. WHO ARE THE GUESTS?
Russell Brand, Dr. Drew Pinsky (of Loveline fame), Hanson (my favorite band when I was a tween), Jennifer Lawrence, Michelle and Barack Obama, Chelsea Handler, Kathy Griffin, Lena Dunham, Bernie Sanders, Amy Schumer, Malcolm Gladwell, Ruth Bader Ginsburg, John Mayer and Alfonsina Storni. It would be a big crew.

YOU CAN ONLY EAT 1 DISH FOR THE REST OF YOUR LIFE. WHAT IS IT?
Gyoza.

IF I DID NOT WORK IN MARKETING,
I would be an interior designer.

IMAGINE YOUR TV IS STUCK ON THE CHANNEL YOU WATCH THE MOST. WHICH ONE IS IT?
I usually have CNN on in the background throughout the day, but then I watch a lot of Bravo to balance it out. My Netflix account gets a lot of use too.

Roasted Salsa

This is a recipe I make often. It comes from Teddy and Alexis Vejar, former co-owners of the Adelita Truck in Chicago.

4 plum tomatoes

3 cloves of garlic

2 jalapeños, stem removed (if you don't like a lot of heat, stem and slice the jalapeños and scrape out the seeds with a spoon)

Preheat oven on the broil setting.

Place whole tomatoes, jalapeños and garlic on a sheet pan and insert the pan into the oven.

Remove the garlic when it is light brown (approximately 2-4 minutes).

Remove the pan once the tomatoes and jalapeños charred thoroughly (approximately 10-12 minutes).

Place all ingredients in a blender and pulse until the salsa reaches your desired consistency.

About the Photography
by Jason & Allison Domingues

Food is life, and getting good food from a truck makes it even better. When we first found out about Alex's food truck book project, we knew we had to be a part of it. Combining our love for food trucks, all things Kansas City, and telling people's stories through photos, it couldn't have been a better fit.

When we're not eating good food, you can find us shooting weddings (in Kansas City and all over the world), headshots, and personal branding photos for small business owners and online entrepreneurs.

People often ask what type of photography we do, and we just say "people." That's the common thread that weaves all of our work together. It's all about people and telling their stories. Our business motto is, "We're a little different. Different is good".

Jason has been a photographer since he was 15 years old, and we've been at it professionally since 2004. Jason takes the photos, and I [Allison] run the business: marketing, social media, design, client communication.

If you would like more information, you can find us at
JASONDOMINGUES.COM.

Jason Domingues and Allison Domingues are a husband-and-wife duo who partnered with Alex to do the photography you see in this book.

www.ingramcontent.com/pod-product-compliance
Lightning Source LLC
Chambersburg PA
CBHW061820290426
44110CB00027B/2924